Emil Nolde
Artist of the Elements

Averil King

Philip Wilson Publishers

First published in 2013 by
Philip Wilson Publishers
an imprint of I.B.Tauris and Co Ltd
6 Salem Road
London W2 4BU
www.philip-wilson.co.uk

© 2013 Averil King
© for the works by Emil Nolde: Nolde Stiftung Seebüll
© for the photographs from Nolde Stiftung Seebüll:
Fotowerkstatt Elke Walford, Hamburg and Dirk Dunkelberg, Berlin
Preface © 2013 Keith Hartley

ISBN 978 1 78130 007 7

Distributed in the United States and Canada exclusively by
Palgrave Macmillan, 175 Fifth Avenue, New York NY 10010

A full CIP record for this book is available from the British Library
A full CIP record for this book is available from the Library of Congress

Library of Congress catalog card: available

Typeset in Secession and Warnock
Designed by Caroline and Roger Hillier
The Old Chapel Graphic Design
www.theoldchapelivinghoe.com

Printed and bound in China by Everbest

Frontispiece: *Ruffled Autumn Clouds* (detail), 1927

Books are to be returned on or before
the last date below.

LIBREX-

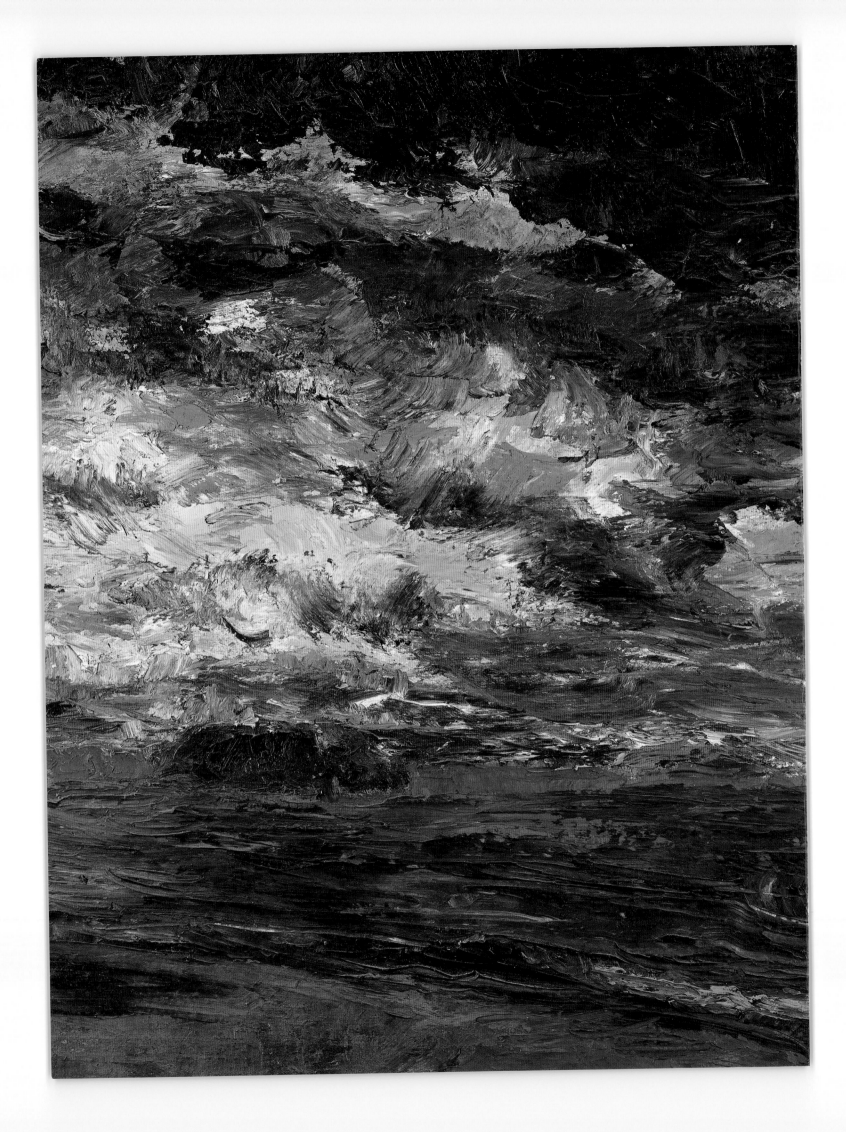

Contents

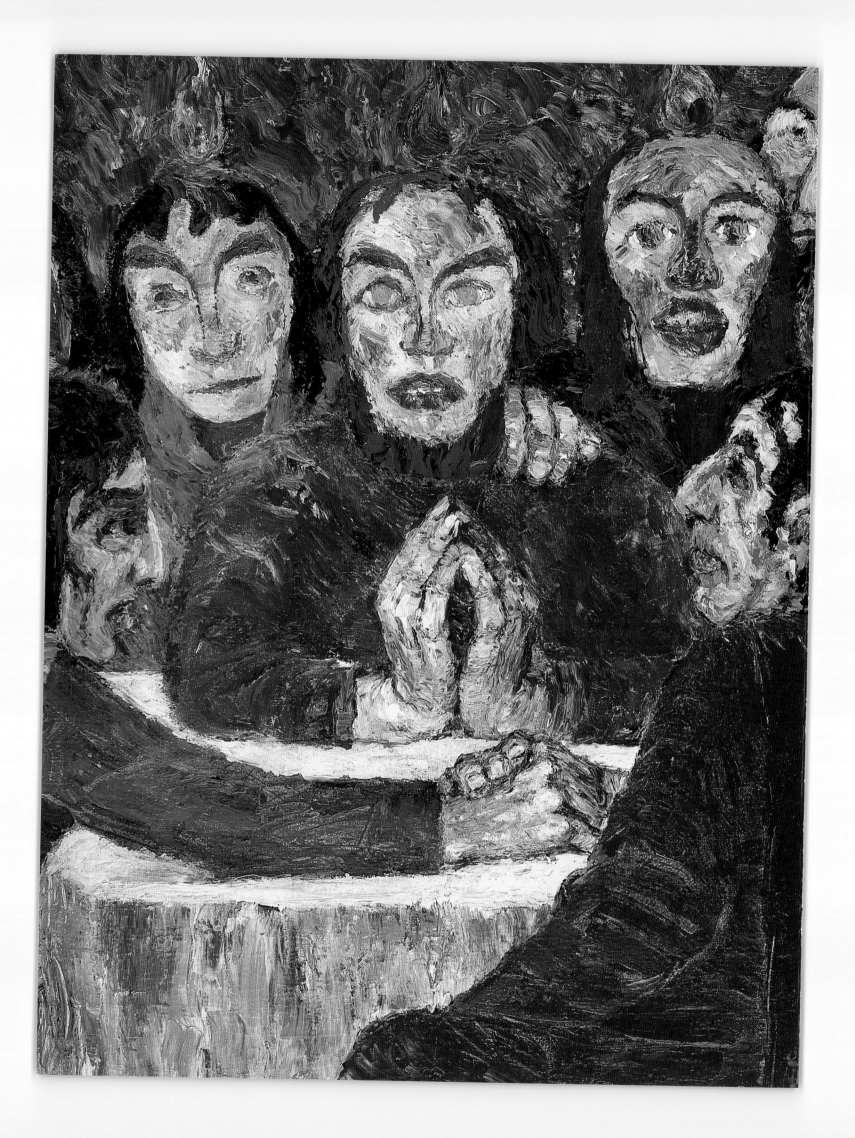

Preface

The work of Emil Nolde is less well known than it should be in the English-speaking world. In the United States, however, the situation is not as pronounced as it is in Britain. There was a major show of the artist's work, curated by Peter Selz, at the Museum of Modern Art in New York in 1963, and there had also been, from 1950 onwards, a steady sale of the artist's watercolours and prints. This has helped to establish a reputation for Nolde as a bold and beguiling colourist, and an adventurous 'primitivist' who followed Gauguin's lead in travelling to the South Seas in search of 'genuine' artistic expression unalloyed by the historical traditions of modern civilization. The United States has continued to display an interest in Nolde's work, most notably in the great exhibition (and accompanying catalogue) of the artist's prints at the Boston Museum of Fine Arts (and tour) in 1995. There has also been a programme of shows and acquisitions dedicated to modern German art, arranged principally by the pioneering Neue Galerie in New York.

In the United Kingdom the interest in Nolde's work has been much less obvious and more intermittent. Apart from one or two paintings in the collections of the Tate and the Scottish National Gallery of Modern Art, and a group of prints in the British Museum, there are few works by Nolde in British public collections. The appreciation of modern German art and especially of expressionism and Nolde was hindered by the two World Wars. The 1938 exhibition of twentieth-century German Art at the New Burlington Gallery in London was a bold counter-move to the exhibition of Degenerate Art that toured Nazi Germany in 1937–8, but the war intervened; it was not until 1985 and the magisterial exhibition of German Art in the Twentieth Century at the Royal Academy that German Expressionism and Nolde were presented in depth. This was followed in 1995 with a show of Nolde's work at the Whitechapel Art Gallery in London. Both exhibitions had fine catalogues. Since then there have been several books on German Expressionism and the Brücke Group (of which Nolde was a member for a short while), but there has been very little at all on Nolde's work on its own.

It is therefore gratifying to be able to welcome this book by Averil King that deals with all aspects of the artist's oeuvre. It is to be hoped that its publication might persuade a major museum to mount an exhibition in Britain of this neglected German master.

Keith Hartley

Pentecost (detail)
1909
oil on canvas
87 × 107 cm
Private collection /
Bridgeman

Chronology

1867 Born 7 August as Emil Hansen, the fifth son of farmers near Nolde, North Schleswig, Germany, close to the Danish border. Brought up in atmosphere of hard work and piety, he helped with farm work, attended Bible readings and rural gatherings, and absorbed the folklore of the area. Nolde's father hoped he would continue to work on the farm.

1884–88 Apprenticeship in cabinetmaking and wood carving in nearby town of Flensburg.

1888–89 Journeyman for furniture companies in Munich and Karlsruhe.

1889–91 Worked in Berlin.

1892–97 Taught industrial design and ornamental drawing at St Gallen in Switzerland; visits to Milan and Vienna. Friendships with Hans Fehr and Max Wittner.

1895–96 Painted series of views showing the famous Swiss mountains as grotesque characters, which he had printed as postcards, and they sold widely.

1898–99 Studied painting with Friedrich Fehr in Munich and then at the Neu Dachau school under Adolf Hölzel. In Munich's Pinakothek saw work of Böcklin, Leibl and Menzel.

1899–1900 In Paris, studied at Académie Julian and visited the Louvre; at Exposition Universelle admired Daumier and Rodin; saw dance performances by dancers including Loie Fuller.

1901–2 In Copenhagen, intending to write about Danish art; met the young Danish actress Ada Vilstrup. Spent summer of 1901 at Lildstrand in North Jutland; married Ada in February 1902 and changed his name to Nolde.

1903 The Noldes rented a fisherman's cottage on island of Als and built a small wooden studio on the beach. Nolde began painting flowers and marine views.

1904–5 Holiday in Italy, paid for by Hans Fehr.

1906 Invited to join the young artists' group the Brücke, based in Dresden. The Brücke artist Karl Schmidt-Rottluff painted with Nolde on Als. Made acquaintance of the museum director Karl Ernst Osthaus and the collector Gustav Schiefler, who would catalogue his graphic works.

1907 March to April worked with Brücke artists in Dresden. Left the Brücke group that autumn. In winter the dealer Paul Cassirer exhibited ten of his paintings at his gallery in Berlin.

1909 At Rutebüll, following illness from drinking poisoned water, painted his first biblical scenes, including *Pentecost*.

1910 February to March rented room in Hamburg and made prints, primarily etchings, of the harbour. Painted more religious works that summer, some of which were submitted to Berlin Secession in October. These were rejected and Nolde contested the decision with its director, Max Liebermann, accusing him of antipathy towards the work of younger

German artists. In December he was expelled from the Secession. In Berlin that winter Nolde painted seventeen oils of the city's nightlife and watercolours in the Deutsches Theater.

1911 Called on James Ensor in Ostend, admiring his 'mask' pictures. Saw paintings by Rembrandt in Amsterdam. Finished his nine-part *Life of Christ*, which Osthaus exhibited at his Folkwang Museum in Hagen the following January. Publication of Schiefler's catalogue of Nolde's graphic work. During the winter in Berlin, Nolde made frequent visits to the city's Ethnographic Museum.

1913–14 The Noldes joined the official expedition to the German colony of New Guinea, travelling via Russia, Japan and China, and returning via Java, Singapore and Burma.

1915 In this productive year Nolde produced eighty-eight paintings, including *Entombment*.

1916 The Noldes bought a small farm at Utenwarf, near the North Sea coast.

1920 Plebiscite held to decide the nationality of people living in the borderland; 75 per cent of voters chose Danish nationality. Utenwarf fell within the new Danish territory, and Nolde became a Danish citizen.

1921 Publication of Sauerlandt's life of Nolde. Visited Paris, England and Spain, painted gypsies in Granada.

1924 Visited Venice and Vienna.

1926 The Noldes bought land at Seebüll and designed and built a house there, which would become a museum dedicated to his work.

1931 Nolde published the first volume of his memoirs.

1931–35 Painted the large watercolours the *Phantasien*. Nolde had a successful operation for stomach cancer.

1937 Following increasing hostility from the National Socialists, Nolde's work was ridiculed at Hitler's exhibition of Degenerate Art in Berlin, and more than a thousand of his works were confiscated from museums.

1941 Nolde was forbidden to work, but continued to paint small watercolours in a small room at Seebüll.

1944 Nolde's Berlin studio was bombed: he lost his print collection and paintings by artists he admired.

1946 Death of Ada Nolde.

1948 Nolde married Jolanthe Erdmann, daughter of the composer Eduard Erdmann.

1956 Nolde died in April, making provision in his will for a donation of eight of his best pictures to the national museum of Copenhagen. The gift was intended as a memorial to his first wife Ada and to promote understanding between Scandinavia and Germany.

Introduction

The German expressionist Emil Nolde (1867–1956) is known for his powerful and flamboyant use of colour. He was born in the village of Nolde in the flat, near-featureless borderland of Germany and Denmark, between the North Sea and the Baltic. Although widely travelled, he chose to live and work there for most of his life, and many of his highly expressive landscapes, with their huge cloud formations and dramatic sunsets, were inspired by its stormy, windswept countryside. He also painted flowers, religious works, scenes of nightlife in Berlin, still lifes, portraits and a long series of magnificent seascapes.

A farmer's son, Nolde spent his childhood among a simple, God-fearing peasant community. After training as a cabinetmaker in the nearby town of Flensburg, from 1892 to 1897 he taught industrial design at St Gallen in Switzerland. In 1900 he began his artistic training, studying at the Neu Dachau school near Munich. His early landscapes and seascapes, with their soft, muted colours, reflected the influence of his teacher, Adolf Hölzel. He married a young Danish actress, Ada Vilstrup, in 1902, following which the Noldes spent their summers in a small, rented cottage on the island of Als off the Baltic coast, where he began his paintings of flowers and gardens and his views of the sea.

From around 1904 Nolde's admiration for Van Gogh and Gauguin was evident in his use of increasingly emphatic brushwork and strong colours. Landscapes such as *Young Fir Trees* and *Bridge in the Marshes* (both 1910), were markedly different from earlier ones. In 1906 the young Brücke artists, admiring his 'tempests of colour', invited Nolde to join them in Dresden, and he worked with them the following spring, but left the group that autumn. In 1909, following a serious illness, he began to paint the biblical scenes that would earn him both notoriety and recognition. During the creation of these, Nolde saw himself as heir to the great German artistic tradition exemplified in the work of Dürer, Grünewald and Cranach. Nolde had been co-opted as a member of the Berlin Secession in 1905 and his work shown since 1906, but in 1910 the directors refused to exhibit the first of his religious paintings, considering them outrageously unconventional. Nolde was deeply upset by this decision, and, in common with several other younger artists, resented the directors' preference for the more traditional work of established French and German artists. He wrote an angry letter to the journal *Kunst und Künstler* in which he criticised the Secession's president, Max Liebermann, with whom he had previously been on good terms. The disagreement became bitter, and Nolde's membership of the Secession was discontinued in December that year. Nonetheless, several German museums began to acquire his work.

In spring 1910 Nolde had spent two months in Hamburg, where he began a series of etchings of the harbour, and over time he would become an accomplished printmaker. As with his oil paintings and watercolours, his graphic works often incorporated an element of fantasy, giving them an unusual and very individual character. The Noldes spent most

Wedding, Copenhagen
1902
photograph
Nolde Stiftung Seebüll

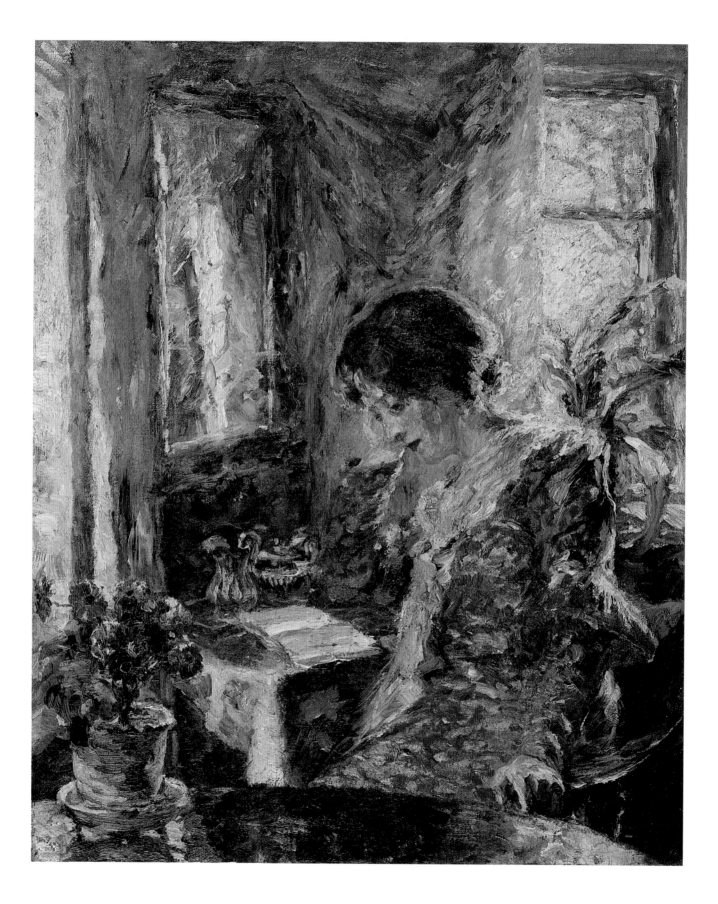

winters in Berlin, where Nolde had a studio; in the winter of 1910–11 he painted a series of oil paintings showing scenes from the theatre and in cafés, ballrooms and nightclubs. In 1913–14 the Noldes were invited to join an official medical/demographic expedition to German New Guinea, travelling overland via Russia, Korea, Japan and China, and returning via Java, Singapore and Burma. Nolde carefully recorded the people and places they saw, taking an especial interest in the lives and customs of the South Sea islanders, and Ada prepared a written record of their experiences.

In 1916 the Noldes left Als to live at Utenwarf, near the village where Nolde was born. In 1926, by which time he was an artist of renown, he and Ada bought land at Seebüll in western Schleswig. There they designed and built their last home and garden, which today is a museum devoted to his life's work. In 1941, having fallen foul of Hitler and the National Socialists, Nolde was forbidden to paint, but continued to do so in secret for the remainder of the War, using watercolours and small pieces of Japan paper. His last years were spent painting views of his native land, seascapes and, above all, the flowers in his beloved garden.

Until 1864, the area that now comprises the Schleswig-Holstein region had been part of Denmark, but it was then conquered by Germany. In response to popular concern, a plebiscite to decide the nationality of its citizens was scheduled in 1866, but not held until 1920, when 75 per cent of voters chose Danish nationality. Utenwarf, where the Noldes were then living, fell within the new Danish territory, and Nolde adopted Danish citizenship. After many years of close and supportive companionship, his wife, Ada, died in 1946; in his will he left eight of his best paintings to the Danish National Museum in Copenhagen, both as a memorial to her and with the intention of building 'a bridge of understanding between Scandinavia and Germany'.

Spring in the Room
1904
oil on canvas
88.5 × 73.5 cm
Nolde Stiftung Seebüll

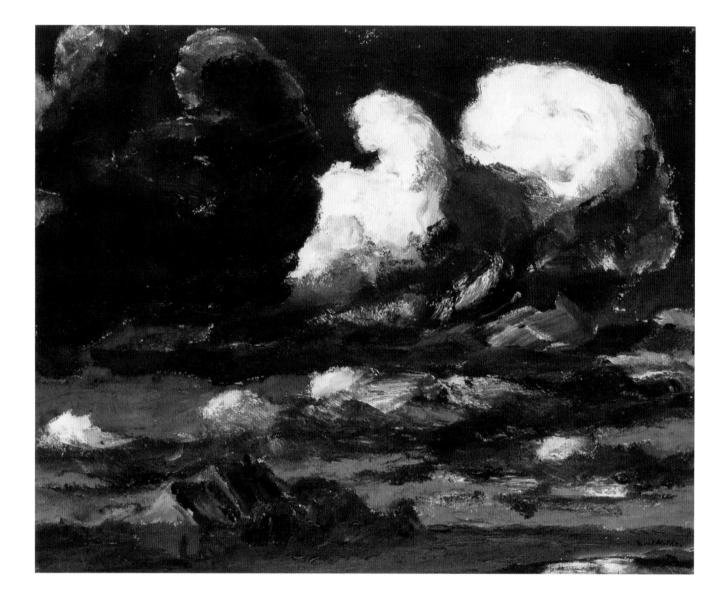

1 Nolde's Wonderland – the Expressive Landscape

Landscape, North
Friesland
1920
oil on canvas
86.5 × 106.5 cm
Nolde Stiftung Seebüll

In his autobiographical writings, Nolde refers to the land where he was born as 'a wonderland from sea to sea' and 'a fairy tale'. He reflected that 'despite many travels to many places... my art remains deeply rooted in my native soil', and it has been said of him that his creative imagination was, indeed, deeply and inextricably bound up with his homeland. Few artists, or groups of artists, are as famed for taking inspiration from the countryside where they spent their formative years. Among these are the Dutchman Jacob van Ruisdael; John Constable, who looked back to his childhood by the river Stour with perennial affection; and the so-called Wanderers, the nineteenth-century Russian artists who painted accomplished landscapes of their comparatively featureless motherland.

For, contrary to popular belief, landscape painters have most often been inspired, as was Nolde, by flat expanses rather than dramatic scenery. In early nineteenth-century England the gentle Norfolk countryside with its calm rivers was commemorated by the artists of the Norwich School, including Cotman and Crome, and from around 1850 the Barbizon artists, including Corot, Daubigny and Millet, excelled at recording the sober reaches and quiet corners of their adopted environs near the forest of Fontainebleau. A little later, Monet himself would require only unprepossessing villages along the Seine and the open fields around Giverny to create some of his best-loved masterpieces.

The most admired Dutch landscape master, Ruisdael, brought to his work a masterly ability to portray the effects of light and weather. He never travelled outside the Netherlands, but working in Haarlem, where he was born, and in Amsterdam, he found lifelong inspiration in his homeland's flat terrain, with its woodland, sand dunes and small sloping ridges. Using low horizons, he painted these beneath benign cirrus, angry cumuli or roving mists, through which a pale blue sky and gleams of sunshine sometimes appeared. Ruisdael's commanding portrayal of such natural elements gave his paintings a sublime character, and they were revered by both Turner and Constable, who spoke of his 'acres of sky', and, in 1819, wrote: 'I have this morning seen an affecting picture by Ruisdael... It haunts my mind and clings to my heart.'

Constable was born almost a century before Nolde, in 1776, the son of a miller working in Dedham Vale, Essex. Although he painted many competent portraits, views around Salisbury and seascapes on the south coast of England, the works of which he was most proud included his famous large-scale views of the Stour. Writing to his friend John Fisher, he insisted that 'I associate my "careless boyhood" to all that lies on the banks of the Stour.' He had, he said, 'often thought of pictures before I had ever touched a pencil'. His recall of his childhood surroundings was so sharp, and so essential an element in his creativity, that in 1819 he formulated and painted his large *The White Horse* while in London, away from the rural scene he was depicting. Other 'six-footers', as he called his large landscapes, sometimes worked up from large-scale sketches, continued to embody the remembered past, rendered with a mature technique; his calm, majestic *View on the Stour near Dedham* and *The Hay Wain* caused a sensation at the Paris Salon of 1824.

The output of the Wanderers, the group of artists exhibiting in St Petersburg, Moscow and other Russian cities from 1871 onwards, is little known outside their country. At a time when Russia was beginning to change from a feudal nation to one espousing more liberal and humane values, many of these artists took it upon themselves to glorify the motherland, with its extensive reaches of dark, gloomy forest, or *taiga*, vast expanses of gently undulating steppe, and innumerable lakes and rivers. For, unlike France, Russia did not abound in picturesque villages, pleasant river valleys or alpine scenery. The great collector Pavel Tretyakov had a fondness for such homegrown landscapes, stating that he 'had no need for splendid landscapes (such as Venetian ones)... a dirty puddle will suffice, so long as it is truthful and poetic... Poetry can be found in all things: this is the job of the artist.' And from this seemingly unpromising terrain the most talented of the Wanderers succeeded in creating great works of art.[1]

For Nolde, the scenically unremarkable, sparsely populated reaches of his homeland – the borderland of Germany and Denmark, between the North Sea and the Baltic – retained an unspoilt, primeval character that held an irresistible appeal. He would walk for miles, and called it 'a landscape full of experiences and history'. Though, during his lifetime, the area was increasingly subject to change, enough remained of its original character to provide him with constant inspiration. Until the 1870s, the sea-bound land had comprised marshland on its western fringes; sandy, infertile heathland in the interior; and more wooded countryside towards the eastern coast; but from around the time of Nolde's birth, wide areas of once dense, now dwindling woodland had been improved, with plantings mostly of salt-resistant silver firs to stabilise the poor soil and provide wood for fuel. Well into the twentieth century governmental policy dictated that unproductive marshland areas continue to be systematically drained, allowing farmers to dig the ground for peat, scatter marl and sand, and sow it with grass, which was burnt in springtime so that crops of rye and buckwheat could be raised.

With the waters of the North Sea rising and falling with a tidal mass of around three metres every twelve hours, high autumn and winter tides continued to flood the western

marshlands, yet Nolde watched these improving measures with regret. Acutely aware of how the countryside had once appeared, and sensitive to those still-visible remnants of an earlier way of life, he bemoaned what he saw as the destruction of 'the landscape's greatness and beauty'. In his art he seems deliberately to ignore what he saw as its enfeeblement, setting himself instead to paint it as a place of primitive and glorious beauty.

The unsophisticated nature of his upbringing on a remote farm, with scant entertainment and little knowledge of city life, meant that he was attuned to the countryside's small happenings, and familiar with the landscape's every feature.[2] With a countryman's sharp observation, he noticed, for instance, the plants that clung to life in this harsh environment, describing its 'rosehip bushes, low creeping willows and crouching trees' and 'defiant elderberry bushes'. He heard the storks rattling in their nests in the farmhouses, and watched hawks following the thousands of other birds swept onto the land by autumn storms; he described pacing along 'the liquid sands' of the beaches on the island of Als, with skuas calling shrilly as they wheeled overhead.

In the autumn of 1900, apparently with thoughts of writing features on contemporary Danish art, Nolde, who had been studying in Paris, travelled to Copenhagen hoping to see the work of the earlier landscapist Peter Christian Skovgaard[3] and to make the acquaintance of a number of working artists, including Vilhelm Hammershoi and Jens Ferdinand Willumsen. In the 1880s Danish artists, like those of other northern European countries, had founded a number of rural colonies where they spent the summer months. In some cases they stayed there for long stretches, recording the lives of the local people and the countryside in which they worked. The colonies were often situated in scenically unremarkable coastal villages: in England, for instance, a community was established at Cockburnspath in Berwickshire, which was described by one visitor as 'windswept and somewhat austere in aspect... [while] the surrounding landscape has spaciousness and dignity and a character quite its own.'

One such colony was at Skagen, a remote village among sand dunes in the northern-most part of Denmark. First visited in the summer of 1882 by the Norwegian-born Peder Severin Kroyer, Skagen became an established base for several artists; Kroyer himself was known for his calm, sun-kissed views of its long, sandy beaches. Though he never became a member of such a colony, Nolde spent the majority of his years living and working near the sea, and such remote coastal locations clearly inspired his own inimitable landscapes.

Inland waters, their surface subject to the beautiful but fleeting summer light, were very often a focus for landscapes created in these northern lands, becoming almost symbolic of human thought. One of many pictures that conveyed the particular quality of the northern light slowly losing its radiance at the end of the day was *Evening Landscape at Stokkavannet*, painted near Stavanger in 1890 by the Norwegian artist Kitty Kieland. Others, such as Eilif Peterssen's *Summer Night* (1886), picturing a deserted lake with slim birch-tree trunks stretching across its clear water, evoked the almost tangible stillness of late evening, and embodied a profound sense of melancholy and emotional tension. Nolde himself, comparing

paintings by artists from warmer, sunnier countries with his own, believed that people born further south found it difficult to comprehend this 'blue hour', the 'twilight fantasy of the north'.[4]

In Copenhagen, during 1900 and 1901, Nolde studied intermittently with the established teacher Kristian Zahrtmann (1843–1917). Known for his colourful naturalism, Zahrtmann worked in a 'warmer' style informed by his love of Italy, a country he first visited in 1875 and where he later spent many summers. He painted mostly historical scenes incorporating a persuasive use of colour, and in spite of the restricted nature of his own abilities, he was responsible for encouraging the development of more than one talent. Artists who studied in Denmark with Zahrtmann at this time, or were associated with him, surpassed their teacher in the production of imaginative and varied landscapes, some highly atmospheric, and some beginning to incorporate symbolic elements. Notions of symbolism in art had spread from France, where in 1886 the literary theorist Gustave Kahn had stated in his *L'Evènement*: 'We are tired of the everyday, the near-at-hand and the contemporaneous'; in 1891 Paul Gauguin, who believed that drama and memory were as important in art as any observation of the real, had been declared the leader of the Symbolists.

In Copenhagen, Nolde briefly made the acquaintance of Vilhelm Hammershoi, who would become known for his dreamy, sombre, near-monochrome paintings of interiors. He also planned to meet Willumsen, who had developed an intense interest in symbolism while working in France in the 1880s, but who more recently had been concerned with natural metaphysics and the depiction of nature. A fascination with their native terrain was also frequently evident in the output of these contemporaries. But although Nolde made concerted efforts to familiarise himself with the work of these and other aspiring Nordic artists, including landscapists, his idea of writing about Danish art came to nothing. Though his diffidence in society meant that he did not get to know Hammershoi well, Nolde probably also saw the work of his friend Laurits Ring. The son of humble Zetland farm workers, Ring, like Nolde, always acknowledged his rural origins, much of his work drawing poetry from the flat expanses of the uneventful terrain of this largest, most easterly Danish island. His masterful *Summer's Day on Roskilde Fjord* (1900), with its cool blue colouring, shows a small ship anchored in a bay; low hills are seen in the distance, while in the foreground a series of elongated pools cut into a grassy shoreline.

Another landscapist with a distinctive style was the Norwegian Lars Jorde, who had met Zahrtmann in Italy in 1896 and studied with him until 1900. His *Hilly Landscape. Evening* (1899), set in the open undulating countryside of Jutland, is highly atmospheric, employing compressed forms and distinctive colours. It is painted predominantly in deep greens and violets; where evening sunlight falls on slopes the ground is ochre, and silver, eel-like streams cut their way through the low hillsides.

Exposure to the varied output of these northern contemporaries may well have informed Nolde's thinking about his own renderings of the landscape. Yet, unlike those of his

northern contemporaries, many of his landscapes were characterised by the representation of exceptionally stormy skies. These were not a figment of his imagination: the sky above his native terrain is in fact fraught with meteorological activity caused by the collision of cold Icelandic air from the North Sea, moving eastwards, with warm air from the Azores travelling over the Baltic to the east. As the wind above the ocean meets the land, it rises abruptly to cause the unusually turbulent cloud formations that often feature in Nolde's paintings. Since his childhood he had been fascinated by such clouds and their procession across the sky, thinking of them as free, natural forms that, unlike the land, could never be tamed by the 'improving' hand of man.

The Baltic Sea to the east is normally calm, but in Nolde's lifetime, before the drainage dykes were built to manage its waters, the far stormier North Sea to the west frequently created great stretches of water driven inland by Atlantic winds, which would remain all winter and into springtime. Nolde and his wife were often forced to punt through the water in a low boat to reach their home at Utenwarf, some ten kilometres from the sea. They loved these autumn storms, with their thousands of wind-driven birds, and the sight of the marshlands full of reflected light. Nolde wrote that 'it was especially beautiful when clouds and rays of sunlight joined in this tableau with reflections and mirrorings.'

It is difficult to imagine Nolde's landscapes being conceived elsewhere, away from this land that he knew so well. Whereas many would have seen its stormy, changeable weather conditions as a deterrent, for Nolde they formed the wellspring of his artistry, and were an incomparable asset. With the western sky above the North Sea rarely empty of billowing clouds, there is often a panoply of rich colours as the sun breaks through at evening, and spectacular sunsets are a frequent occurrence; it was probably some splendid, fiery sunset off the coast that prompted Nolde to paint the well-known *Sultry Evening* (1930), with its Fauvist colours.[5] The distant clouds are scarlet, the sky green. A heavy black cloud wraps itself around the farmhouse, which has itself been turned red by the rays of the setting sun. The large, deep-mauve flowers growing in the foreground heighten the scene's Gothic atmosphere.

The distinctive *Landscape with Young Horses* (1916) is like no other landscape. The two springy young animals are seen on a windy day, to one side of a wide, sunny green meadow. A succession of enormous, reaching fingers of cloud blows across the sky, almost filling the picture plane, and the ponies seem nervously aware, as if alarmed by this natural phenomenon.

A number of cloud studies dating from the 1920s exhibit Nolde's beautiful handling of colour, for which he became widely admired. In *Landscape with Rain Clouds* (1925), painted on an exceptionally dull, stormy day, he uses a highly exaggerated palette to portray the diminutive farmhouse as it cowers beneath dense, bottle-green cloud masses that are shot through with apricot light. The mood of *Light Clouds* (1927) is quite different, forming as it does a symphony in blue, green, blue-green and white. A procession of elongated clouds sweeps across a reach of grassland. Given weight by touches of mauve, they relay an irresistible

Sultry Evening
1930
oil on plywood
73.5 × 100.5 cm
Nolde Stiftung Seebüll

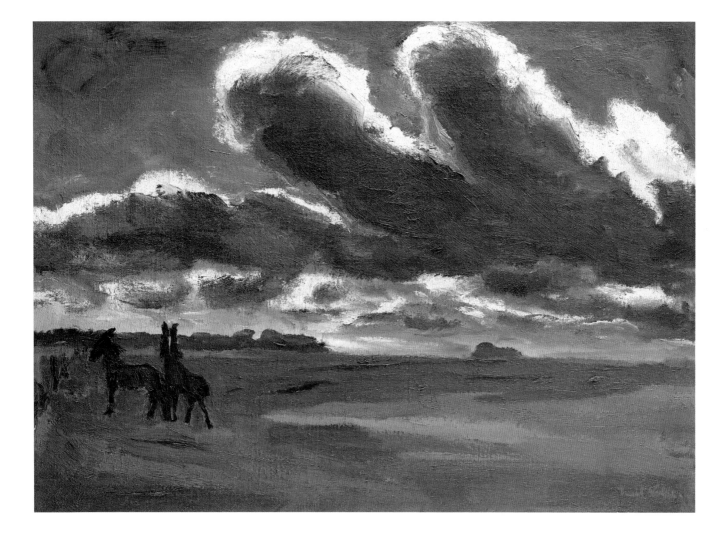

Landscape with Young Horses
1916
oil on canvas
73.5 × 101 cm
Nolde Stiftung Seebüll

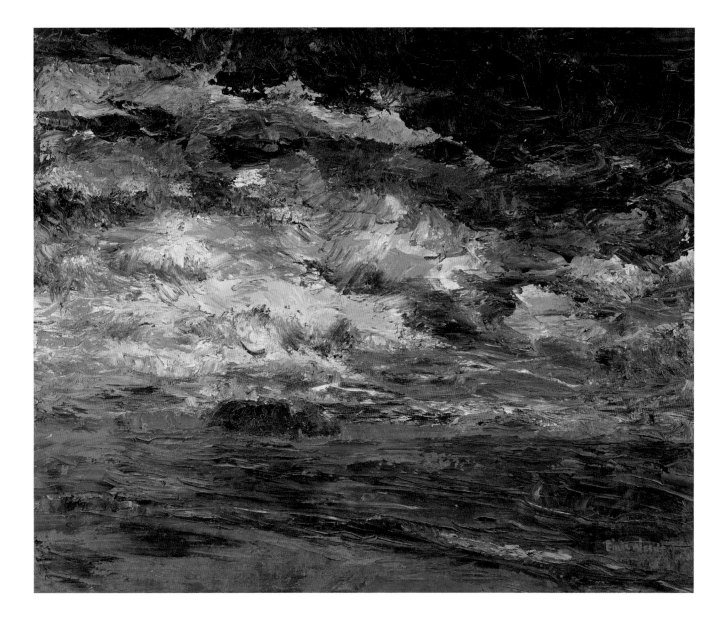

impression of movement. In *Ruffled Autumn Clouds* (also 1927), astringent yellow and orange sunlight bursts through dark, ill-formed clouds that seem almost like waves threatening the small farmhouse and its green meadowland.

In spite of the success of his early *Harvest Day* (1904), Nolde rarely portrayed farmers at work, or the results of their labours. *Corn Ricks by the Dyke* (1939) was an exception. This calm, sunny scene, where tall yellow ricks are stacked near the low red-brick walls and deep thatched roofs of a farmhouse, perhaps hints at his appreciation of his own peaceful environs as war approached. The following year he revised his much earlier painting, *Mowing Corn* (1901), which shows a row of farm workers bent at their scythes, oblivious to everything but their task of reaping the golden field.

Ruffled Autumn Clouds
1927
oil on canvas
73.5 × 88.5 cm
Nolde Stiftung Seebüll

Nolde incorporated his love of flowers into some of his landscapes, often painting their blooms against a backdrop of land and sky. Poppies, which evidently flourished in the marshland, were among his favourites. In *Flowers and Clouds* (1937), the vivid hues of red, yellow and rich blue flowers, seen in the foreground, appear to compete with the flaming orange of the sky behind them. In *Poppies and Red Evening Clouds* (1943), the multicoloured poppies bloom, fully open, in front of green marshland, seeming to offer themselves to an unfriendly scarlet sky. It was painted in oil on canvas, which was unusual for wartime. In the beautifully coloured *Poppies and Lupins* (1946), the flowers' delicate, rose-pink and purple forms blossom near the sea, and behind them lies a stretch of water, above which a pale yellow light glimmers on the horizon, below commanding deep-grey and soft white clouds.

Poppies and Lupins
1946
oil on canvas
67 × 88 cm
Nolde Stiftung Seebüll

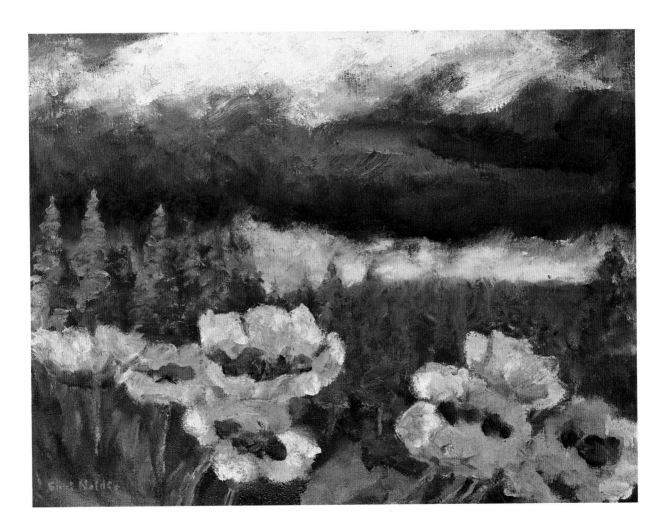

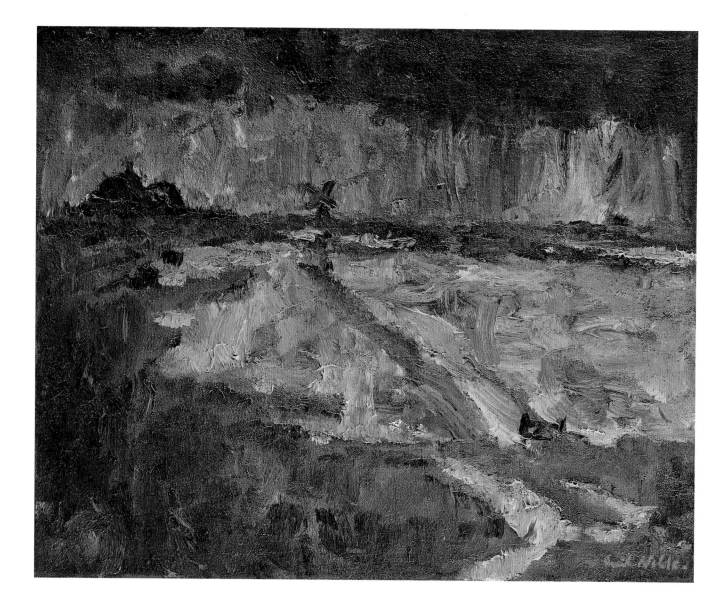

2 Nolde's Place in the History of European Landscape Painting

Nolde emphatically denied the influence of any other artist, but his landscape paintings, however innovative and different they were, necessarily formed part of the European landscape tradition, and of the northern landscape genre in particular. In general, though, in devising his singular, highly expressive representations of his homeland in the flat, desolate reaches between the North Sea and the Baltic, he rarely looked to outside sources or other masters. For his own muse was responsible for their creation, and he once declared, perhaps a trifle bombastically, that 'the art of the artist must be *his* art... whoever has much to learn is no genius.'

As a farmer's son, in one way Nolde had a highly pragmatic view of the landscape: he was familiar with every feature of the countryside where he was born and knew, for instance, how many cattle a given area could support, and just how the meagre soil could be cajoled into crop production. Yet his later, almost mystical representations of these lands, in which any shreds of realism are cast aside, could be said to align him not only with expressionism but also with the Romantic movement that began in the eighteenth century. At the time, Romanticism was a revolutionary concept, injecting an element of mysticism into landscape painting and freeing it from both early topographical renditions and the idealised, carefully delineated classicism that followed them.

One of the greatest Romantic artists was the German Caspar David Friedrich (1774–1840), who was born at Greifswald on the Baltic coast. Nolde once wrote regretfully of him as 'a silent artist', implying that he had been unjustly forgotten, and he evidently held him in high regard. Friedrich, too, found inspiration in the bleak coastal landscape where he was born and in the sight of the sea, his poetic, atmospheric compositions being among the first to imbue the natural world with symbolic, spiritual and emotional overtones. His landscapes, quite unlike Nolde's, were rendered in a carefully delineated style and often included human figures. There were, too, frequent references to Christianity, for instance in *The Abbey in the Oak Forest* (1809), which features the deserted Danish Cistercian Abbey near Greifswald; here the delicate tracery of the abbey's one remaining window seems symbolic of the decline

Wet Day
1918
oil on canvas
73.5 × 88.5 cm
Nolde Stiftung Seebüll

of religious faith during Friedrich's lifetime. While working with the Brücke artists in Dresden in 1907, Nolde may well have seen Friedrich's *Large Enclosure near Dresden* (1832) in the city museum. In some ways atypical of his work, it depicts marshy reaches and trees in full leaf more boldly than many of his compositions, yet the pale, glowing orange sky and subdued colours of the landforms hint at something intangible. Friedrich's views of the sea, of flat expanses, vast cliffs or craggy mountainsides were overhung by mist, bathed in late evening sun or seen at twilight; the people viewing them were often seen from behind, as if marvelling at the vagaries of the natural scenes they are witnessing.

For two centuries before Nolde was born, European landscape painting had generally followed the examples of Claude Lorraine (1600–1682) and Nicolas Poussin (1595–1665). Their 'heroic' landscapes, peopled with classical or mythological figures and often including classical buildings or ruins, acted as models for generations of artists. The young Claude, born near Vosges in the French province of Lorraine, began to paint his 'ideal' landscape views in the dramatic coastal area around Naples. From 1627 he lived in Rome, and there his gentle and elegiac pastoral vision, consistently marked by a concern with the effects of light upon the scene, began to shape itself more emphatically in a long series of calm, magnificent compositions.

In his own time Poussin was not known primarily as a landscape painter; indeed a letter from 1648 seems to reveals that he himself regarded his landscapes as lesser works. Instead, he was initially thought of as a creator of narrative scenes peopled with groups of figures, but he gradually developed a sharper appreciation of the relationship between landscape, the natural scene and the genre element, so that he became admired both for his graceful figure groupings and their verdant surroundings. His later masterpieces, including *Landscape with a Man Killed by a Snake* (probably 1648) and the serene *Landscape with a Calm* (1648–49), with their underlying musings on man's life and death, were long regarded as the high point of European landscape art. If outmoded by the time Nolde was painting, the output of both Claude and Poussin had exercised a considerable influence upon other artists for over two hundred years, and generations of aspiring landscapists, both in Europe and elsewhere, had emulated them. Even in mid nineteenth-century Russia, many chose to paint in Italy or to depict their homeland in an Italianate manner.

A third artist working in seventeenth-century Italy was responsible for creating an entirely new and very different type of landscape. Salvator Rosa (1615–1673) was born in Naples, and his studies there made him conscious of the legacy left by Caravaggio, with his use of a dark tonality and dramatic light and shadow. For several years from 1640, Rosa spent his summers in the rocky countryside around Volterra in Tuscany, where he developed his own distinctive landscape style, in which man was depicted as an insignificant presence in a wild, tortured countryside. In his art, old trees with splintered trunks and jagged branches clung to rocky crags or precipitous ravines, great waterfalls tumbled down beneath livid skies, volcanoes or earthquakes threatened. The sense of religious awe imparted by these

dramatic scenes was greatly admired, and Rosa's take on the natural world was often imitated both during his lifetime and throughout much of the nineteenth century, when British collectors competed for his paintings.

Meanwhile, in contrast to both the classically inspired landscapes and the 'Gothic' creations of Rosa, a more measured type of landscape art was developing in the Netherlands, becoming equally sought after in Britain. Lacking dramatic scenery, Dutch artists including Jacob van Ruisdael (1628–1682), Jan van der Heyden (1637–1712) and Meyndert Hobbema (1638–1709) were skilled at depicting the evidence of human habitation in rural settings – for instance the country's churches, mills, small settlements and fairs and other gatherings of people in the countryside. With these they created detailed foreground interest, showing the comparatively empty hinterland, again minutely and carefully rendered, stretching behind them. Nolde may well have seen Ruisdael's landscapes in the collections of the city of Dresden, and a certain parallel can be seen between the Dutch artist's depictions of the Netherlands countryside and Nolde's paintings of his native land, both artists drawing on the prevailing meteorological conditions in painting their landscapes. While the Dutchman's views were overhung by wide, benevolent or threatening skies, Nolde's were often characterised by huge cloudscapes or dramatic sunsets.

Largely untouched by the artistic rhetoric of Europe (including both these seventeenth-century landscapists and ones working nearer to his own time), Nolde chose, year after year, to portray the scenically unremarkable reaches of his native North Schleswig. Indeed, he felt privileged to do so, and his highly subjective representations of the landscape about which he felt so passionately served to inspire viewers, too, with awe for its forlorn beauty. He was, in fact, a little unusual among German artists of the time in choosing to paint the open countryside: his fellow Brücke artists and the generation of artists that followed – including the Neue Sachlichkeit or New Objectivity artists Max Beckmann, Otto Dix and George Grosz – were more concerned to record city life.[6] One other artist working mainly in Germany, however, also included landscapes in his oeuvre. Lyonel Feininger was born in New York of German parents in 1871, moved to Berlin in 1887 and became a member of the Secession in 1909. Returning to America in 1937, he became known there for representations of architectural forms split by prismatic splinters of light, but while in Germany he, like Nolde, worked on the beaches of the north Baltic coast, painting scenes that included large, looming cloud formations above flat, sandy shores.

As already described, Nolde's homeland was frequently subject to exceptionally stormy meteorological conditions. His exaggeration of them, and his heightened use of colour in depicting them, were paramount in the development of his unique form of expressionism. This is perhaps most evident in his landscapes and paintings of the sea. From an early age he was interested in the properties of colours, and extraordinarily sensitive towards them, recognising some as delicate and others as powerful, and acknowledging their warmth or coldness. Once, as an adult, hearing a rabbit screeching in a trap, he said that for him that particular sound

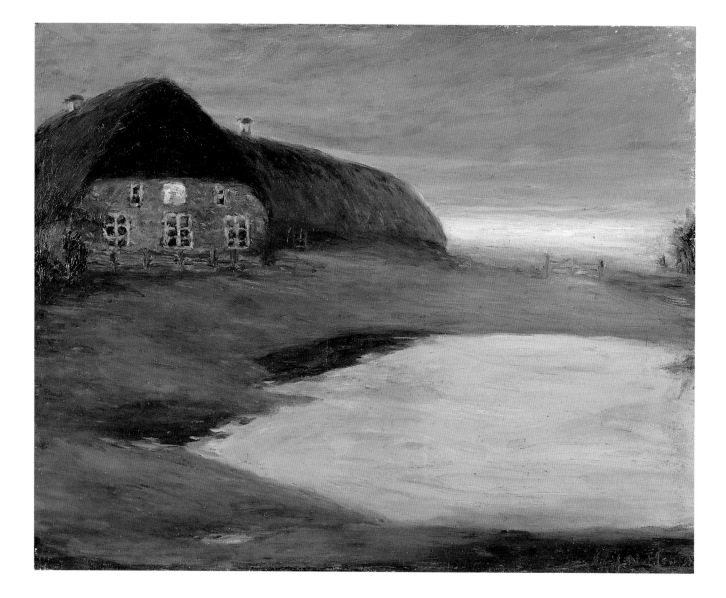

represented a bright yellow, whereas the haunting screech of an owl hunting at night brought to his mind a deep, dark violet. For Nolde, especially in his landscapes, colour would quickly become both a compositional tool and an instrument in creating atmosphere or mood.

In 1899, Nolde was disappointed at failing to gain admission to Franz Stuck's highly regarded classes at the Munich Academy; he later wrote that he had much wanted to meet Kandinsky, Klee and March, who were studying there. Instead he studied for a while at the private art school of Friedrich Fehr, and then with Adolf Hölzel in the artists' colony at Neu Dachau, to the south-east of Munich. Though Hölzel came to be considered a forerunner of Kandinsky in his development of a semi-abstract formulation, he was probably more important to Nolde for his expertise as a colour technician. Representing the small, winding rivers crossing the often misty Dachau heathland, with their graceful riverside birches, willows and poplars, Hölzel painted a number of gentle, atmospheric moorland landscapes. Several of Nolde's early landscapes achieved a comparable tranquil effect thanks to his use of muted, subtly blended colours. These included *Home* (1901), and *Moonlit Night* (1903). In *Heath Farm* (1902), the scene showing the farm with moorland rising behind is also painted in soft, persuasive tones, albeit with slightly more jagged brushwork to indicate slivers of light through the grey cloud-mass above the low farmhouse and its outbuilding. Similarly, the appeal of some of his early seascapes came from their gentle, shimmering tonality, for example *Light Sea-mood* (1901), which combined soft aquamarine tones with light, sandy browns, and *Fishing Harbour* (also 1901), painted in pale blues and turquoise.

In around 1905 Nolde began experimenting with much stronger tones, gradually becoming proficient at marshalling colours so bold that they almost shout at the viewer. Although he categorically denied the substantial or lasting influence of other artists, his more dramatic approach to landscape painting and his practice of using a quite different colouration from this juncture surely reflects his discovery of Van Gogh and Gauguin.[7] In, for example, *Spring in the Room* (1904), it seems that the intensity of his palette and his emphatic and expressive brushwork at this time looked to Van Gogh, with strokes more elongated than those of the Impressionists. Meanwhile, his development of an increasingly brilliant and powerful use of colour was sparked by his admiration for Gauguin.

At first Nolde seems not to have noticed the occasional pictures by Van Gogh that were included in exhibitions he visited, except for the fact that he reported having seen his *Self-portrait with a Pipe and Bandaged Ear* (1889) in Munich as early as 1898. There were, for instance, several works by Van Gogh in the Exposition Universelle in Paris in 1900, which Nolde attended; and during the winter of 1899 to 1900 he may well have seen others shown in the city's commercial galleries such as Ambroise Vollard and Meier-Graefe. Five Van Goghs were included in the Berlin Secession in 1901, and seven in the Munich Secession in 1903, but it is not certain that Nolde went to these. By around 1904, however, he was well aware of the Dutchman's oeuvre: the composition of his own *Harvest Day* quite closely followed that of Van Gogh's *Two Peasants Digging*, painted in 1889 in homage to Jean-François Millet.

Home
1901
oil on canvas
57 × 70.5 cm
Nolde Stiftung Seebüll

Though Nolde shows his harvesters working in bright sunshine, they bend to their work in a way much like Van Gogh's two rural workers, who are seen under an overcast sky.

Several other works painted between 1904 and 1910 reveal Nolde's admiration of the Dutch artist. Among them are *House by the Wood* (1908), where a small house nestles below trees at the edge of a field in which stooks of hay are drying, and *Young Firs* (also 1908), where the young trees stand on a hillside of green-gold beneath a rich blue sky. In both, the brushwork consists of emphatic, directional applications of paint. And the exceptionally bold brushstrokes and brilliantly coloured palette of his *Lake*, painted just a few years later, in 1910, seem to reveal a similar indebtedness. Nolde's acknowledgement of Van Gogh's mastery would seem to culminate in two other paintings made that year, *Bridge* and *Bridge in the Marshes*, both incorporating bold brushwork and strong colours and directly echoing Van Gogh's representation of the same motif in the countryside near Arles.

With Gauguin it was a different story. Nolde was hugely impressed by his paintings at the Grand-Ducal Palace in Weimar in July 1905, where thirty-six of Gauguin's works were exhibited. He wrote to Ada about 'the magnificent exhibition', saying that 'the sumptuous colours' of Gauguin's pictures had 'ravished' him and describing how he had sat among them surrounded by the most splendid colours he had ever seen – exceeding even those of Van Gogh, whose work was also exhibited in Weimar. The latter, he wrote, 'also uses beautiful colours, but he impresses one more by his turbulent temperament and his great sensitivity and liveliness'. It is fair to assume that it was not primarily Gauguin's Breton landscapes that enchanted him, but his Tahitian scenes, peopled by native women wearing brightly coloured clothes, seen among lush vegetation and exotic fruits and flowers. Already capable of great subtlety in his use of tonality to create mood, Nolde now proceeded to introduce a more powerful colouration in portraying – as ever – his native land. Yet while his use of tonality is striking, he continued to use a limited range of colours to create the effect he wanted. Writing that he 'loved purity and avoided mixtures of cold and warm... that lead to the killing of the brilliant forces', he rarely used more than two or three basic colours in a landscape. He was preoccupied with the creation of his series of religious subjects from 1909 onwards, and in 1910 he and Ada began their wintertime sojourns in Berlin, but in summers from 1910 onwards, during time spent on Als, Nolde began his lifelong occupation of rendering his impressions of a landscape many saw as forlorn. Painting outdoors in oil on canvas, he seldom lacked inspiration.

Nolde's landscape paintings are extraordinarily evocative and very varied. In the vividly coloured wartime *Dusk* (1916), brilliant green grass, Prussian-blue sea and lemon-yellow sky blend in what David Platzer has called 'a vision of eternity'.[8] The atmospheric *Wet Day* (1918) depends on a balance of cool silver-greys to denote pools of water lying on the ground and emerald-green to indicate the soaking grassland, while darker greys denote the cloudy sky, shot through with gleams of weak yellow sunlight. In one of his most expressive works, *Landscape, North Friesland* (1920), a small red farmhouse cowers beneath billowing, dark, angry cloud masses that are edged with white and shot through with the yellow of the

House by the Wood
1908
oil on canvas
63 × 78 cm
Nolde Stiftung Seebüll

Marshland
1927
oil on plywood
70 × 82 cm
Nolde Stiftung Seebüll

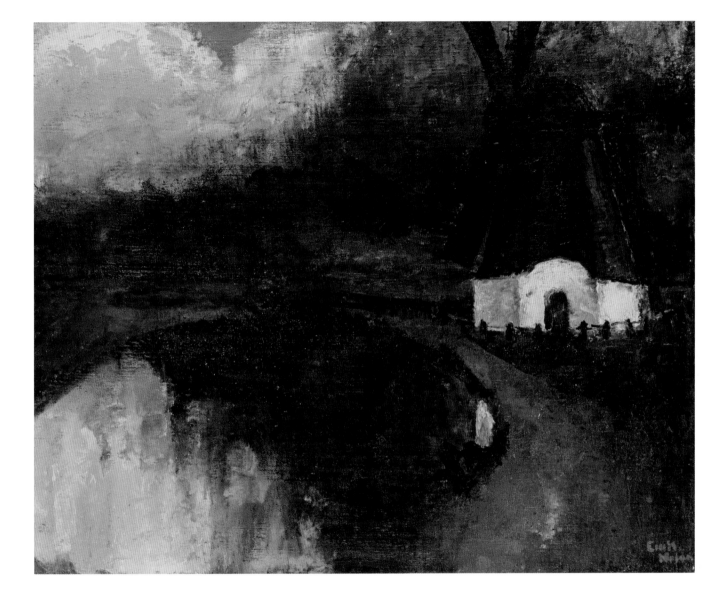

Northern Mill
1932
oil on canvas
73 × 88 cm
bpk / Pinakothek der Moderne, Munich

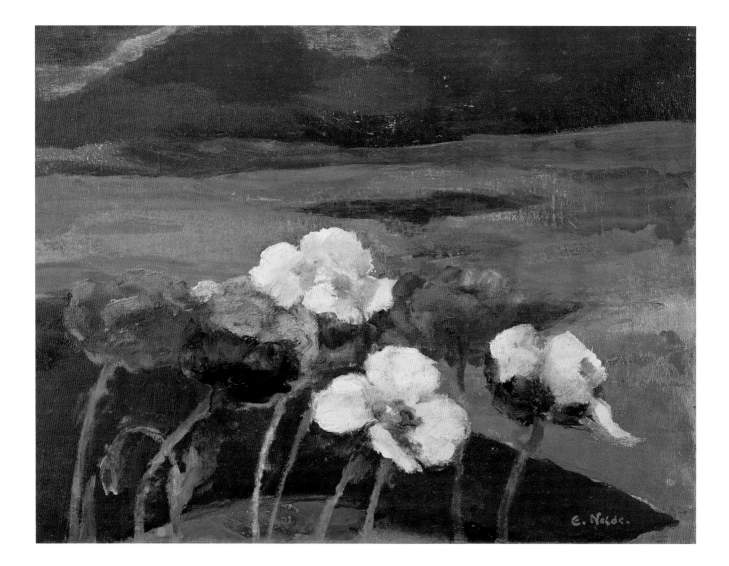

Poppies and Red Evening Clouds
1949
oil on canvas
67.5 × 88 cm
Nolde Stiftung Seebüll

sun's rays. The almost other-worldly colouration of *Marshland* (1927) converts a potentially mournful scene into one of splendour, as the near-featureless marshes take on the fiery reds of the evening sun, below a sky of yellow and green.

There were, in the early twentieth century, more than a hundred corn and pumping mills dotting the landscape of North Friesland, a familiar sight in the flat countryside. Nolde often painted these, featuring both the small wind-pumps used to drain the sodden fields and the larger, more powerful corn mills. Unusually for him, he painted two versions of a corn mill at evening, *Mill* (1924) and *Northern Mill* (1932). The dimensions of both were the same, his canvas in both cases a slightly squarer shape than he often used, measuring approximately 73 × 88 cm. Painted on a forbidding, overcast evening, the white mill's reed-clad cap and sails appear an inky black, the clouds on the horizon a pungent mauve, with deep-grey ones looming above. In the foreground a stretch of water reflects both the dark clouds and the late, flaming orange-yellow light of the sinking sun.

The jewel-like colouring of *Frisian Farm on a Canal* (1935) makes it an unforgettable image of Nolde's environs. Deep-yellow ricks abut the low, brown farmhouse and the meadows that surround it are bright green; above the humble building and the canal near which it stands, the sky reigns in brilliant turquoise. A peaceful, sun-drenched scene, it could be said to encapsulate his unbounded affection for the environment in which he chose to work for so long.

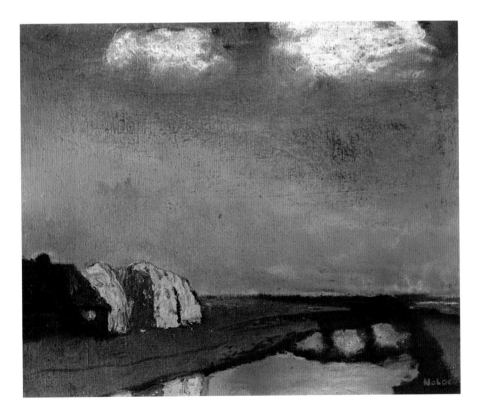

Frisian Farm on a Canal
1935
oil on canvas
73.5 × 88.5 cm
Nolde Stiftung Seebüll

the Brücke made strenuous efforts to recruit prominent artists from outside Germany; though they were never able to include Munch among their members, they succeeded in recruiting the Swiss Cuno Amiet, the Finn Akseli Gallen-Kallela, the Dutchman Kees van Dongen and the Czech Bohumil Kubišta.

The Brücke first saw Nolde's paintings at the Galerie Arnold in Dresden in January 1906. Greatly impressed, they wrote to him the following month. In his letter their spokesman, Kirchner, assured him of their admiration for his 'tempests of colour', and invited him to join them. Just at this time Nolde made the acquaintance of Karl Ernst Osthaus, director of one of the most daring German exhibition venues, the Folkwang Museum at Hagen. Osthaus bought Nolde's delightful portrait of Ada in a sunny room, *Spring in the Room* (1904), one of his most Impressionistic works, and invited him to paint in the small Westphalian town of Soest. Though this was an opportunity to meet other artists, including Christian Rohlfs, Nolde did not find it a congenial place in which to work, and spent only a few weeks there.

In June the following year, Nolde joined the Brücke, but was only briefly a member, resigning in November 1907. Some years older than Kirchner and Heckel, and already an established figure, he seems to have felt uneasy amid their youthful and unbridled enthusiasm, disagreeing, for instance, with their worship of Van Gogh and joking that they should have called themselves the 'Van Goghiana' group. Nor did he want to base himself in Dresden for any length of time in order to work alongside his 'young comrades'. Nonetheless, it was at his suggestion that the Brücke recruited so-called 'passive members', who supported them financially and helped to publicise their exhibitions. Among these were Nolde's patron, the Hamburg collector Gustav Schiefler. For the next few years Nolde's own career and the Brücke artists' ran in parallel, as he and their leading members focused on similar goals and painted similar subjects.

Paramount among these common concerns was an interest in the art of so-called primitive peoples, which owed much to the ethnographic collections they were able to study in Dresden and Berlin. The Dresden Museum für Volkerkünde, or Ethnographic Museum, had reopened in March 1910, displaying items culled from German colonies in Africa and New Guinea and purchased by the museum in the 1880s. Among the various African exhibits were sculptures, carved wooden figures from Cameroon and a Benin bronze relief, and there were Indonesian shadow-puppet figures and a pair of painted wooden beams from a men's clubhouse at the Pacific island of Palau in the German South Seas. Dating from before the 1860s, the Palau beams were carved in bas-relief and decorated with boldly seen male figures, their penises erect; they were painted in red, yellow, green and black with pigments from vegetable dyes. Greatly admired by the Brücke for their striking design, the clubhouse beams probably impacted on their art more than any of the Museum's other artefacts. Soon 'tribal' objects such as carved statues and furniture appeared in their paintings, and the Brücke themselves began to carve simple wooden figures. Among these were Kirchner's *Standing Girl, Caryatid* (c.1910) and *Reclining Woman* (1911–12). The bold angularity of many of the

Girl among Plants
1912
by Otto Müller (1874–1930)
woodcut
28 × 37.5 cm
Galerie Nierendorf, Berlin

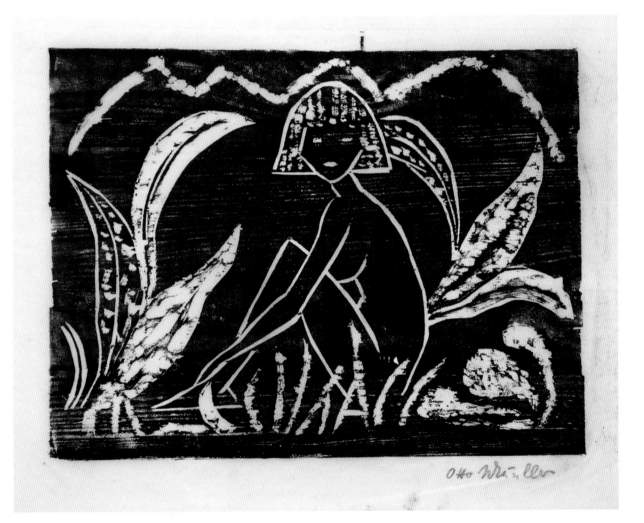

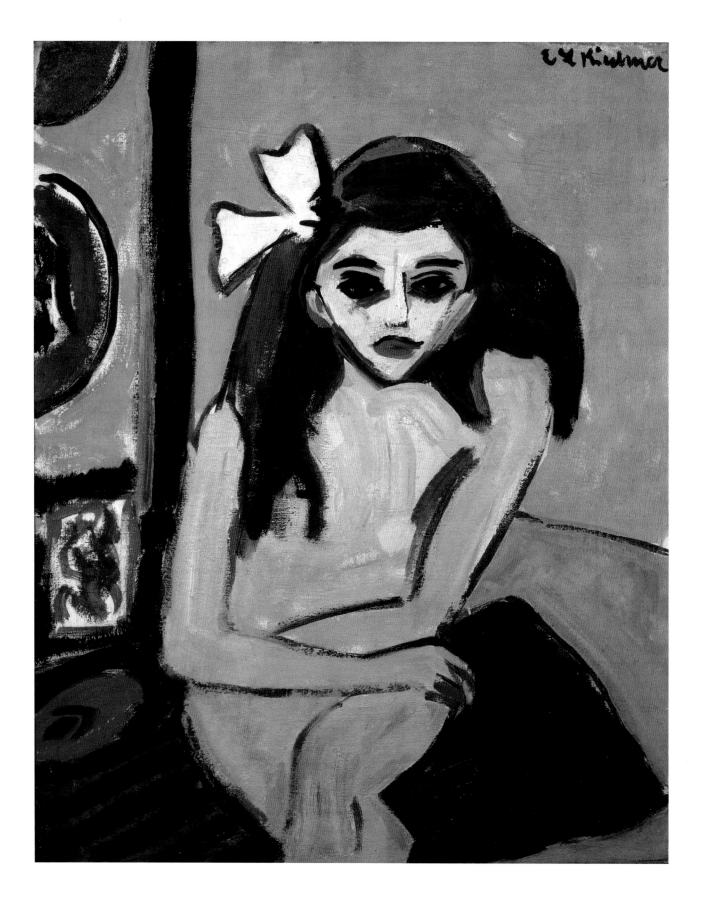

woodcuts the group produced, especially those by Heckel and Kirchner, also derived partly from the African objects they saw. Another, slightly later example was Schmidt-Rottluff's 1913 woodcut, *Woman with Loose Hair*, with its rounded simplicity, monumentality and zigzag 'tribal' decoration in the background.

Nolde, on the other hand, made his first visits to ethnographic collections in Berlin in 1911, and found the displays in the rooms of the city's Ethnographic Museum in a chaotic state of disarray. Exasperated, he managed to make over 150 drawings of exhibits, which would bear fruit in a series of thoughtful, carefully composed still lifes in the following few years. Nolde's reverence for primitive works of art was perhaps more profound than the Brücke's; he saw these hand-crafted objects as a more natural expression of the experience of life than anything contained in recent European art. Recognising their universal and timeless validity, he would later concern himself with the display of tribal art in both Osthaus's Folkwang Museum and Max Sauerlandt's museum at Halle.

In early 1909 the Brücke artists were delighted to discover a young working-class girl, Fränzi Fehrmann, whose parents allowed her to model for them and to live with them in their studio. Fränzi was only nine when they found her living nearby, but rapidly became their 'child of nature', a child-woman who seemed to validate their beliefs about the innocence and unworldliness of primitive peoples. Sharing their daily life in Dresden and accompanying them on summer excursions, Fränzi would be the subject of several distinctive portraits in both oil and woodcut, including Kirchner's *Fränzi* (1909–10) and *Fränzi in front of Carved Chair* (1910), Max Pechstein's *The Yellow and Black Swimsuit* (1909–10) and Erich Heckel's *Girl with Doll* (1910). Whatever we may think today of their many representations of this pre-pubescent girl, often shown nude and made alluring with reddened lips and painted nails, Fränzi, also known as Marzella,[10] became iconic for the group, appearing on their posters and exhibition programmes.

With their enthusiasm growing, the Brücke's fascination with the art of non-European peoples soon manifested itself in the way they decorated their workplaces. In November 1909 Kirchner moved to a new studio at Berlinerstrasse 80, Dresden, where he surrounded himself with objects from and inspired by other cultures. Along with African sculptures, including a nineteenth-century African leopard stool from Cameroon, he furnished the rooms with wooden furniture that he carved himself, hung curtains that he made of brightly coloured batik fabrics, and painted murals for the walls. In this setting the Brücke and their girlfriends fulfilled their dream of a bohemian, anti-bourgeois existence, disporting themselves naked, and mixing freely. Among surviving photographs of the studio there are several showing the black circus performers Milly, Sam and Nelly. Evidently welcome guests and at ease in this relaxed environment, they were the subjects of a number of portraits.

Beginning in 1909, the Brücke spent the summer months with their girlfriends and models at the Moritzburg lakes, some 13 kilometres north-east of Dresden. There, in keeping with the German vogue of the day, a back-to-nature lifestyle, they enjoyed a 'primitive'

Fränzi
1909–10
by Ernst Ludwig Kirchner
(1880–1938)
oil on canvas
76 × 60 cm
Moderna Museet, Stockholm

existence, swimming naked in the lake and camping on its banks. These periods of unusually close harmony seem to have acted as a catalyst in the way primitivism was introduced into their work. The paintings they produced, albeit referring to the bather pictures of Cézanne and Matisse, embodied their vision of an idyllic, alternative lifestyle very different from that of both the bourgeoisie and modern industrial workers. Yet in spite of the innovative and highly original nature of much of the work they produced in the next few years, their output, especially works inspired by influences outside Europe, was initially seen as overly derivative. They were not without opponents, one eminent critic, Carl Einstein, decreeing that 'the Saxon primitives' intoxication with the exotic derived from their lack of visual imagination.'

Waterside locations were, of course, also a vital element in Nolde's working methods. From 1903 until 1916 he chose to spend the summers living and working on the island of Als, and visits to other coastal locations would enable him to work very productively. In 1930, while his new home at Seebüll in Schleswig-Holstein was undergoing repairs, he spent a while on the island of Sylt, off the west coast. Although he occasionally painted holidaymakers enjoying the beaches, he was not generally concerned with figure painting, unlike the Brücke at Moritzburg. Only by living near the sea, where he could observe its changing moods, was he able to paint his many varied and magnificent marine studies.

At the time of their first visits to the Dresden Ethnographic Museum in the spring of 1910, Heckel discovered, and recommended to Kirchner, a book by the English historian John Griffiths about the Buddhist cave paintings at Ajanta, in India. This was a publication generously illustrated with images of the paintings' sensual female figures, and both artists made sketches of them. And, as for many early twentieth-century artists, Gauguin's example was an important precedent for the Brücke. They especially admired his paintings of dignified, monumental Tahitian women. Though other influences were also at work, including the Fauves and even Picasso, paintings such as Pechstein's oil piece *Two Girls* (1909) were clearly indebted to these figures by Gauguin, as was Schmidt-Rottluff's 1912 painting, *After the Swim*, where two voluptuous nudes comb their long, blue-black hair. That same year Nolde, too, glanced towards Gauguin: in his *Nudes and Eunuch* a grey, stony-faced eunuch stands behind two seated courtesans, and the composition bears a distinct resemblance to Gauguin's *Contes barbares* (1902), where an evil figure (in this case, Gauguin's former friend Meyer de Haan) lurks behind two beautiful young women.

Kirchner and Heckel, especially, took every possible opportunity to see 'exotic' visitors to Dresden. They visited the 'African village' on display in 1909 and 1910, that had been imported by the entrepreneur Carl Marquardt, frequented nightclubs and cabarets, and attended many circus and variety performances. As their art matured, such attractions gave rise to an important element in the Brücke's oeuvre. Kirchner's attractive *Tightrope Dance* (c.1909), for instance, painted in warm pinks, scarlet, deep blue and black, showed Japanese artistes balancing precariously with the help of a parasol. After the Brücke were reunited in Berlin in late 1911, they continued to search out this kind of experience. In

After the Swim
1912
by Karl Schmidt-Rottluff
(1884–1976)
oil on canvas
87 × 95 cm
Staatliche Gemäldegalerie,
Dresden / Bridgeman / DACS
2013

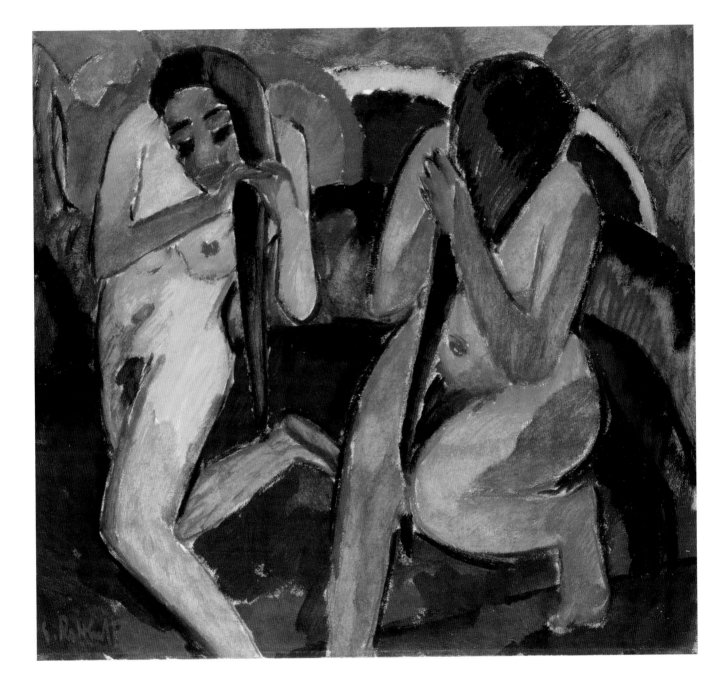

of woodcuts, including the innovative *Apocalypse* of 1498, as well as individual engravings of religious and secular subjects in which he achieved an extraordinary subtlety of tone. Lauded by the eighteenth-century man of literature Goethe[11] as a German cultural hero, he was revered, too, by Germany's Romantic artists, including the Nazarenes,[12] while the simple outlines and fine crosshatching of his workmanship were imitated by the Biedermeier wood-engravers.[13] Nearer to the Brücke's era, Dürer's admirers included both the Jugendstil[14] artists and the Brücke's own hero, Nietzsche, who once cited the exquisitely crafted engraving *Knight with Death and the Devil* (1513) as a talisman for despair.

Two other late medieval German artists also inspired the thinking of the Brücke. At the onset of the twentieth century several art historians looked to Matthias Grünewald as an exemplary, truly German artist, whereas Dürer had spent several years in Venice, appraising the work of Italian Renaissance masters including Bellini. Grünewald lived between around 1470 and 1528, and worked mainly in the Middle Rhine area. He was known for a small body of paintings, rather than prints, in which his highly individual style, with its distorted forms and splendid colouring, caused him to be categorised as an early German expressionist. The Brücke held him in high regard: as a student Heckel, on an educational visit to the artist's birthplace, Aschaffenburg, had made sketches of his *Lamentation* in the town's museum. And Grünewald's work would impinge significantly on Nolde, the earlier artist's highly expressive early sixteenth-century crucifixion scenes figuring largely in his consciousness as he painted his own *Crucifixion* (1912) and other religious works dating from 1909 and 1910.

Lucas Cranach (1472–1553), who was born at Kronach in southern Germany, was also an important inspiration for the Brücke. In 1901, as Bleyl and Kirchner began their training in Dresden, the first major survey of Cranach's work was held in the city's Zwinger Palace. Outstanding examples of his output were also held in the collections of the Gemäldegalerie and Kupferstichskabinett in Berlin. Cranach was regarded as a medieval rather than a Renaissance artist, and his graceful nudes and naked heathen goddesses, their bodies portrayed in flowing, sensual lines, were beloved by the Brücke. The most specific reference to them is perhaps in Kirchner's *Standing Nude with Hat*, painted between 1910 and 1920. Here, Kirchner's Dresden girlfriend, Doris Grosse (Dodo), is posed in a similar way to the earlier master's Venus in *Venus with Cupid Stealing Honey* (*c.*1530). Both female figures glance coquettishly at the viewer, their heads tipped slightly sideways beneath large-brimmed hats, and each wears a small necklace, or choker. But though Cranach's Venus is barefoot, Dodo's fashionable, low-cut red shoes immediately locate her in the twentieth century. And unlike the medieval Venus, who stands in a wood close to a tall tree-trunk, Dodo is seen in a multicoloured indoor setting, perhaps a room in Kirchner's batik-hung studio in Dresden.

In a letter he wrote in 1908, Nolde, who as has been noted was not generally given to acknowledging the influence of other artists, made reference to another great German predecessor, Hans Holbein (1497–1543). He wrote of 'the first period of great German art – the time of Grünewald, Holbein and Dürer'.[15] Finally, Rembrandt was an artist whose output

was continually studied in Germany. Thanks to Julius Langbehn's well-known if dubious and highly contrived study, *Rembrandt als Erzieher* (*Rembrandt as Educator*), published in 1890, Rembrandt was considered to be of German origin: he was born at Leyden in the Netherlands in 1606, thus giving him a claim to Nordic roots. He was hugely admired and regarded as part of Germany's artistic heritage. Both Kirchner and Nolde revered his etchings, and in 1907 Nolde's fondness for the windmills of his birthplace took the form of two lithographs, *Windmill* and *The Great Windmill*, which were actually free copies of Rembrandt's *Windmill* (1641).

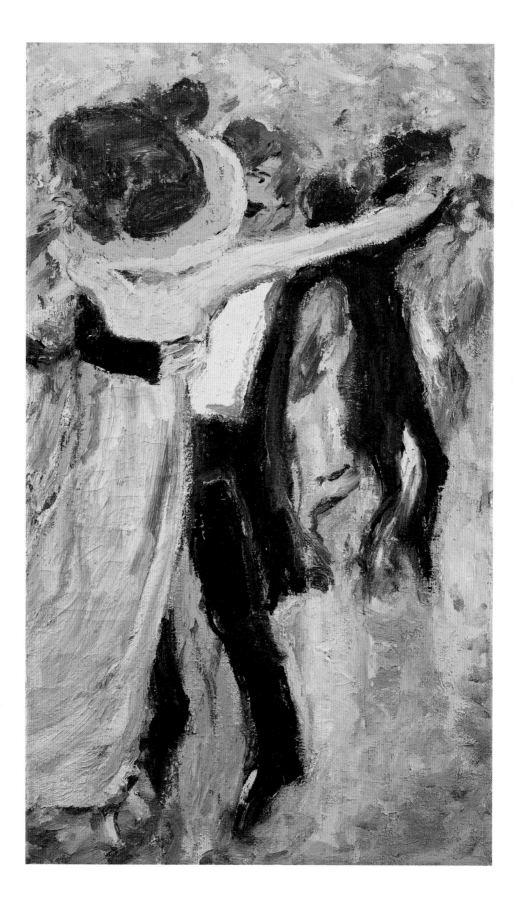

Berlin and the Dance

With the formation of the German Reich in 1871, Berlin had become the imperial capital. Soon after it adopted this new status numerous large manufacturing companies were established in the city, and as industrialisation took hold, many thousands arrived from the provinces in search of employment in the new factories. Berlin's population swelled as it absorbed its large new working class, and the city was the source of many varied themes for the Brücke artists, including Nolde.

In 1889, when he was twenty-two, Nolde spent two years among the city's workers, employed as a furniture carver and decorative craftsman. This was an unhappy time for him: he suffered from incipient tuberculosis and was racked with loneliness, the long, narrow, smoky streets in which he lived adding to his sense of dereliction. From the start, he both loathed Berlin and felt drawn to it, fulminating about its filth and the smell of its streets and the habits and morals of its people, but choosing to return to the city frequently for most of his life. In the winter of 1901 he rented lodgings so that he could spend the winter months there, perhaps drawn back by the prospect of sharing the ambience in which other young German artists were working.

From 1905, in spite of Ada's disastrous attempt the previous year to support them financially with a nightclub act in Berlin – she appeared on stage with a tame goose, but her act was ridiculed by theatre managers – the Noldes spent nearly all their winters there. At first they lived in cheap lodgings, but they were later able to afford to rent an apartment and studio in Bayernallee, and in 1910 to set up home at 8 Tauentzienstrasse, where they overlooked a large garden. The apartment was destroyed during the Second World War, but during the Noldes' time there its living rooms held many of Nolde's pictures, with objects from his collection of tribal figures lining the shelves.

As an artist never willing, or able, to forget his childhood as a country boy, Nolde was fascinated by the very different spectacle of nightlife in the metropolis. Declaring his dislike of this 'vacuous form of banal sociability of elegant people enjoying themselves', he was nonetheless captivated by the alternative face the city presented after dark. The winter of 1910

Dance II
1911
oil on canvas
104.5 × 61 cm
Nolde Stiftung Seebüll

to 1911 was one of feverish activity for him, during which, as well as countless watercolours, he produced seventeen oil paintings of evening and night-time society in the city. He did not repeat this experiment in other years, but regarded these works with affection, keeping the majority of them all his life. Among those paintings are his *Bar, Slovenes, In the Box, At the Wine Table, Party, Women and Two Men, Gentleman and Lady* (*in Green Dress*), *Cabaret Audience, Ball, Coffee-House, Night Café*, and two dance scenes. Of the others, *Woman's Profile* was lost during the Second World War, Nolde left *Tea Table* to his second wife, *Gentleman and Lady (in Red Room)* is owned by the Kunsthalle Hamburg and *In the Coffee-House* by the Kunsthalle Essen.

On evenings that winter in Berlin, Nolde later recounted, he would change into his dark trousers and the suit tails surviving from his days in St Gallen in 1892–97, and Ada would put on her best dress, and at eleven o'clock they would set off to masked balls, cabarets and cafés in quest of the socialites he so condemned. As the night wore on, they made their way to late-night wine bars and sleepy early-morning cafés.

He and Ada sat quietly perusing the scene, and he would quickly light upon a subject he wanted to paint. His compositions were rapidly painted, and generally executed in a light, bright palette, so that they have an exceptionally spontaneous character. Nolde maintained a curiously impersonal stance in portraying what he saw, tending to focus on way-out couples – thin, showy women in 'audacious' dresses and large hats accompanied by 'the wildcats of the streets' – men in dinner jackets, 'as pale as talc', who smoked incessantly. Indeed, they were figures in their own way just as seedy and degenerate as those sometimes portrayed by the Impressionists. 'The people themselves,' he wrote, 'were not important to me: they came, danced, sat down and went away again.' Indeed, 'the painter looked at the poisonous flowers like an apothecary, noting what might be of use to him.'

In this respect, Nolde veered away from earlier representations of modern life, for instance those created by the Impressionists in France from the 1870s onwards. Although he admired Manet, his paintings did not incorporate the social comment that is found in Manet's views of Parisian cafés and bars. Manet's *In the Bar* (1878), for example, showed a working-class couple drinking at a table, the man smoking and the woman slumped, exhausted, against the table-top. Painted in subdued colours, it presented a telling and disturbing glimpse into life in this far-from-prosperous marriage. At other times, Manet captured the wistfulness and sadness of young women obliged to work in night-time venues. His *Waitress* (1879) showed a busy young woman at the beck and call of her customers; the famous *Bar at the Folies-Bergère* (1882), shows the pretty barmaid looking sadly ahead rather than at the 'gentleman' trying to engage her attention.

Both Degas and Picasso chose to paint the disastrous aftermath of drinking absinthe, Degas in his *Absinthe* (1875–76), with its mournful, heavy-eyed young woman, and Picasso in his portrait of Angel Fernández de Soto, who had shared a studio with him in Barcelona, but by the time the portrait was painted in 1903 had abandoned his artistic career for a life of

At the Wine Table
1911
oil on canvas
88.5 × 73.5 cm
Nolde Stiftung Seebüll

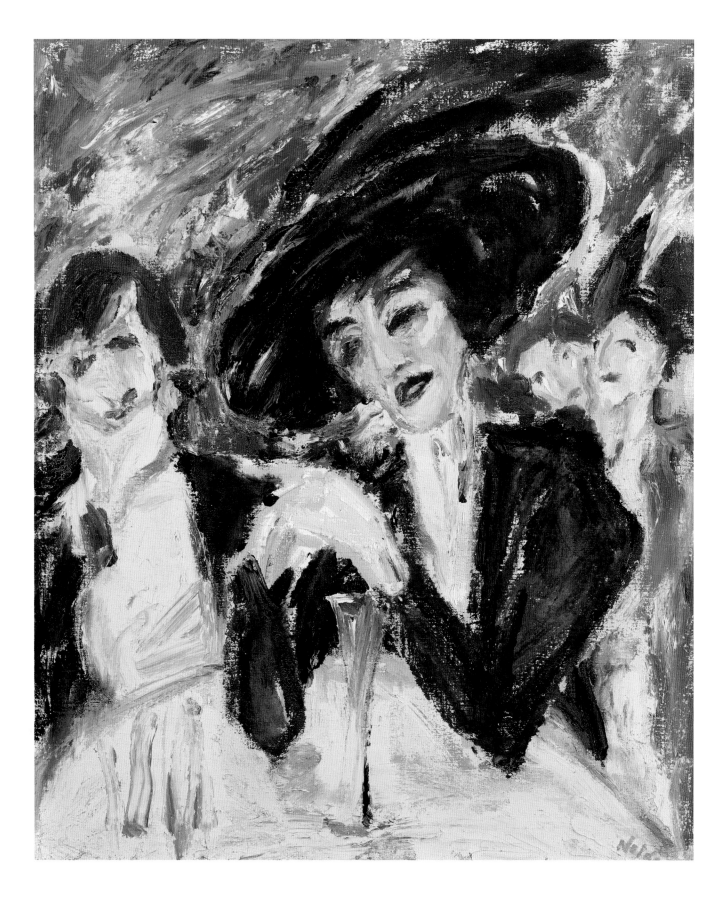

dissipation. By the early twentieth century, with the increased interest in psychology, there was a certain vogue for representing couples sitting at tables: the Russian artist Natalia Goncharova painted works such as *In the Restaurant* (1907), which shows a sour-looking prostitute and her pimp, or client, sitting together but averting their eyes from each other, while the woman helps herself from a delectable dish of fruit. Nolde's café and wine-bar drinkers are bemused, even vapid creatures, and perhaps in choosing to paint them he, too, brought to bear a certain psychological insight, his criticism of their arrogance and snobbery implied by the cocktail of expressive, effervescent colours in which they are painted somehow equating to their aimless lives. Like most of Nolde's Berlin pictures, *At the Wine Table* is painted in bright, sparkling colours. Together with her diminutive, suited escort, a woman wearing a dark blue costume and enormous matching feathered hat leans towards her wine glass. She is evidently far gone from the wine she has drunk, but overall a cheerful, almost festive orange and red colouration predominates. *Gentleman and Lady* shows a similarly effete man sitting with a stylishly dressed woman in a green dress and large pink and yellow hat. In front of their glasses their bottle of wine rests in a cooler placed at the centre of the table. Again, the colours are pleasant, ranging from the yellow of the vessels set out on the white tablecloth to the cool blue of the background. In *Party*, several men and a woman in an orange dress gaze at another woman, who might be a singer about to break into song and who wears a pale turquoise dress and plum-coloured stole; the background here, perhaps reflecting the play of the room's harsh lighting on its paintwork, is a haze of yellow and orange. The singular lack of delicacy of *In the Box*, also dating from that winter, is a far cry from the Impressionists' view of such milieux; the wealthy couple are seen in harsh profile, and seem very different from the elegant occupiers of Renoir's *La Loge* (1874).

The winter of 1910 to 1911 also provided Nolde with an opportunity to indulge his enthusiasm for the theatre. Soon after arriving in the city, he introduced himself to Max Reinhardt, Berlin's leading theatre manager, quickly obtaining his agreement to provide two reserved seats in the front stalls, close to the stage, for any performance at Reinhardt's Deutsches Theater that he wished to attend. There in the semi-darkness, evening after evening, helped by Ada who cleaned his brushes as he worked, Nolde used a specially designed watercolour box in which each colour rested in a differently shaped container that he could recognise by touch, to record what was happening on stage. Reinhardt, known for the entertainment value of his productions rather than their realism, used a revolving stage and highly elaborate sets to convince his audience that they were far away from the city pavements. For his famous adaptation of Shakespeare's *Midsummer Night's Dream*, tall trees soared upwards at either side of the stage, representing the forest in which some of the scenes took place. For *Faust*, the tragic story of the scholar's pact with the devilish Mephistopheles, Auerbach's Cellar, where he tried to tempt Faust beyond endurance, was recreated as a rowdy student hang-out. Wine casks lined its walls, and Mephistopheles, played by the famous Albert Basserman, sat astride a wine barrel. Nolde's many rapid, washy impressions of performances, to which he

Auerbach's Cellar
(Basserman as
Mephistopheles)
1910–11
watercolour
29.7 × 37.7 cm
Nolde Stiftung Seebüll

did not give titles, were not detailed, but successfully captured colours and movement and the interactions between the principal performers. Though that wintertime they evidently provided a unique outlet for his creative energies, these colourful but imprecise impressions cannot be counted among his most accomplished works.

The last two paintings Nolde produced in Berlin that winter were dance scenes, and they are the most expressive and appealing. The subject of *Dance II* is a woman in a pale green dress and large lemon, pink and mauve hat waltzing with a fellow in a dazzling black and white evening suit. She is seen from behind, her improbably long, slender arm held in his, stretching across the picture plane from left to right, and in this dreamlike confection of colour the pleasure of the waltz seems to transport them away from their daily concerns into an imagined world. Dance, in its many forms, was not only a popular sort of entertainment in the

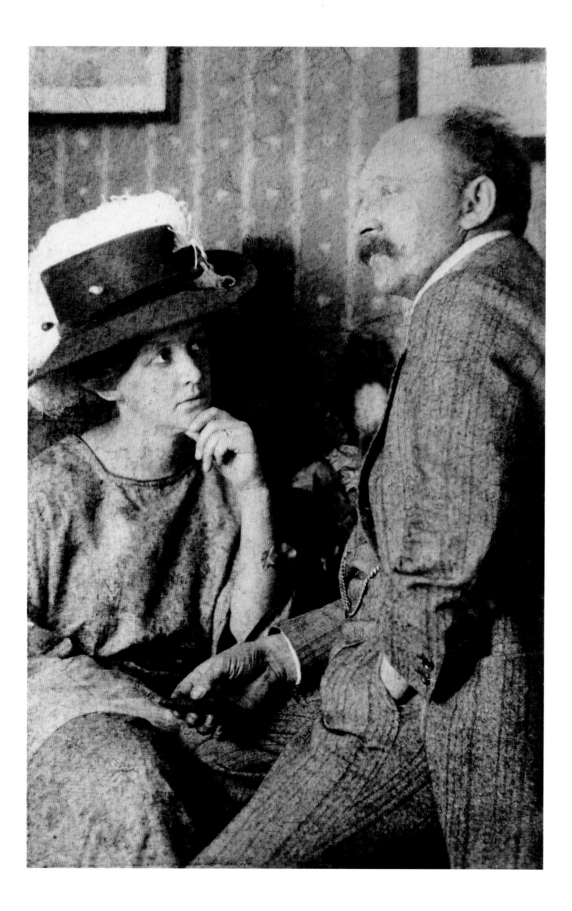

European capitals but also frequently a subject for artists in the decade before the First World War. For painters, especially, the new dance styles that were emerging symbolised a break with formality and tradition. There was, for example, the tango, which arrived in Paris around 1910, possibly as a result of Argentine sailors dancing with French girls in Marseille. In 1910 the Russian-born dancer Aleksandr Sakharoff performed in Munich; claiming that he wanted 'to make music visual', he and his German wife, Clothilde van Derp, would become the most successful dance couple in Europe. Diaghilev's Ballets Russes company, which first visited Paris in 1909, also performed at the Kroll Opera House in Berlin in 1910. Diaghilev, a brilliant ambassador for the Russian arts, would bring to Europe highly innovative productions using exotic costumes and stage decor, in which charismatic solo male dancers and much freer movement largely replaced groups of women dancing in tutus and *en pointe*. Initially the astute Diaghilev, sensing the romantic appeal of Old Russia, introduced ballets that drew heavily on Russian folk traditions. Productions such as Rimsky-Korsakov's *Schéhérezade*, performed in Paris that year, incorporated his designer Lev Bakst's magical, brilliantly coloured and sensual costumes, and soon other ballets would be created to instil an international dimension onto the stage.

Long before this, of course, Degas had pursued his lifelong love of the ballet in many pictures of dancers, resorting to pastel as his eyesight grew weaker in order to continue to paint them in movement. Degas's fascination with the mechanics of the theatre, and particularly the contrast between the darkness of the stalls and the stage brightly lit for performances, had also led him to paint the orchestra pit at the opera, in *Orchestra Musicians* and *The Orchestra at the Opera House* (both 1870), and rehearsal rooms where dancers practised, in *The Dance Class* and *Ballet Rehearsal* (both 1874), and *Dancers Practising at the Bar* (1876). In his *Café Concert Singer* (1878) where the singer's face and throat catch the café's bright lights, his interest in lighting effects is evident.

While Henri Matisse's huge, iconic paintings of the dance, *Dance* (1910 and 1912), would glorify the human body in motion, in the late nineteenth century Toulouse-Lautrec focused on distinctly less refined aspects of night-time entertainment, and ushered in a vogue for portraying the dance in a different light. In *At the Ball* (1912), for example, the Russian artist Boris Grigoriev, taking his cue from Lautrec, shows his dancers as raunchy, provocative creatures, using heavy make-up and exaggerated movements to attract lecherous glances from the male participants. Alexander Rodchenko's *Strange Dancer* (1913), apparently a design for the stage, showed a single naked dancer in front of a cast of performers. Nolde's one-time fellow Brücke artists, particularly Kirchner and Pechstein, were also fascinated by dancers whom they saw in Dresden and Berlin, especially 'exotic' ones from elsewhere in the world. The visit of a Russian dance troop to Germany occasioned Kirchner's *The Russian Dancer Mela* (1911) and his *Two Dancing Girls* (1910–11), which showed Russian dancers performing a can-can, while Heckel commemorated the visit of dancers from Samoa in his woodcut *Samoans* (1911).

Ada and Emil Nolde, Berlin
1908
photograph
Nolde Stiftung Seebüll

Somewhat surprisingly in someone normally so reserved, Nolde particularly enjoyed watching what became known as modern dance, considering the solo dance an art form in itself. Recalling the appeal it had for him over much of his life, he remembered being in Paris as a young man, watching the Australian dancer Saharet. Her real name was Clarissa Campbell, and he later described how in her inventive dances full of free movement she whirled around wildly like some primeval being. He admired performances of the American artiste Loie Fuller (1862–1928), who first attracted attention at the Paris World Fair in Paris in 1889; Nolde would have seen her 'serpentine dance' and '*danse du feu*' at the Folies-Bergère, where she was engaged from 1892 onwards. Considered the first modern dancer, her clever use of light silk garments that billowed around her as she danced was said to recreate the flowing lines of art nouveau. In some of her dances she resembled a butterfly opening and closing its wings, and when Loie visited the Noldes at their Berlin apartment, Nolde commented that she seemed to him like 'a pale yellow moth'.

For though he did not seek the company of other painters, Nolde and his wife received many guests at their Berlin home, including young dancers, theatrical figures and artistes from the world of entertainment. In his forties by the winter of 1909–10, Nolde thrived in their company, and he and Ada sympathised with their lives and encouraged them in their careers. Nolde's friendship with the German-born dancer Mary Wigman (1886–1973) lasted many years. Meeting her early in her working life in 1913, he encouraged her to train with Rudolf von Laban; in 1920 she established her own school of dancing near Dresden, where the Noldes visited her more than once. Thanks largely to Wigman's dedicated tuition, a new form of dance called *Ausdruckstanz*, or expressive dance, became widely popular in Germany.

In his important paintings of the dance, which include *Wildly Dancing Children* (1909), *Dance around the Golden Calf* (1910) and *Candle Dancers* (1912), Nolde's taste for the liberating, ecstatic character of more natural forms of dance is clear. Once saying that he disliked 'sugary ballet and dancing on points', he loved to watch the body in such free and natural movement, associating this with the lives of primitive peoples and their joy in the activity of dancing. In the first of these paintings, the young dancers give themselves over to a joyful celebration, oblivious to their surroundings, their bodies in frenzied motion. *Dance around the Golden Calf* forms one of the series of religious pictures painted at Ruttebüll in 1909 and 1910. Brilliantly coloured in yellows and blues, the scene is one of turbulent movement as Jewish dancers worship a forbidden idol. In the highly expressive *Candle Dancers* the sinuous bodies of the female dancers imitate the flames of candles that have been set on the floor as they weave amongst them.

In Berlin Nolde had enjoyed both a busy social life and many inspirational visits to the dance and theatre, yet stimulating as he found these winter months, with the approach of spring he and Ada quite suddenly tired of city life. They yearned 'for long grass and dunes of sand... for sunshine and the west wind', and as soon as they could the couple returned thankfully to the quiet and solitude of their fisherman's cottage on Als.

Candle Dancers
1912
oil on canvas
100 × 86 cm
Nolde Stiftung Seebüll

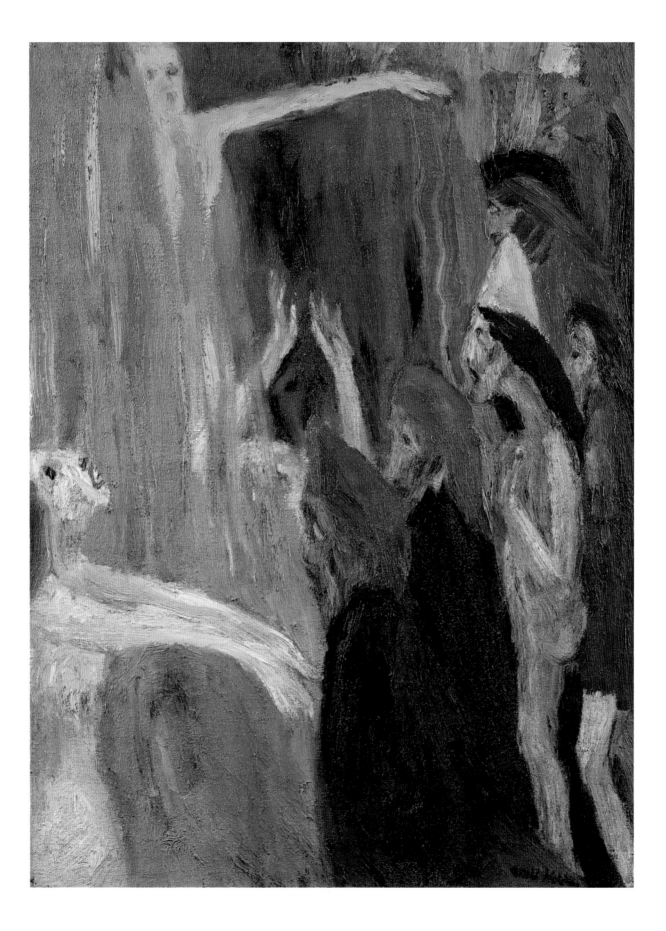

5 Religious Works and the Berlin Secession

The rural farming community in which Nolde was brought up, and which he represented in works such as *Fishermen* (1901) and *Peasants* (1904), was a God-fearing one. The rough-hewn, work-hardened people amongst whom he lived enjoyed few pleasures and knew scant luxuries. For the Noldes, attendance at church on Sunday was a weekly ritual; at home, the Bible was one of the few books his father owned. On summer evenings and by winter firelight, Nolde read and reread the biblical stories, so that they impressed themselves indelibly on his mind and saturated his imagination. As a young adult, slow to form relationships with his peers, for a while he considered becoming a missionary. As a working artist, and especially in times of difficulty throughout his life, he continually recalled the moral teachings of the Gospels, and they were in his mind as he embarked on his great religious pictures.

In 1909, in the village of Ruttebüll on the North Sea coast, recently recovered from a serious illness caused by drinking poisoned water, and seized with a mood of religious fervour, Nolde began to paint the biblical scenes that were to earn him both notoriety and recognition. The first of these were *The Last Supper*, *The Mocking of Christ* and *Pentecost*, and they were followed over the years by a further twenty paintings. Aesthetic considerations play little part in these works, which portrayed the biblical happenings that aroused his most deeply felt piety. In these early religious paintings, he continued the practice introduced by Caravaggio of including in men and women like those living around him, whose appearance was 'ordinary' rather than idealised. In these first three, the faces of the disciples, and those of the crowd goading Jesus on his way to Calvary, could be those of simple, weather-beaten, coarse-featured Frisian fishermen and farmers, comprehending only slowly the momentous nature of the events unfolding.

Nolde's *Last Supper* heralded a group of work that was both passionately envisioned and highly original, owing little to traditional religious iconography. Familiar with Leonardo's *Last Supper* and Rembrandt's *Supper at Emmaus*, Nolde would also have known the woodcut version in Dürer's *Large Passion* of 1510, which includes a servant with a vessel of wine as well as Jesus and the twelve disciples. In his own version of the scene he conspired to cut new

Last Judgement
1915
oil on canvas
117 × 87 cm
Nolde Stiftung Seebüll

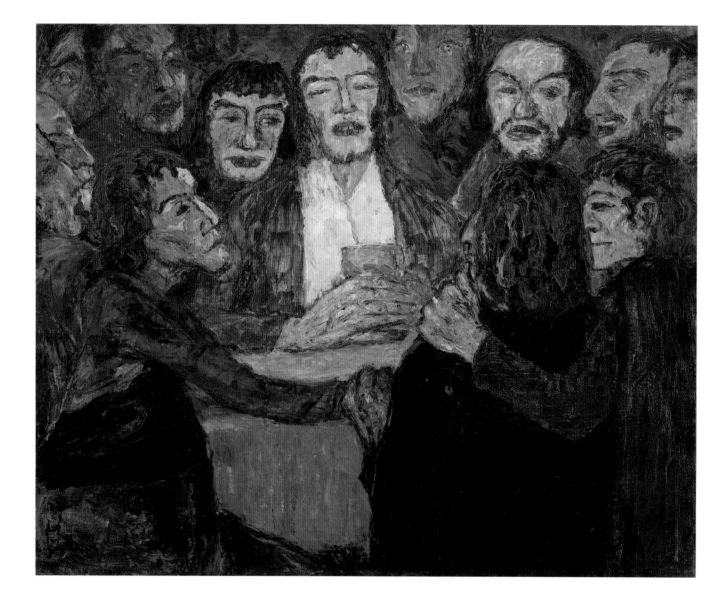

Last Supper
1909
oil on canvas
86 × 107 cm
National Gallery of Denmark, Copenhagen / SMK Photo

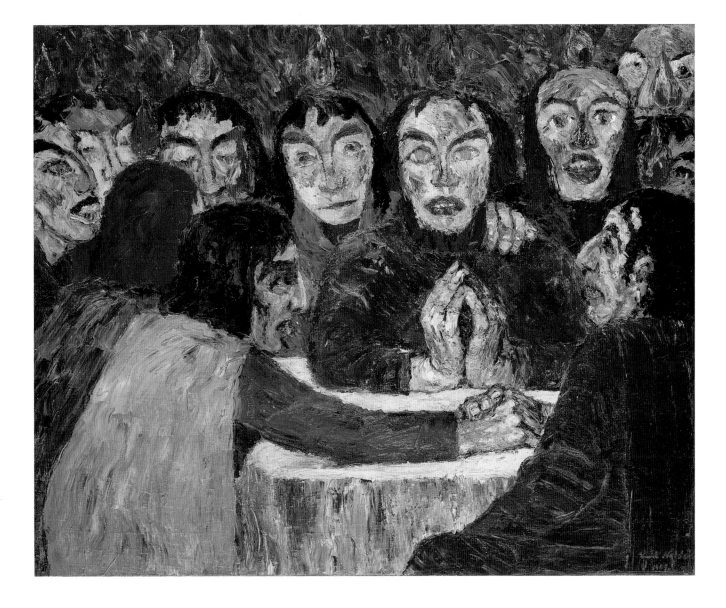

Pentecost
1909
oil on canvas
87 × 107 cm
Staatliche Museen Preussischer Kulturbesitz,
Nationalgalerie, Berlin / Bridgeman

ground. The representation of the thirteen figures presents any artist with the problem of fitting them into a composition without necessitating the use of too low and wide a horizontal format. This Nolde overcame by a severe compression of the subject, focusing on the heads of the disciples as they crowd around Jesus. Their faces are close to his, and only the figures of the three disciples in the foreground are shown, and these half-length. Thus they are made to fill the picture plane completely, while a brilliant and unprecedented use of light and vivid colour serve to make Jesus the unmistakable centre of attention. He is shown with orange hair, wearing a red robe and white shirt, his expression calm and imposing, his hands cupped around the blue vessel from which he prepares to offer his companions wine.

The colouration of *Pentecost*, which forms a pendant to the *Last Supper*, is again bright. The disciples' faces, seen beneath a row of glimmering candles that represent the presence of the Holy Spirit, are bemused and wondering. Expressive use is made of their hands: one disciple rests his fingers on the shoulder of the central figure, who is not Jesus, but Peter, while in the foreground two others clasp each other's hands across the table. Peter himself looks fixedly ahead, his own hands held together as if in prayer. In *The Mocking of Christ*, painted in between these two works, the calm figure of Jesus is surrounded by leering, grimacing soldiers, the whites of their eyes catching the light, their metal helmets glinting. Here again, the tense, busy composition and burning, abrasive colours combine to create a highly dramatic effect.

In the summer months of 1910 Nolde, mindful that he had worked there so productively the previous year, rented the small lock-up house at Ruttebüll for the second time. The brief period of activity that followed resulted in a further seven religious pictures: *The Wise and Foolish Virgins, Dance around the Golden Calf, Paradise Lost, Christ among the Children, Pharaoh's Daughter Finding Moses, Christ in Bethany* and *Joseph Recounting His Dreams*.

One of these, *Dance around the Golden Calf*, was an Old Testament subject that had been painted many times since the Renaissance, by artists including Botticelli and Ghirlandaio in Italy, Cranach and Dürer in Germany, and the Dutch master Lucas van Leyden (1494–1533). The episode of the golden calf is recorded in the book of Exodus and describes the Israelites' defiance of their leader Moses. Waiting for him to descend from the mountainside, where God has entrusted him with the Ten Commandments, they cast a statue of a calf in gold melted down from their jewellery. To the accompaniment of dancing and feasting, the less godly among them begin to worship the shining statue instead of their God.

While Cranach had depicted the scene in a woodcut, his *Dance around the Golden Calf with Moses Receiving the Tablet of the Law* (*c*.1527), in around 1530 van Leyden recorded it in a magnificent triptych, painted in rich, glowing colours in oil on panel, and expensively framed. Now in the Rijksmuseum in Amsterdam, this work shows Moses as a tiny, distant figure high up on a craggy mountainside, while a group of Israelites dance in the middle distance. In the foreground, a crowd of splendidly dressed people eat, drink and make merry, draining their wine from expensive golden flagons. Another famous version was Poussin's

Adoration of the Golden Calf, painted in 1633; this too is a scene of revelry taking place in front of a large statue of the golden calf that stands on a plinth decorated with garlands. Nolde, painting the same subject centuries later, singled out the most dramatic element of the story, focusing on a small group of ecstatic, wildly dancing figures who are oblivious to everything but the rhythm of the dance.

On Als the following summer he painted three further religious works, *The Magi*, *Jesus with the Doctors* and *Christ and Judas*. Only in Berlin that winter, at the beginning of 1912, when Ada was away, did he conceive the idea of completing a polyptych modelled on medieval examples. With the door of his studio locked, and painting furiously, he produced the remaining scenes of his *Life of Christ*, including *Holy Night*, *Women at the Tomb*, *Resurrection*, *Ascension*, *The Incredulity of Thomas* and the singular *Crucifixion*. When Ada returned, he arranged them around the low walls of his studio well enough for her to imagine them as a polyptych. We have his touching description of the event: 'We stood in front of them, as artists have often done with their beloved in front of new work, and looked at them for a long while.'

When studied carefully, Nolde's *Crucifixion* shows clear, deliberate references to a work revered by many, including the Brücke artists: the crucifixion scene in Matthias Grünewald's *Isenheim Altarpiece*, painted almost five hundred years earlier.[16] As we have seen, in their 1906 manifesto the Brücke determined to reject the precepts and ideals of 'long-established older powers' – that is, artists who had become well known in their own lifetimes – yet they clearly considered the early Renaissance artists Dürer, Grünewald and Cranach highly important, if not exemplary figures in the genesis of German art. And while Dürer's prints were foremost in their minds as they sought to reaffirm the supremacy of German printmaking, the literature of the time, such as Paul Fechter's groundbreaking study *Der Expressionismus* (1914), would begin to categorise Grünewald as an early and original expressionist, using figural distortion and extreme colouring to convey violence and tragedy. From quite early in his career he adopted Leonardo's practices of recording human heads with exaggerated features and distorting human physiognomy as means of portraying extreme emotion. Nolde himself may well have studied the examples of Grünewald's drawings held in the collections of the Dresden and Berlin print rooms.

Matthias Grünewald was probably born in Würzburg sometime between 1470 and 1480. He became known as a painter, engineer and manufacturer of paints and soaps, and by 1509 had been appointed court painter and clerk of works to the elector of Mainz; he continued to work for the electors of the city until 1525. In 1510 he was commissioned by a Frankfurt merchant to paint two fixed wings for an altarpiece by Dürer, *The Assumption of the Virgin*. Grünewald's fame today, however, arises largely from his great *Isenheim Altarpiece*, painted in 1515 for the wealthy Antonite order of monks, whose hospice at Isenheim, near Colmar, was dedicated to the care of sufferers from the terrible skin disease known as St Anthony's fire.[17] A work of immense drama and compassion, described by the French novelist

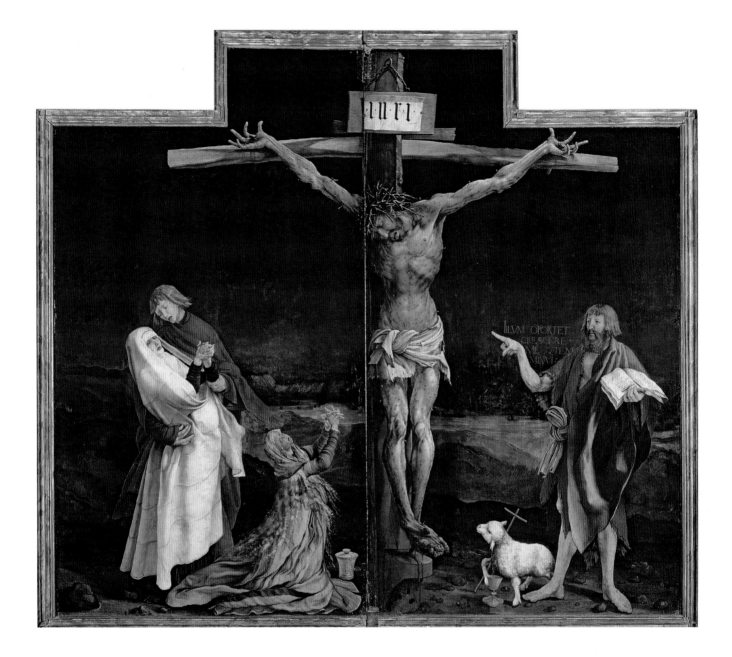

Crucifixion
*c.*1515
by Matthias Grünewald
(central panel from *Isenheim Altarpiece*)
oil on panel
270 × 310 cm
Musée d'Unterlinden, Colmar / Bridgeman

Crucifixion
1912
oil on canvas
220.5 × 117 cm
Nolde Stiftung Seebüll

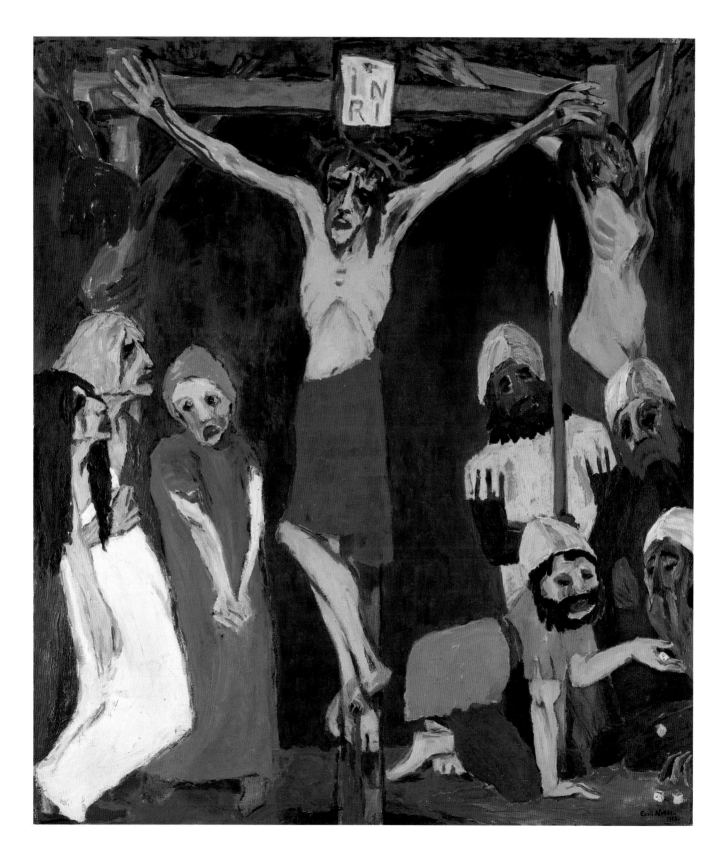

and writer J.-K. Huysmans[18] as 'a typhoon of art let loose', the main section of the altarpiece showed the tortured, convulsed body of the crucified Christ covered with sores. In this pitiable scene, the agonised figure of the mother of Jesus stands on the left, wearing white robes and supported by John the Evangelist in red, with Mary Magdalene kneeling at the foot of the cross, and St John the Baptist standing to the right, draped in a red cloak with a lamb beside him. The use of flame-red pigments and the fluttering, hard-edged folds of the garments of the protagonists somehow augment the intense emotions they are experiencing. When the outer wings of the altarpiece are open, calmer scenes are revealed of the Annunciation and the Resurrection, rendered in glowing colours, while the side panels of the innermost section portray St Anthony and his meeting with the hermit St Paul.

Nolde's early twentieth-century version of the Crucifixion clearly echoes the composition and colouration of this great work and perhaps constitutes a personal homage to the earlier master. To the left of his painting, the mother of Jesus is again shown in white, and a figure wearing red appears close behind her, like John the Evangelist in the sixteenth-century work. In front of her the kneeling Mary Magdalene, however, wears brilliant green, but this replicates the acid green of the strips of grass Grünewald painted behind the cross. To the right, Nolde replaces John the Baptist with the soldier who offered Jesus sour wine, holding up his spear, and three other soldiers throwing dice in competition for the clothes of the crucified men.

Nolde's religious works met with acclaim in some circles and huge dislike in others; in fact they would cause ruptures in the German art world. Karl Ernst Osthaus enthusiastically displayed the *Life of Christ* in his Folkwang Museum at Hagen, and the young museum director Max Sauerlandt exhibited *The Last Supper* at Halle, yet he had to battle severe opposition from the museum trustees before he was able to buy it. After its purchase, he faced heated criticism from Wilhelm von Bode, the leading figure of the German art establishment in Berlin.[19] Sauerlandt, however, remained one of Nolde's staunchest admirers, publishing the first monograph on the artist in 1921.

Nolde had exhibited with the Berlin Secession since 1906. He had received particularly warm support from the Jewish art dealer Paul Cassirer, who had prevailed upon his fellow jury members to agree to exhibit his *Harvest Day* in 1906. Cassirer also showed Nolde's work in his Berlin gallery in both 1905 and the winter of 1907–8. But when Nolde submitted his first religious works for exhibition in the autumn of 1910, the Secession's president, Max Liebermann, who also happened to be Jewish and who was already somewhat hostile towards the work of younger German artists, was adamant that they should not be accepted. In particular he objected to Nolde's painting *Pentecost*, where the disciples are shown as simple, rough-hewn peasants. When his jury demurred, Liebermann threatened to resign; this time he won the day, with Cassirer joining the rest of the jury in refusing to allow the paintings to be hung. Nolde retaliated in a furious letter to the journal *Kunst und Künstler*, occasioning an unfortunate and bitter personal struggle with Liebermann and other Berlin connoisseurs and art dealers

that resulted in his expulsion from the Secession in December. This was somewhat ironic as, unlike other artists, particularly those of the Renaissance, Nolde often envisioned the events represented in his religious works taking place in the biblical lands east of the Mediterranean, and peopled them with dark-haired, olive-skinned figures with Jewish features.

Nolde defended his pictures with conviction, saying that above all he sought 'clarity and truthfulness'. Yet his highly unconventional presentation of the biblical stories, and his characterisation of some of the figures as Jewish – which lent them an authenticity absent from generations of religious compositions from both northern and southern Europe – continued to antagonise many. And in 1912, when Osthaus arranged to show the *Life of Christ* in the German section of the Brussels World Fair, it was withdrawn by the city authorities because of the danger that it would 'disturb the (largely Roman Catholic) clergy and faithful'.

In the summer of 1912 Nolde painted one of his most dramatic works, the triptych *Legend: St Mary of Egypt*. Books recounting the lives of legendary saints were popular in Germany at this time,[20] and by basing this painting on a legend rather than a biblical event Nolde followed the example of several northern, late medieval and early Renaissance artists. Martin Schongauer's print of the temptation of St Anthony (*c*.1480–90) was well known, and Hieronymous Bosch had painted the legend of the saint several times; Nolde may well have seen the version of Bosch's St Anthony owned by the State Museum in Berlin.

St Mary of Egypt –
the Conversion
1912
oil on canvas
105 × 120 cm
bpk / Kunsthalle Hamburg /
Elke Walford

In the triptych, Nolde recreated the life story of Mary, a former prostitute from the port of Alexandria. After converting to Christianity she went to live in a desert, where she died many years later. In the first, lewd episode of the triptych, the semi-naked Mary offers herself to a group of sailors; in the central canvas, she has joined a group of pilgrims and, dressed in a long scarlet robe, kneels in remorseful ecstasy in front of a statue of the Virgin and child; and in the final scene she lies dying in the wilderness, watched over by the elderly, bearded St Zosimus and a lion.

As with the *Life of Christ*, this triptych attracted both admirers and detractors. The collector Heinrich Kirchhoff was among those converted. Horrified when he first saw it exhibited in Wiesbaden, he returned to look at it again an hour later and felt quite differently; this time he found it inspirational, and he later bought it for his collection. When both works were exhibited in Lübeck's St Catherine's Church in 1921, a viewer noticed that, even with their brilliant colours muted by the diffused light of the church, Nolde's paintings achieved an exceptionally vibrant, glowing effect.[21]

In 1915, when he and Ada had returned from their expedition to the German colonies in the South Seas to their rented fisherman's cottage on Als, Nolde resumed work with renewed vigour. He was distant from the First World War, but doubtless aware of its burgeoning horrors; nevertheless his prodigious output that year included six further biblical paintings, including *The Tribute Money*, *Entombment* and *Last Judgement*. Each of these espoused a new and radical treatment of its subject. In the bold *The Tribute Money*, a dark-haired Jesus looks sternly at the Pharisees as they question his identity; his arm is outstretched towards and almost meets their wildly gesticulating hands. The singular *Last Judgement* is very different from the medieval 'dooms' still found in many churches, confronting their congregations with the sight of the ranks of the naked righteous and damned in terrifying detail. Nolde's much simpler format has a single ghostly, pale blue figure ascending heavenwards, another sinking downwards, and a few other naked and semi-clothed figures awaiting their fate, with tall green 'flames' replacing the more usual fiery orange ones.

Nolde allotted a special significance in his oeuvre to the monumental *Entombment*, calling it 'one of my most beautiful pictures' and extolling its glowing golds and silver-blues. Here, the well-to-do senator Joseph of Arimathea, who had dared to ask Pilate for Christ's body, cradles his spare, gaunt form in his arms, while the elderly, white-haired Nicodemus holds his pierced, blood-stained feet. Behind them the red-haired, ruddy, mask-like head of St John, his teeth bared in agony, intersects the blocks of blue and yellow pigment. Some critics saw in *Entombment*'s pared-down simplicity the influence of the art of primitive peoples. Yet only a few years earlier Nolde had written of his desire to create a new, intensely German art that would perpetuate the old and honourable traditions of Dürer and Grünewald,[22] and other viewers saw this work as exemplifying these ambitions. Indeed in describing this painting some time later the critic Werner Haftmann wrote of its late Gothic character, noting that it seemed to constitute a return to medieval German examples of the pietà.[23]

Entombment
1915
oil on canvas
86.5 × 117 cm
Nolde Stiftung Seebüll

The year 1921 saw a further series of religious works that included the *Martyrdom Triptych* and *Paradise Lost*, but in general Nolde's production of biblical works was more sporadic after 1915. The occasional paintings, however, suggested a new tenderness, for instance in *Holy Family* (1925), *Be Ye as Little Children* (1929) and *Adoration of the Magi* (1933).

It is perhaps unsurprising that Nolde's religious pictures were not always received with widespread enthusiasm. Unconventional in concept and format, painted in colours approaching the acidic, and frequently employing a figural distortion verging on caricature, for the discerning and those attuned to the creative tenor of the early twentieth century, however, they contained a profound spirituality. Appreciation of this aspect of Nolde's art began to gather momentum after the First World War, and was perhaps best encapsulated by Carl Georg Heise in his 1919 study of the religious works.[24] Noting that they departed radically from historical painting, he commented that they could be considered almost a vessel of the divine. Many now believe that these paintings marked the high point of Nolde's art, encompassing his unique ability to convey both his personal spiritual beliefs and a more general, even archetypal longing for the existence of a just and feeling God.

6 Still Lifes

The still life has been assigned many disparate purposes by different artists, for it is a genre in which they have assiduously juxtaposed inert objects to achieve various aims. It was at its most popular in the seventeenth-century Netherlands, when Dutch flower pieces preserved the beauty of anemones, irises, roses and above all tulips for year-round contemplation, while paintings of luxury goods collected by the wealthy celebrated Holland's success as a maritime and trading nation. The floral still lifes of the period also gradually took on a philosophical character, as withered leaves, blooms about to be ravaged by insects or prowling lizards threatened to do away with the flowers' fragile beauty. It was a similar story with the still lifes or *pronkstilleven* that commemorated rare and expensive objects, for into these arrays of jewellery, glassware, armour, books and other prized possessions crept hourglasses, watches, candle-snuffers and half-smoked tobacco pipes, to indicate that Father Time pursues even the most privileged among us.

There was often, too, a moralising aspect to such works. Painters hinted that, since life is short, it should be lived virtuously. The inclusion of items such as wheat, bread or wine to denote the Eucharist, or fruits such as redcurrants and cherries as symbols of Christ's Passion, served to remind the viewer of the teachings of the church. In his beautifully rendered *Still Life with Cherries* (1635), the German artist Georg Flegel (1566–1638) showed a glass of wine, a loaf of bread, a large cheese, and scarlet berry fruits; and although the long-stored cheese represents longevity, a dragonfly alighting on the bread serves as a reminder of the transient nature of man's existence. Yet other still lifes, particularly the popular studies of game birds by Dutch artists such as Hondecoeter and Frans Snyder, pointed to the useless slaughter of such beautiful creatures for human consumption. And both Rembrandt and Goya portrayed, and made to look immeasurably pitiful, dead animals, fish and birds such as peacocks that had been killed for the table.

There were, after all, certain advantages in painting still lifes. Artists could arrange their subject matter exactly as they wished, and inanimate objects, unlike the subjects of portraiture, did not blink or twitch, or comment adversely as the work proceeded. Cézanne, who

Masks III
1920
oil on canvas
87.5 × 73.5 cm
Nolde Stiftung Seebüll

found portraiture notoriously difficult, composed his still lifes with minute care, setting freshly ironed white cloths delicately on the table's surface and then balancing his glorious, 'solid and alive' apples and other fruit on small coins such as sous so that they did not roll away.

Nolde was no exception, then, in using the still life to relay certain beliefs and, occasionally, to make statements about the society of his time. He first became interested in the genre in around 1911, producing a number of still lifes in 1911–12 and a further batch in 1920, and thereafter painting them from time to time. His still-life paintings fall into two broad groups: the so-called 'mask' pictures, and those showing objects from his collection of carvings and other artefacts from distant countries, sometimes combined with flowers. While the first group is an interesting – and distinctive – phenomenon in his output, the latter forms an important part of his oeuvre, quite often embodying his beliefs about primitive art.

In April 1911, Nolde was able to follow up his interest in the work of the Belgian artist James Ensor (1860–1949) during a visit to Brussels. His friend and patron Karl Ernst Osthaus, proprietor of the museum at Hagen, already had close links with Belgian art, and Nolde may well have discovered Ensor's work through Osthaus's acquisitions there. Nolde was probably drawn at first to the drawings and etchings on religious themes, particularly Ensor's *Life of Christ*, made in around 1886. Some critics have, indeed, found stylistic similarities between these and Nolde's early religious paintings. In Brussels, however, Nolde was shocked to find that Ensor was not represented in the collections of the Museum of Fine Arts. He then visited the exhibition of non-European art at the Palais Stoclet before travelling to Ostend, where he had arranged to meet Ensor in his studio. In spite of his early brilliance, the Belgian had, like Nolde, known rejection by his country's artistic establishment. After studying at the Brussels Academy, by the early 1880s he had developed an attractive and sophisticated painterly technique, and was already the author of accomplished interiors and still lifes. But in 1883 his career suffered a sudden downturn when his *Woman Eating Oysters* (1882) was rejected by the Antwerp Salon; in 1884 the Brussels Salon also refused to exhibit his work. Ensor returned to his parental home in Ostend to live in its dark, heavily curtained upper rooms for the remainder of his life.

During the next few years he painted both portraits and works featuring the carnival masks sold in his mother's curiosity shop and used in the parades that took place in wintertime Ostend. Ensor's attractively coloured 'mask paintings', for which he is now perhaps best known, showed the masks' distorted faces, with their contrived registering of laughter, sadness, astonishment or horror, appended to human forms. By this means he was able to imply criticism of the snobbery and ambivalence he found in society. One example of such a work was his *Intrigue* (1890), which showed a group of people whose mask-like heads register a conversation that is gossipy, muttering, self-congratulatory and even sinister. In his *Portrait of the Artist surrounded by Masks* (1890), Ensor himself appeared as a single, discerning human face looking out from a sea of mindless mask-heads. His masked figures sometimes became skeletons, as in *Skeletons Trying to Warm Themselves* (1889), where several partially clothed skeletons seem magnetised to a brazier placed in the centre of a bare room.

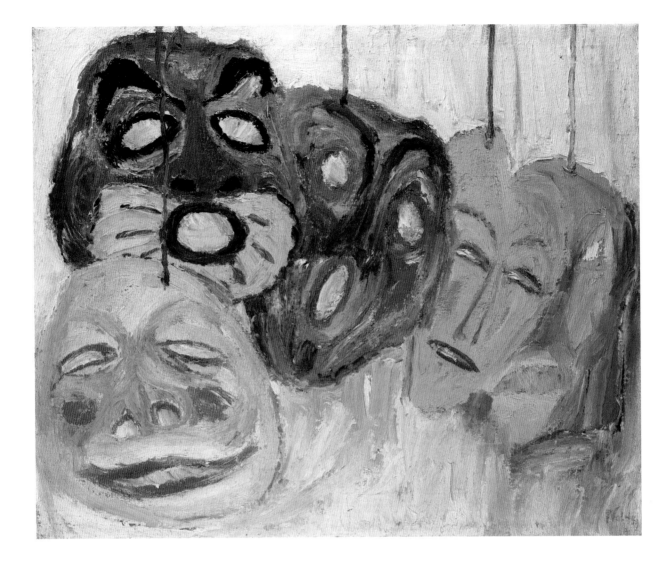

Still Life with Masks I
1911
oil on canvas
64.5 × 78.5 cm
Nolde Stiftung Seebüll

Ensor was thus a highly original artist, who has been described as far removed from the formal emphasis and restraints of his own period, and on a painterly level, one writer at least considered that 'his world of masks heralded the beginning of the expressionist movement'.[25] As in his earlier encounter with Munch, Nolde was unable to converse with Ensor in any detail, this time because of language difficulties, but it seems that, once in his studio, he was able to see examples of his mask pictures, for the visit prompted the creation of a series of his own such paintings only months afterwards. His motivation in painting these, however, was initially somewhat different from Ensor's. Rather than incorporating any implied social comment, his *Still Life with Masks I* simply showed five imaginary, simply constructed masks, arrayed against a pale blue background and painted in appealing, Ensoresque colours. His next mask paintings, however, were based on careful sketches made in Berlin's Ethnographic Museum, and actual masks are recognisable in them. The first includes a Mexican Teotihuacan mask and a small Aztec ornament, and in the joyously coloured *Still Life with Masks III* the

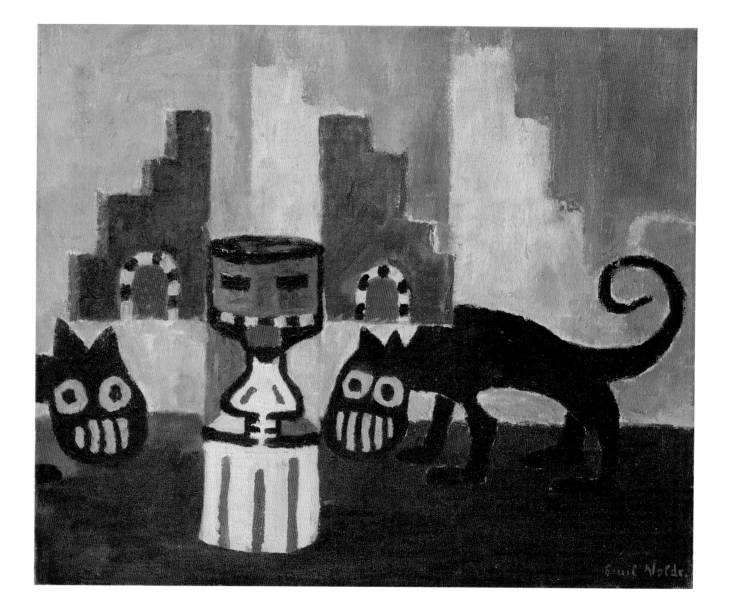

deep-red, sharply pointed head to the left of the five masks portrayed is derived from the stern of a canoe from the Solomon Islands. Nolde had sketched many other examples of these artefacts, including dancing masks from Africa and the South Seas, and masks designed for various other purposes from Ceylon, Java, Bali and pre-Columbian America. He evidently thought highly of this original group of mask pictures, lending them to various exhibitions from 1912 onwards, while Osthaus quickly acquired *Still Life with Masks III* for his museum.

Unlike Picasso's apparent adoption of African masks in a series of pictures made from 1907, and Brancusi and Modigliani's unashamed drawing from African examples in the sculptures they created in Paris at around this time, Nolde's use of masks was not creative, nor did their inclusion in his oeuvre cause him to alter or refine his technique. His renderings of masks and other tribal artefacts were usually faithfully reproduced, for he considered that the craftsmen who made them had already subjected them to a process of simplification and monumentalisation. In this respect he was more sincere than his fellow Brücke artists Kirchner and Pechstein in their portrayals of similar items – Kirchner, particularly, exploited the examples he saw of Oceanic art simply as sources of new and erotic motifs. For Nolde, the products of other, primitive societies he saw and collected were, rather, an armoury of objects that would 'speak' in still-life paintings. Like Ensor, in choosing to paint them he created an arena that lay between the living and the inanimate, and by arraying the different masks alongside each other, he protected their validity as objects and emphasised the individual characteristics of each. Indeed, he later compared non-European examples favourably with 'ugly and vulgar' carnival masks, perhaps reflecting on those he had seen in Ostend – though the latter were, of course, produced as consumer goods rather than works of art.

For well before the journey he undertook to the German colonies of the South Seas in 1913, and his experience of the lives of non-European peoples at first hand, Nolde had sought out examples of tribal art and craftsmanship nearer home. His friendship with Osthaus, beginning in the spring of 1906, had given him an opportunity to view such artefacts in his new patron's museum, for Osthaus was an early exhibitor of such items, having included them in his collections since 1902. In the autumn of 1911, following his visit to Ensor, Nolde began visiting Berlin's Ethnographic Museum and was instantly drawn to the art forms of distant, so-called 'primitive' peoples, making numerous sketches of ritual and ceremonial objects, as well as weaponry and items for daily use. He quickly came to admire both the skilled craftsmanship and the colourful ornamentation they embodied. Whereas European works of art, he said, always seemed to need preliminary sketches or studies on paper, he admired the vigour and spontaneity of these works, stating that: 'The products of primitive peoples are created with actual material in their hands, between their fingers. Their motive is their joy and love of creating.' In fact the artefacts so intrigued him that he thought of writing a study of them, to be called *The Art of Primitive People*, but he did not pursue this idea beyond writing an introduction.

Exotic Figures
1911
oil on canvas
65.5 × 78 cm
Nolde Stiftung Seebüll

Nolde was deeply distressed by the way in which the director of the Berlin Ethnographic Museum, and, he suspected, the other more conservative custodians of Germany's art collections exhibited their tribal objects. Rather than being accorded any aesthetic significance, they were crowded, even jumbled together in inadequate, glass-fronted display cases, and divided into historical or 'scientific' groups as records of specific non-European peoples. In 1913 and 1914 Nolde formulated his thoughts in his correspondence with Osthaus. Even though the Berlin Museum's director, Wilhelm von Bode, planned to separate off the collection of Asiatic artefacts and display it differently, Nolde praised and would continue to advocate Osthaus's policy of giving primitive works of art much more space, and showing them adjacent to European ones, thus according them equal importance. Displayed in this way, their beauty and the quality of their workmanship would be self-evident, while their very different and distinctive character would serve to commemorate the civilizations and celebrate the regions that had created them. The two men's thoughts concurred, and before Osthaus's early death in 1921, he exhibited Nolde's *Still Life with Masks III* and *Still Life with Wooden Figures* in his museum, hung behind metre-high plinths on which stood equally tall, intricately carved African figures.

Karl Ernst Osthaus
1903
by Ida Gerhadi (1862–1927)
oil on canvas
110.5 × 76.5 cm
Osthaus Museum Hagen /
photograph Achim Kukulies,
Düsseldorf

Nolde's first mask paintings were, in fact, to lead the way towards certain of his other still lifes that expressed his views on the colonisation and treatment of native peoples. In his *Figure and Mask* (1911) a small, dark, African figurine wearing a white skirt appears beside a large yellow mask that has a long, downwards-sloping and cynical, disapproving nose, causing the viewer to reflect, perhaps, on the regrettable consequences of Europe's intercourse with Africa at that time.

The most telling of all Nolde's still lifes in this vein is, perhaps, *The Missionary* (1912), which juxtaposes a tall Korean wayside figure, a female figure from the Yoruba region of Nigeria and a Sudanese bongo dance mask. The Korean figure, with a Bible clasped between his hands, is transmuted into a European missionary, even though his face is painted brown instead of white and therefore hints at subterfuge. In front of him the African woman kneels submissively, as if in prayerful supplication, her baby on her back and a small pot in her hands. Behind them both the bongo mask appears horrified at the Christian missionary's ploy to deflect the African – and her child – from their native beliefs.

In two other still lifes, *Man and Woman with Cat* and *Man, Fish and Woman* (both 1912), artefacts sketched in the Berlin Museum mingle with imagined primitive figures. In the former, the male figure is based on one appended to an intricately carved wooden

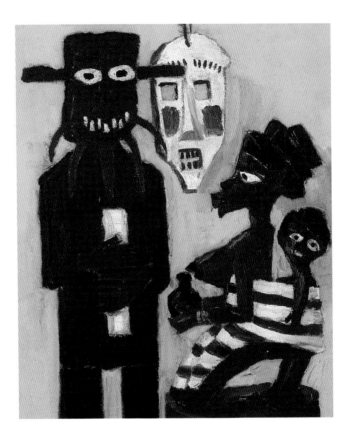

The Missionary
1912
oil on canvas
75 × 63 cm
Private collection

Cameroonian throne decorated with glass beads. Nolde had sketched the attendant figure that stands behind it, holding a bowl in his hands, while the long-bodied cat derives from the top panel of a wooden carved door from Nigeria, also found in the Ethnographic Museum. In *Man, Fish and Woman*, however, the figures seem rather more generic.

While the first decades of the twentieth century saw a widespread appropriation of tribal artefacts by artists in Paris, in Munich the members of the Blaue Reiter group also conceived an intense interest in the art of primitive peoples. Nolde would almost certainly have been familiar with the activities of the latter group, which was led by the Russian Wassily Kandinsky, then living in Germany, and Franz Marc. Their *Der Blaue Reiter Almanach* was first published in 1912, its cover showing a skilfully designed horse and rider. Inside, the almanac displayed primitive works of art alongside European ones. We can only surmise whether Nolde's quite frequent inclusion of figures of riders in his still lifes at this juncture was coincidental. His *Still Life, Exotic Figure, Mask and Rider* (1913) combines a north-west American Indian figure and a mask that is probably Egyptian, for in the winter of 1912 he had visited the Thaulow Museum in Kiel, with its collection of Egyptian and Etruscan heads. They are shown full-frontal, with a European glazed ironware horse and rider behind them, seemingly riding towards or past them – as if they are frozen in time while it moves forward. In other works including figures of horses, for instance *Still Life with Brass Horse, Cushion*

Cover, etc. (1915), the animal's lively stance contrasts with the static objects. The horse became a favourite motif with Nolde, and his fondness for young, spirited equine creatures is evident in other still lifes featuring gazelles, does and stags, such as the radiantly coloured *Still Life with Striped Goat* (1920). In *Still Life with Dancers* (1914) a piebald cow makes an appearance, hiding behind a vase of tulips in front of the pair of exotic dancers.

Nolde's intention in painting other works in this genre is less obvious, and many were probably painted purely for pleasure, especially in wintertime. In several paintings, seemingly in thrall to their distinctive appearance and their very 'difference' from the products of European craftsmen, he continued to juxtapose disparate artefacts he had seen and sketched, or ones he had bought. In *Negro Statuette and Poppies* (1920) a small statue of a black person

Still Life with Striped
Goat
1920
oil on canvas
75 × 88 cm
Private collection

is shown adjacent to a vase of poppies, while *Still Life H* (*c*.1914), for instance, includes an upright carved Uli figure from New Ireland in the South Seas, a Russian porcelain group bought in Moscow and a decorated cushion cover that Ada had woven from her husband's design. In this attractive work, he perhaps sought simply to suggest the individual character of each carefully crafted object.

In his *Masks and Dahlias* (1919) Nolde once more painted masks, this time delicate male and female Japanese Noh masks from his own collection, hanging above a jug of scarlet blooms from the garden at Utenwarf. The following year saw a second group of evocative, colourful still lifes featuring masks, in which, though they are less demonic than those from 1911, they still have a powerful resonance as objects. In the roughly painted *Masks I* (1920) a large male mask bears down on a Noh mask; in *Masks II* (1920) four masks are rendered in a striking palette of grey, red, white, wine and ochre. In *Masks III* (1920) a pair of white gloves seems to hover protectively above a group of three boldly coloured masks: while two of the masks are present as grotesque, the central green and yellow one seems submissive, its eyes downcast beneath their long lashes. Here again, the palette is rich and glowing, incorporating wine-red, white, greens, yellow and red. *Masks IV* (1920) shows just three masks jostling together, one looking ahead, and one long-nosed one looking aside at the third one, which hangs upside down. In these attractive last mask pictures, it seems as if the artist has cast aside any serious or didactic concerns and is simply expressing his enjoyment of the masks as colourful objects – albeit ones possessed of a certain magic.

Still Life with Dancers
1914
oil on canvas
88 × 105.5 cm
Musée National d'Art
Moderne, Centre Pompidou,
Paris / Bridgeman

7 Travels

In 1891, when Nolde was aged twenty-seven, his father died. The following year, Nolde applied for a teaching post at the Museum of Industrial Design at St Gallen in Switzerland, and was the successful candidate among more than thirty others. He remained in this position for five years, enjoying a secure income, respected by his students and forming lasting friendships in the locality.

The old city of St Gallen lies in a high, snowy, Alpine valley in north-eastern Switzerland. Overlooking the town are the twin towers of its centuries-old abbey, with its fine baroque interior. Accustomed as he was to the flat reaches of his native Schleswig-Holstein, Nolde must have found these mountainous surroundings an intoxicating milieu. He walked in the Alpine meadows and made several difficult and daring ascents, including one of the Matterhorn. And, importantly, he formed valuable friendships with his student Hans Fehr and with Max Wittner, son of a cultured Jewish banking family. While Fehr became a lifelong friend and supporter of Nolde's art, Wittner talked to him about the works of many contemporary writers, including Ibsen, Gorky, Knut Hamsun and Jens Peter Jacobsen. In his autobiography Nolde professed his ignorance of these at the time and his gratitude to his new acquaintance for introducing him to them. Sadly, his friendship with Wittner did not survive Nolde's falling out with the leaders of the Berlin Secession, who were also Jewish.

Nolde's familiarity with the rocky contours of the Swiss and north Italian mountains was to have an unexpected bounty. In the mid-1890s he produced a series of views of the famous peaks, inhabited by human heads and painted in watercolour with touches of gouache. Inside his *Jungfrau, Mönch and Eiger* (1894), for instance, appeared the faces of a smiling young woman, a scraggy, long-nosed monk wearing a hood and a rotund older man. In *The Matterhorn Smiles* (1896) the sharp, triangular peak of the famous mountain was transformed into the grimacing, silver-haired head of an old man. In conceiving his 'portraits' of the Swiss and Italian mountains in this way, Nolde was subscribing to the vein of the grotesque inherent in much earlier Germanic art, exemplified not only in the works of Grünewald but also in the woodcuts and engravings of the Swiss-born printer and mercenary soldier Urs

Native with Red Hair
undated
watercolour and Indian ink
50.8 × 38.5 cm
Nolde Stiftung Seebüll

Graf (1485–1529) and the sculpted character heads of Franz Xaver Messerschmidt (1736–1783). Working in Munich, Messerschmidt produced a gallery of busts of men and women with horribly contorted facial expressions – creations that would probably have been ignored elsewhere in Europe. Nolde's mountain caricatures, printed as postcards using the process of chromolithography, were immensely popular, selling in thousands, and rewarding him with enough money to allow him to live independently and finance his studies at art school.

Also resulting from his years spent in mountainous country was Nolde's oil painting *Before Sunrise* (1901). In a scene that oscillates between the grotesque and the mystical, mysterious equine creatures hang suspended above a steep mountain valley, across which flickers the orange light of early day. With its seductive combination of deep cobalts and pale orange tints, this composition is strangely appealing.

While living in Switzerland, Nolde visited Milan, Vienna and Munich, primarily in order to see their art collections; he would continue to visit European art centres throughout his life as opportunity arose. During his studies with Friedrich Fehr in Munich in 1898, he often went to the city's Pinakothek, studying paintings by Böcklin, the Germans Menzel and Leibl, and works by Millet and Goya. In Paris in 1900, while studying at the Académie Julian, he spent time in the Louvre, admiring especially Titian's *Entombment* and Rembrandt's *Supper at Emmaus*. With his friend Hans Fehr he visited the Exposition Universelle of 1900, noting especially works by Daumier and Rodin. Copenhagen was another city that Nolde knew well, for he had studied there with Zahrtmann and it was there that he met his wife, and towards the end of his life, as a long-time Danish citizen (see Introduction), he donated eight of his finest paintings to the city. The Noldes' visit to Italy in 1905, when they stayed at the beautiful coastal resort of Taormina and on the volcanic island of Ischia, was financed by Hans Fehr mainly for Ada's benefit, since she was often in poor health at that time.

As we have seen, in 1911 Nolde began visiting the Ethnographic Museum in Berlin, quickly developing an abiding interest in the art of so-called primitive peoples. When in 1913 he and Ada, who was now well recovered, were invited to join the Imperial Colonial Office's 'medical-demographic' expedition to German New Guinea, they were delighted. A photograph of them with the expedition's leader Professor Alfred Leber and the nurse Gertrud Anthal, taken a few weeks before they left, shows the Noldes wearing expressions of eager anticipation. Commissioned to study the health of the colonies' native populations and the reasons for their declining numbers, the party left Berlin in early October, travelling by train to Moscow and onwards by the Trans-Siberian Railway via Manchuria to Korea; they then visited Japan and China before travelling to their destination via the Philippines. Nolde prepared carefully for their travels and the records he was commissioned to make, sending ahead oil paints, canvases and an easel, and equipping himself for the journey with a stock of watercolours, Indian ink, crayons, chalk and thin stable paper, as well as a supply of pens, pencils and brushes. During their travels he worked tirelessly and conscientiously to assemble records of the people and places they saw.

Nolde's drawing chalks while
in the South Seas
photograph
Nolde Stiftung Seebüll

Nolde's legacy from this official expedition, cut short as it was by the opening salvoes of the First World War, comprised a large cache of images that form an invaluable record of the life of the New Guinea islanders of the time. Although he travelled with motives very different from those of Paul Gauguin, who first visited the Caribbean island of Martinique in 1889 and Tahiti in 1891, settling there in 1895, both artists were distressed by the evidence they met of the infiltration of the European lifestyle and mores on the native peoples and their culture. Gauguin, who went originally in search of new, 'exotic' and above all marketable subjects for his paintings in the sophisticated salerooms of Paris, made a serious and sustained attempt to understand Tahitian history and the beliefs underlying the islanders' lives. Nolde, meanwhile,

was already mesmerised by non-European art forms, and an earnest search for their origins was certainly an important motivation. On the journey there, however, he was disappointed to find that European consumer goods were supplanting local products in many countries, and in New Guinea itself, which had been colonised by Germany under Bismarck from 1871, he was to find that Europeans constituted a somewhat unwelcome presence. With the native population numbering around forty thousand, almost a thousand European administrators, planters and traders were engaged in the lucrative production of copra.

As well as Nolde's visual record of their journey, we have Ada's written recollections, dedicated 'To my beloved painter husband'. Characterised by a spirit of adventure and laced with many frank observations of the peoples and behaviour they encountered, these were written with the intention of giving talks to schools at home. Leaving Berlin on 2 October 1913, the party took the train to Moscow, where they marvelled at the Kremlin, and travelled on through the Ural Mountains to join the Trans-Siberian Railway at Chelyabinsk. As they progressed through the seemingly endless steppes, bearded Tartars in huge sheepskin coats appeared at the stations and were often found sleeping in the railway waiting rooms, glad of the warmth they offered; Ada noticed that the train's compartments were heated by 'silvery white birch logs'. Travelling on past the cities of Omsk and Tomsk in lands inhabited by various nomadic peoples, they reached Irkutsk and Lake Baikal, the beautiful 'holy lake', where they watched seals swimming.

Reaching Manchuria, where the Chinese Railway began, they were pleased 'to look into the face of the first Chinaman with his long pigtails and slanted eyes'; in Harbin, they left their train, which was completely covered in dust from the Gobi Desert, to transfer onto luxurious Japanese Pullman carriages, for it was Japan that held sway in this region. To reach Japan they travelled across Korea to its capital Seoul, which the Noldes found delightful, with its peaceful palace and lotus ponds and inhabitants neatly dressed in light blue, green or white coats and white trousers. Once in Japan they were invited into people's homes, and were impressed by their simple, clean houses decorated with pictures painted on silk. Determined to make the most of their time there, they visited both Shinto and Buddhist temples and travelled inland by horse and donkey to within sight of Mount Fuji.

Arriving in China, they found Beijing a busy and noisy city, but were fascinated by the variety of its inhabitants, from coolies to scholars. They took the train to the Great Wall, then set off on horseback to wonder at the Ming tombs in their remote, sombre valley surrounded by mountains. They travelled on to Hankou at the mouth of the great Yangtze river, from where the produce of the inner Yangtze region is shipped, and then inland along the wide, turbulent Han river, busy with shipping and crowded with Chinese people who had made their homes on the water. All the while Nolde had been sketching the inhabitants of the different countries in watercolour and pen and ink; now he was fascinated by the countless junks – sailing boats of ancient design whose many-battened sails enabled them to skilfully navigate the river's fast, tricky currents. When the sun suddenly appeared through the clouds,

wrote Ada, her 'painter husband came into his own'. Working at speed, he made numerous fluid, washy watercolour sketches of the junks with their sails of different colours.

On reaching Hong Kong the party boarded the *Prinz Valdemar* bound for New Guinea. They sailed via Manila in the Philippines and experienced more than one tropical rainstorm before duly arriving in the German colonies. At Madang they saw their first islanders, tribesmen invited aboard to meet the Europeans. The Noldes were intensely moved by their first sight of native people whose way of life had changed little through the ages, and whose customs and lifestyle were, in fact, considerably more primitive than those of the Tahitians immortalised by Gauguin. With their dark, glistening skins, long braided hair and noses pierced with teeth or curved pieces of bone, to the Noldes they were indeed representatives of still-primitive peoples 'emerging from their primeval forests'.

The party sailed on to Rabaul, the main settlement in German New Guinea, arriving there in late 1913. Based there for several weeks before travelling inland and to the other islands, Nolde set to work, producing both a number of chalk drawings of plants and scenery and, using watercolour and Indian ink, a gallery of portraits of natives willing to pose for him. Once home, he would select some of these to work up into more finished oil paintings. These varied, vivid likenesses, which well relay the islanders' dark, luminous eyes and uncertain and uncomprehending expressions, are distinguished by his obvious sincerity in recording them. No two are alike, for Nolde selected men and women with different ornaments or accoutrements: some wear headscarves or flowers in their hair, or ornaments such as earrings or necklaces made of bone or shells, some are bearded, some are young and others old; and they are variously painted face-on, in three-quarter profile, or in profile. *Jupuallo* (1914), showing a young man with two scarlet flowers pinned in his hair, is especially magnificent, while the colourful *Native with Red Hair* (undated) has long coral locks and a scarlet necklace. The subject of *Native (Green and Red)* (also undated) wears a necklace fashioned from sharp, pointed teeth, and his face seems to reflect the light of a nearby fire. In all, Nolde painted fifteen such portraits, which the German government later acquired from him for a handsome payment.

In early January 1914, allotted five horses and the services of Professor Ludwig Külz,[26] with his intimate local knowledge, they began their expedition to the interior of the island to investigate its various native peoples. This would be a precarious journey through thick forests to villages of bamboo huts roofed with palm leaves, whose inhabitants were sometimes friendly and sometimes hostile, with a furious beating of drums relaying their progress and announcing their imminent arrival at a village. As they travelled, the Noldes learnt of the islanders' worship of evil spirits and their 'tender and moving' love of the moon; and, importantly for the artist, they witnessed several sessions of wild, rhythmic dancing. Nolde made brisk watercolour sketches, too, of native life: family groups, women with children, men walking by the sea or fishing, lighting fires, etc. Yet he also became aware that many native artefacts were disappearing: in a letter to Osthaus in March that year, which he copied to Sauerlandt in Halle, he wrote angrily about their appropriation by European collectors and museums.

The Noldes' return journey began in May, as they sailed home via Java – where they attended a local wedding – Rangoon and Mandalay in Burma, where they watched a performance of Burmese dancing, Malaysia and Ceylon. In Aden, they heard of the assassination of Archduke Franz Ferdinand of Austria and the opening hostilities of the First World War. After a problematic onward journey by boat and train, they arrived in Berlin on 7 September, and from there made their way to Als.

Nolde was not the only Brücke artist to journey to the South Seas. Among the collections of Dresden's Ethnographic Museum, the carved and painted wooden clubhouse beams from Palau, acquired for the city by Carl Semper in 1861–2, had attracted particular attention from the members of the Brücke. Admiration for these, together with the example of Gauguin's visual idealisation of Polynesian life, inspired Nolde's one-time fellow artist, Max Pechstein, 'to leave Europe and seek out the Elysian Fields in Palau'. In the spring of 1914 he set sail for the Palau islands, which had been taken over by Germany in 1899. Most of the spirited and evocative pencil and pen-and-ink drawings he made there were lost in wartime Berlin, but his memoirs record his experiences.[27] Unlike Ada's account of the Noldes' expedition, Pechstein's recollections were tinged with idealism, as indeed were his impressions at the time. Although there had been relatively little commercial exploitation by Europeans on the Palau islands, the traditional clubhouses he sought out had, in fact, become dens where men absented themselves from their families and often sold their daughters into prostitution. Yet Pechstein chose to write of the island's 'unsurpassed natural lushness… where huge butterflies flutter about', and described the natives, whom Semper had indeed noted as dignified, gentle and childlike, as 'slim bronze beings in their godly nudity'. In writing in this way Pechstein demonstrates a lesser consciousness than Gauguin of what Jill Lloyd has called 'the fissure between imagination and experience, between myth and reality'.

Nolde's months away had given him a store of memories on which he drew for many years. His assiduous recording of the places, and especially the people they saw, meant that he assembled a great many works, including sketches of burly Russians, delicate figure studies of locals in the Far East, and his many watercolour portrayals of the islanders whose lives he and Ada were privileged to share for a while. Soon he was able to work up some of these into oils, a project that resulted in works such as *Two Siberians* (1915), which showed a man and woman huddled together and muffled against the cold, and *Three Russians* (also 1915), a study of three men, evidently from different parts of the Russian empire, wearing heavy fur hats. As well as his paintings of islanders, he made a number of oils recording the splendid tropical sunsets he had witnessed in the South Seas, including a scene showing small boats anchored in a bay, *Nusa Lik* (1914), with its large, decorative, rhythmic areas of blues and greens, and the magnificently hued *Red Evening Sky* and *Evening Glow* (both 1915). In *Tropical Sun* (1914), the scarlet sun hangs in a flame-red sky, reflected in a glowering deep-green sea. Other oils feature palm trees swaying in the wind close to shores on which white-crested waves are breaking.

Bay
1914
oil on canvas
70 × 104 cm
Nolde Stiftung Seebüll

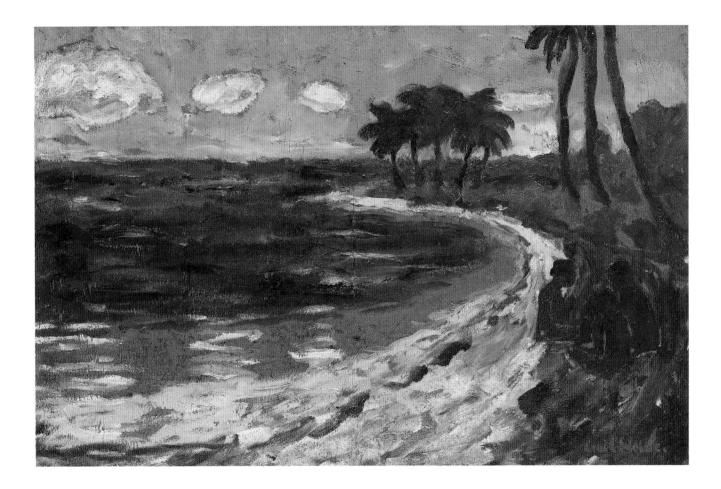

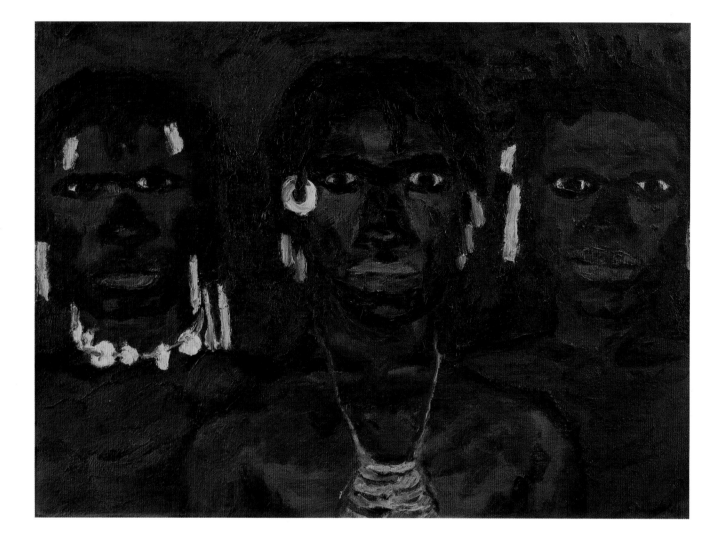

Nolde's feeling for the primitive peoples he lived among is perhaps best shown in *Papuan Family* (1914) and *New Guinea Tribesmen* (1915). The former shows the splendid figure of a father, his hair dyed orange and yellow, standing close to his wife, who holds their baby in a red papoose, the fringe of her own hair carefully separated into decorative strands. *New Guinea Tribesmen*, too, has a certain magnificence: here three native tribesmen are seen full-frontal, their dark skins enhanced by assorted yellow-gold ornaments. Two later woodcuts made in 1917 also seem to incorporate Nolde's compassion for the islanders: unlike his more decorative 1912 woodcut *Man and Woman*, in which two natives wearing patterned skirts sit on the ground in front of a starry sky, *Family* and *Conversation* show islanders squatting on the ground, semi-naked, their facial features greatly exaggerated. Unable to read or to travel, and unaware of the concerns – and delights – of the civilized world, they talk animatedly amongst themselves.

New Guinea Tribesmen
1915
oil on canvas
73 × 100.5 cm
Nolde Stiftung Seebüll

There were other travels, too: in 1921, for instance, Nolde journeyed abroad extensively, expressing particular interest in the life and customs of the Spanish gypsies, and in 1924 he and Ada visited Venice, Arezzo and other Italian cities, and also Vienna. Having also spent time in Paris and England, Nolde was considerably more urbane than he would have us believe from his autobiography. His exposure to the art treasures of Italy and France, however, served to reinforce his opinion of himself as an inherently German artist. According to Ada, 'the land of Donatello and Piero della Francesca… Dante, Titian and Leonardo da Vinci… the land of German longing',[28] made an unfavourable impression on him: he found the Italians frivolous and the landscape unappealing, and the bright sunlight troubled his eyes. More than once he expressed his dislike of Paris as 'the city of modernism'. Nolde's comments on Impressionism were more than a little acerbic: writing to Hans Fehr in 1911, he commended Manet, Cézanne, Degas, Gauguin and Van Gogh, but said how distasteful he found 'the sweetness' of Monet, Renoir and Sisley. These views were repeated in the first volume of his autobiography, in which he stressed how little the art of Monet, Renoir and Pissarro appealed to his 'rough Nordic nature'.

Nolde deeply regretted that it should be French art, rather than German – or Nordic art – that was breaking the artistic mould. He believed that artists were formed by the land in which they were born, and that once their art became diluted by other influences it was in danger of losing its integrity. Such nationalistic views may not accord well with the prevailing beliefs today, but they were ones that Nolde held with conviction.

Family at the Edge of
the Woods
1913/4
watercolour and Indian Ink
34.7 × 48 cm
Nolde Stiftung Seebüll

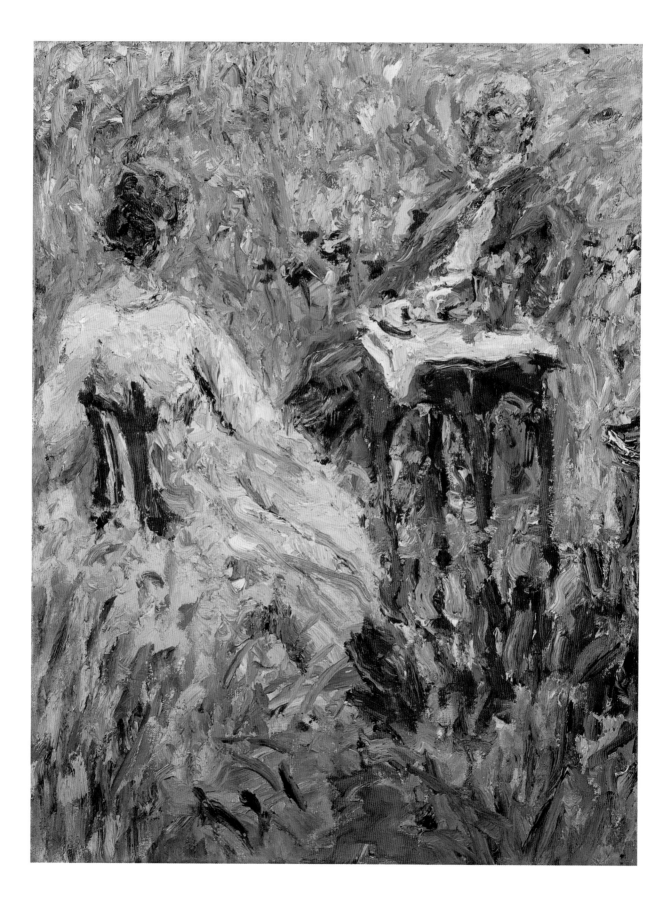

8 Flowers and Gardens

Nolde, usually quiet and pensive, could become rhapsodic at the sight of his garden in bloom. His love of flowers was heartfelt, reviving memories of his childhood and comforting him at times of uncertainty, and his observation of their brilliantly coloured blooms was instrumental in the development of his skill as a colourist. He had an absorbing interest in the life cycle of flowers and what he called their destiny, and this mindfulness of their endless cycle of birth, growth and death was one element of his pantheistic relationship with nature. In his autobiography, he wrote of his love for 'the purity of their colours... their shooting up, blossoming, glowing, bringing joy, drooping, fading... and ending on the rubbish tip'. Like the Dutch and Flemish artists who painted floral still lifes centuries before him, Nolde recorded flowers in full bloom so that their beauty could be enjoyed all winter.

In each of the homes they bought, he and Ada were quick to plant up their surroundings, creating an abundant garden at Utenwarf and a carefully designed horticultural area at Seebüll. The small cottage they rented on Als from 1903 onwards was surrounded by woodland and had no area they could cultivate, though roses climbed up to the eaves and bloomed against its front walls, and in Nolde's affectionate portrait of his wife *Spring in the Room*, which was painted here in 1904, Ada sits surrounded by pots of flowers. Nolde took pleasure in his neighbours' small but fertile, colourful and lovingly tended gardens, and portrayed them often. The villagers were knowledgeable gardeners and knew how to make their gardens flourish until late in the year, so that they were especially colourful in autumn. Gustav Schiefler, visiting them on the island one summer, watched the artist at his easel painting flowers in a nearby garden. He described how Nolde positioned himself among 'a profusion of stocks and asters, pinks and carnations', and noticed that as he and Ada talked, the artist grew quiet, 'his eyes glowing with pleasure as he applied one colour after another, subjecting the confusion of colour to the logic of form'.

Nolde was conscious that his pictures of flowers and gardens were easier on the mind and more readily appreciated than much of his other work, especially, perhaps, his religious subjects; indeed, many people come to his art via his flower paintings. Later, he would recall

that his own pictorial language began to be formed as he first immersed himself in painting the clear, bright colours of the flowers in the gardens of Als. A lingering admiration for Van Gogh's bold application of paint also played a part in the genesis of his early garden paintings, for these briefly echo a work owned by Schiefler, the Dutchman's *Flowering Garden* (1888), with its swathes of flowers in different colours. Nolde's appreciation of Van Gogh's prowess was shared by the expressionist Christian Rohlfs, with whom he worked for a brief while at Soest in 1906. But above all, it was Nolde's own sensual appreciation of the colours of the flowers themselves that began to unleash his ability to employ colour so brilliantly.

Among Nolde's first garden paintings were those of several belonging to his neighbours, in which he sometimes included figures. In the loosely painted *Young Woman Reading* (1906), the woman's figure and the cottage wall are drenched in bright sunlight; the undated *Flowering Lilacs*, showing a sunny pathway lined with lilac bushes leading to a row of cottages, is as joyous as any of the Impressionists' offerings. Such works exemplify Nolde's early painterly experimentation, in which he evidently glanced towards both Impressionism and pointillism.[29] It would, after all, have been surprising if he had not been conscious of Monet and Renoir's many pictures of gardens, and the subtle effects achieved by Seurat, with his new style of painting. While Nolde's approach in *Roses in Front of the House* (1907) is highly impressionistic, his *Young Woman* (also 1907), showing a woman in a red and blue dress standing in a flowery meadow, is rendered in small, distinct, pointillist dabs of colour. 'Portraits' of gardens included *Trollhois Garden* and *The Burchards' Garden* (both 1907), which showed tightly planted, multicoloured flower beds. In these paintings, with their streaky paintwork, individual species of flowers are not always distinguishable, but in the latter a tall yellow standard rose and orange tiger lilies can be seen.

Quite quickly, in painting these garden scenes, Nolde moved through this early stage to evolve a method of applying pure, contrasting colours. The beginnings of this change can be seen in *Conversation in the Garden* and the charming *Anna Weid's Garden* (both 1908). The former shows a woman in a cream dress and a man wearing blue talking among a profusion of flowers; *Anna Weid's Garden* has been sown with pink and mauve flowers interspersed with small yellow ones, which bloom in front of blue-leaved plants, presenting itself as a tapestry of contrasting hues. Also marking this development is *Flower Garden with Seated Woman* (1908), which shows a woman sitting at the end of a path, allowing the borders of huge, deep-red oriental poppies, with their blue-green leaves, to claim our attention. In the appealing *Large Poppies* (1908), a drift of deep-scarlet blooms emerges from blue-green foliage and seems to move across the picture plane from left to right.

The Noldes returned to Germany after their journey to the South Seas in 1913–14, and the wartime summer of 1915 saw the production of numerous flower pictures in which, rather than presenting 'tapestries' or 'carpets' of colour, Nolde focused increasingly on distinct, recognisable species, as if to cherish their blooms. Not unexpectedly, the move in 1916 to Utenwarf, where they renovated an old Frisian farmhouse and built a beautiful

Ripe Rose Hips
undated
watercolour
45.6 × 34 cm
Nolde Stiftung Seebüll

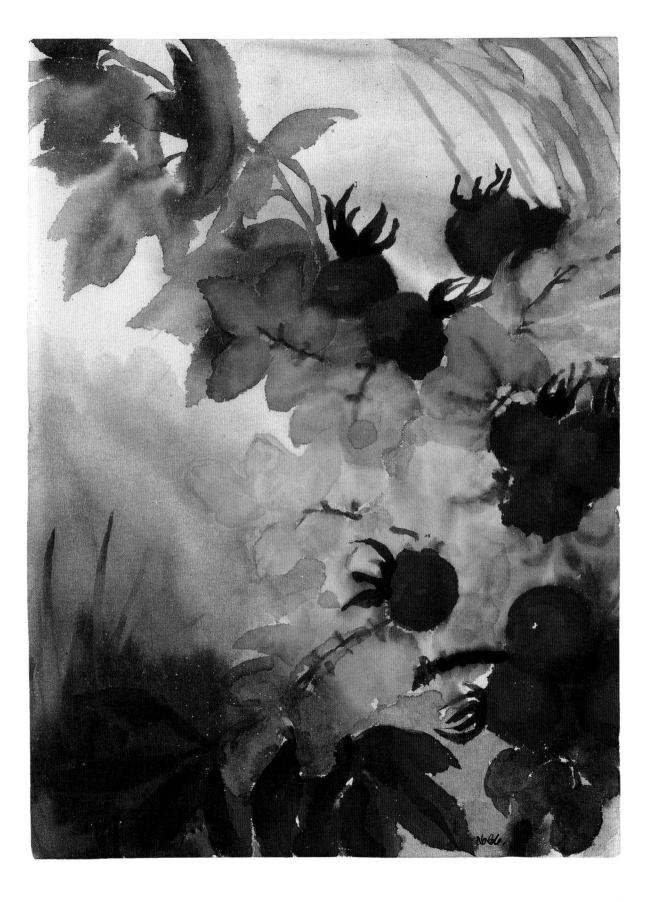

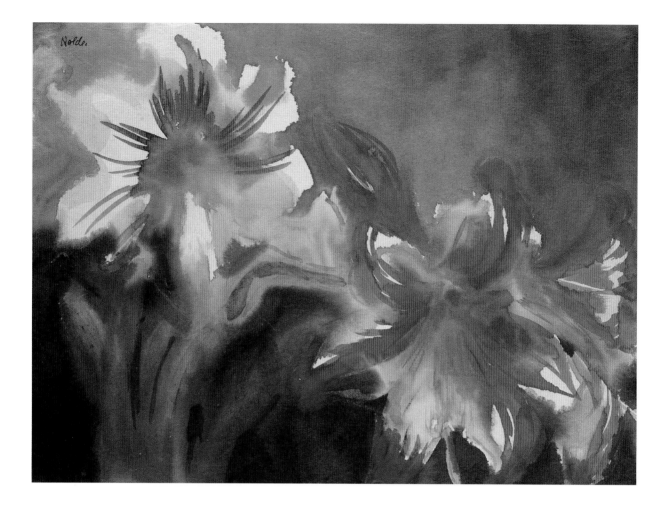

garden, engendered a further spate of paintings as the garden there became established. As Nolde worked hard on its construction, he and Ada carefully chose which varieties they wanted to grow around their home, and in later years they were gratified when villagers from near and far made pilgrimages to look at varieties of flowers they had never seen before. In these paintings from 1916, which portray individual varieties or species of flowers, Nolde almost always selected brightly coloured blooms. In very few of these studies of flowers is there any particular sense of perspective or suggestion of a spatial context; instead, they are orchestrations of colour or compositions celebrating the beauty of the flowers. *Flower Garden with Roses, Calendulas and Tiger Lilies* (1917) is a symphony in orange, red and cream, while in other works tall, statuesque flowers appear. Nolde's beloved pink, red, mauve, white or scarlet poppies often feature as 'cloud' shapes, while taller lilies, larkspur, foxgloves and gladioli are employed to act as verticals, for instance in works like *Flower Garden with Foxgloves* (1917). In *Marguerites and Lilies* (1917) the lilies tower behind the smaller marguerites, and in *Flower Garden with Foxgloves and Tiger Lilies* (1920), tall spires of foxglove curve in front of a bed of tiger lilies. In *Woman and Little Girl* (1918), which shows a woman and child in a floral

White and Red Amaryllis
undated
watercolour
33.5 × 45.6 cm
Kunsthalle Hamburg /
Bridgeman

setting, the flowers are almost as tall as the little girl. *Flower Garden, Lilac and Red* (1920) combines two of Nolde's favourites, as pale, shimmering plumes of foxglove rear up in front of a bed of deep-red poppies.

On a few occasions, Nolde painted exotic species that were unfamiliar to the local people, or varieties that simply did not usually grow there. The small chalk sketches he had made while travelling in the German South Seas in 1914 included one of deep-pink crocuses, measuring only 8.5 × 13.7 cm, which he worked up into his much larger oil painting *Crocus Blossom* (1914), measuring 70 × 111 cm. Here, the pathway, thickly carpeted with crocus blooms, has a rich pink colouration that contrasts with the deep-green leaves of small trees lining it on either side. Another appealing oil painted on this journey, this time in New Guinea, was *Hibiscus and Red Shrubs*. Here the red hibiscus and deep wine-red foliage of the shrubs are set off by the yellow-green foliage behind them.

In 1920, perhaps in wintertime, Nolde embarked on a series of still lifes that included flowers. These were not floral still lifes per se, but ones in which containers of colourful blooms were juxtaposed with ceramic figures and other artefacts he had collected from different countries. *Parrot and Poppies* features a glazed ceramic bird and deep-red poppies; *Figure and Dahlias* a china-clay figure of a standing woman; *Bird and Dahlias* a tall bronze statuette, perhaps from Persia. In *Madonna and Dahlias* a baroque German wooden carving stands on a woven cloth from Nolde's native region of North Schleswig, decorated with stylised flowers and animals; in the striking and colourful *Still Life with Striped Goat*, a curious brass figure of the sun, perhaps from a South American civilisation, seems to stand guard over a green and white glass goat, while behind is a yellow bowl of red and mauve poppies. In none of these attractive compositions, however, do the flowers themselves take centre stage.

During the winter of 1923–24 Nolde visited Berlin's Botanical Gardens, and that same season painted a number of still lifes that included foreign and exotic plants, with items from his collection accompanied by magnificent orchids, strelitzia and flowering cactuses. A year or two later, in autumn 1925, Nolde painted two atmospheric seasonal scenes. Based on small preparatory chalk studies, *Autumn Glow* and *Autumn Garden* show his garden on late autumn afternoons with the crepuscular light enhancing their deep, glowing colours. In the former, beyond a bed of marigolds, a red bush and two yellow ones are caught in the day's late sunlight against a darkening sky; while in the second composition, thickset clumps of blue swamp iris, together with red and yellow bushes, screen off the early evening sky.

From 1926 the design of the new garden at Seebüll occupied much of Nolde's time. Its heavy clay was improved by mixing it with sand, and fences of wild plum, hawthorn and blackthorn were planted to create a microclimate in which his favourite species could flourish. After experimenting with several designs, Nolde hit upon a system of pathways incorporating the letters A and E to signify his wife's and his own names, linked by a small area of water; as the garden grew to maturity, he described his feelings of joy as he walked among its radiant blooms.

In the summer of 1928 Nolde noted that the sunflowers grew unusually high, so that he had to lean his head back to admire them. His experimentation with autumn subjects a few years earlier was now followed by many paintings of these monumentally tall, statuesque plants. These particular works are often thought to reveal Nolde's admiration for Van Gogh, for he continued to attend exhibitions of the Dutchman's work in the 1920s and 30s, long after the period in which the Brücke artists had so revered him. Van Gogh's now world-famous *Sunflowers* pictures, created at Arles in 1888 and 1889, however, have not always been quite such iconic favourites, and it was probably just as much Nolde's love of his sunflowers' tall habit, dusky centres and bright yellow petals that set him on this path.

Nolde's sunflowers are given many different personalities, shining brilliantly, nodding down at other species, leaning over with ruffled petals, shaking in the breeze, rearing up behind other flowers, or seemingly watching over them in paternal fashion. His early *Tall Sunflowers* (1926) seem to smile; the three flowers in *Sunflowers in the Wind* (also 1926) are bent in a gust of wind as clouds speed across the sky; in the still life *Dahlias and Sunflowers* (1928) two heavy yellow blooms lord it over the splendid red and white striped dahlias; in *Large Sunflowers* (1928) their leaves curl over; in *Sunflowers I and II* (1928) they are shown full-frontal, in various stages of flowering; in *Blue Sky and Sunflowers* (1928) they struggle to stand upright on a windy day, below bright blue heavens. In *Yellow and Brown-Red Sunflowers* (1935) a single yellow flower-head looks out of the picture, while the other, darker ones are seemingly upstaged, and shy away from the viewer. In the late *Large Sunflower and Clematis* (1943) the golden yellow head of a sunflower is combined with small, delicate, inky-blue clematis blooms.

Between painting these many canvases, Nolde worked on watercolours of floral subjects, often on Japan paper. Nolde seems to have begun painting these in the mid-1920s, finding the medium of watercolour much to his liking. Always impulsive rather than methodical, he relished being able to apply the paint quickly and with great fluidity; indeed, it suited his temperament admirably. Nolde's floral watercolours are among his most attractive works, and in them his ability as a colourist comes to the fore. These paintings usually represent just one species and give no suggestion of location, so that the eye immediately focuses on the flowers' good looks: huge red and mauve poppies; red, purple and ink-black tulips; bright dahlias; or clouds of ethereal white roses or magnolia float across the picture's surface. In others, creepers with colourful foliage or clusters of scarlet berries climb upwards, accompanied by flowers such as tiny, nodding blue clematis flowers, and phlox, asters, yellow and purple iris, lilies and large, impressive sunflowers are on parade.

Nolde's colours, with his favourite reds, deep mauves, lurid greens and brilliant yellows, have been called Fauvist. Though this palette may have unconsciously echoed that of Fauvist artists such as Matissse and Derain, Nolde used 'hot and holy' colours because they were among his favourites. He always maintained that an artist should be guided by inspiration rather than knowledge. In 1908, as his friend Hans Fehr recalled, he defended his use of such radiant hues:

Large Sunflower
and Clematis
1943
oil on canvas
67 × 88.5 cm
Private collection

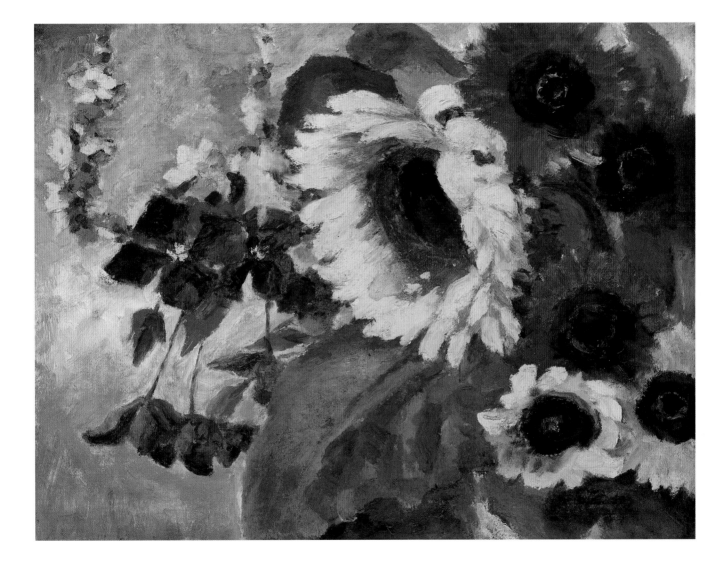

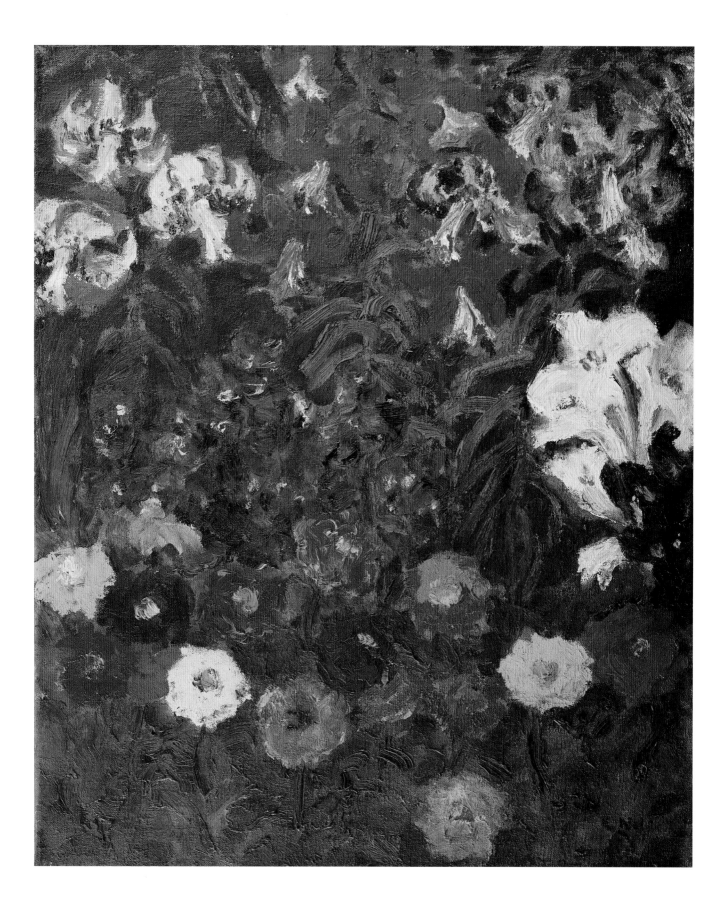

Zinnias and Lilies
1931
oil on canvas
88.5 × 73 cm
Nolde Stiftung Seebüll

Large Poppies
(Red, Red, Red)
1942
oil on canvas
73.5 × 89.5 cm
Nolde Stiftung Seebüll

once, criticised by an onlooker for exaggerating the colours of the flowers he was painting, he moved his easel into the flower bed to demonstrate that the colours of their petals outshone the ones on his canvas. In many later flower pieces, in fact, he deviated from his tendency to use primary colours, using mixed tones to great effect, for instance in *Peonies and Iris* (1936), where the great creamy-whites 'bowls' of the peonies are neighbours to bronze, ochre and wine-coloured irises. *Love-lies-bleeding* (1939) capitalises on the deep, dusky blood-red of this tall shrub, combined here with the flame orange of tiger lilies behind a scattering of golden marigolds. Clear reds were undoubtedly the colour that Nolde found most inspirational. He remembered the 'noble' red roses in his mother's garden; at Utenwarf he was gladdened to see the 'waves of red roses' he had planted in full bloom. A painting he made in 1942, showing a group of pale pink poppies and taller scarlet ones, with larger blooms in flower against a pale summer sky, was entitled *Large Poppies (Red, Red, Red).*

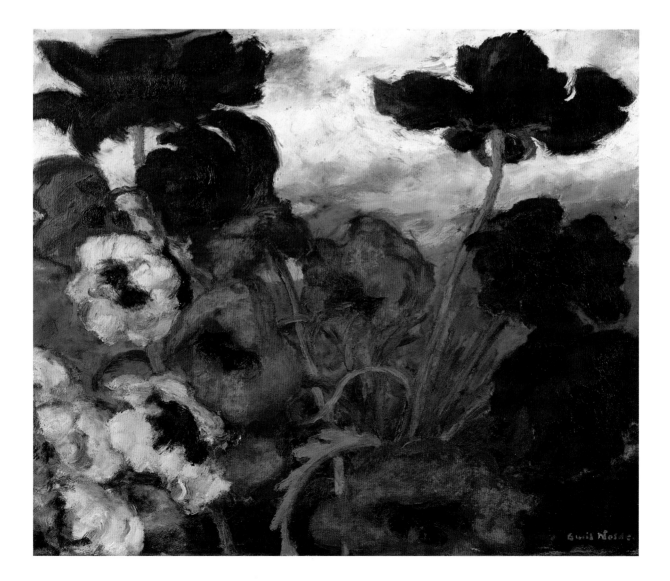

Nolde's passion for flowers, which stemmed from his childhood, lay behind the creation of some of his most affecting images. Often at odds with a father who wanted his son to dismiss his artistic leanings and throw himself into work on the family farm, Nolde recalled loving visits to his mother after his father's death. During these visits, when, in his memory at least, the sun was always shining, they walked in the garden together so that his mother could show him her newest blooms, 'burgeoning, blossoming, radiant'; on other days, suffused with happiness, he watched her working at tasks such as pruning roses.

Nolde's paintings of flowers reveal a sensitive, more feminine side of his personality. One oil painting in particular, which was based on a watercolour made a little earlier, seems to encapsulate his love for them and for all young, growing things. In *The Great Gardener* (1940), we see the face of an elderly, bearded Creator tending his garden, looking down lovingly at his plants and gently touching the top of a small, spindly sapling with his fingers. Within Nolde's oeuvre only occasional pictures of parents and their young children – for instance *Family* (1931), *Little Son* (1932) and *Adoration of the Magi* (1933) – are characterised by such tenderness and solicitude. In *Family* there is a sunflower at the top right-hand corner of the composition, watching over a mother and father; their heads incline towards their baby, and he smiles up at them and reaches out his arms to his mother's face. *Little Son* shows a mother looking adoringly at her small child, who stretches up to touch her lips with his hand. In *Adoration of the Magi*, while the three kings look eagerly at the newborn Christ-child, his mother, dressed in a blue robe, bends her head downwards to rest her chin on her baby's head. And in a painting featuring both flowers and the young, *Woman and Little Girl* (1918), the gentler side of Nolde's nature is again evident: here a woman kneels with her little girl, holding her hands in front of a bed of many-coloured gladioli.

The Great Gardener
1940
oil on canvas
71 × 56.5 cm
Sprengel Museum, Hanover

Emil Nolde.

9 Graphic Works

The graphic medium was one in which Nolde excelled. Though he was thought of as a colourist, he discovered in the woodcut, etching and lithograph – most usually printed in black and white – alternative means of expression that appealed strongly to his creative impulses and allowed him to make many distinctive images. In Nolde's print works he returned to the themes that preoccupied him in his oil paintings, including the dance, religious subjects, fairy tales and the fantastical, and meetings (or confrontations) between people. In each technique of graphic reproduction his approach was intuitive and unorthodox, as he pushed the boundaries of conventional procedures to their limits. Indeed, his precise ways of working have mystified scholars and defied classification.

He had begun an apprenticeship as a cabinetmaker and wood carver as far back as 1884, and then continued to work for various furniture companies, so it was somewhat surprising that Nolde did not begin to produce woodcuts until 1906. Karl Schmidt-Rottluff introduced him to the art form when the two artists painted together that summer on Als, and Schmidt-Rottluff also arranged the delivery of a printing press for his friend. Nolde quickly mastered the technique, and soon began to revel in its creative possibilities. In each instance, rather than beginning with a rigid concept for his design, he would build on the unique character of a particular block of wood, once speaking of 'its diverse and charming grain'. (The Norwegian Edvard Munch, whom as we have seen Nolde greatly admired, worked similarly: in *The Kiss* (1897), for instance, the vertical striations of the wood and a knot are clearly visible in the finished print, adding to its impact as the two tall figures clasp each other closely, forming a single upright.) Developing an original, highly expressive language of his own, and preferring to be ruled by chance, Nolde deliberately avoided creating perfectly even impressions, so that no two prints were exactly alike.

Unlike those of the Brücke artists Kirchner and Pechstein, Nolde's woodcuts derive their power and authority mainly from contrasting areas of dark and light, black and white, rather than the finely incised line or intricate design. Although the first Brücke woodcuts, especially those advertising their exhibitions, incorporated bold and punchy designs, they

Prophet
1912
woodcut
29.8 × 22 cm
Nolde Stiftung Seebüll

Emil Nolde.

Der große Vogel. Sch. 9 III Ho 7

gradually became more complex. Kirchner's *Bathers Throwing Reeds* (1909), which he printed in black, orange and green, was composed of simple shapes outlined in black, but in later works the precision of his workmanship was much more evident. His finely worked *Head of Ludwig Schames* (1917–18), for instance, relied for effect on the finely carved details of the subject's thick hair and long beard, while in the attractively coloured *Winter Moonlight* (1919) he carefully registered the uneven surfaces of the mountainsides and the snowy slopes streaked with moonlight. Conversely, Pechstein's coloured woodcut *Dancer in the Mirror* (1923), printed in black, yellow, orange and blue on cream wove paper, used the dramatic compositional line to advantage.

In all his prints, Nolde seemed to be most at ease when creating fantastical subjects; early examples of his woodcuts included ten fantasies produced in 1906, of which the most striking example is *Large Bird*, where a small girl confronts a large avian creature and both seem wary of each other. In 1910 he made several woodcuts of steamers, tugs and sailing boats in Hamburg harbour, and two of Egyptian women, making bold use of the medium to characterise them with long, straight dark hair, large dark eyes and ample mouths. His woodcuts of 1912 included *Farm Worker* and the iconic *Prophet*, which is often regarded as his most outstanding work in the medium. In each of these, heavily inked areas form emphatic contrasts to white, uninked ones. Thus the rural worker's rigid, determined expression is aptly recorded, and in the final printing of *Prophet*, which was based on several preparatory drawings, the sage's staring eyes and resolute mouth combine to create an extraordinarily compelling image.

Nolde returned to the woodcut in 1917, imbuing his works with an unusual content and an increased graphic sensibility. While *Fishing Boats* reveals an interest in pattern, with the sails of the five boats arrayed across the picture plane, *Marching Soldiers* is an image of war, unique in the artist's oeuvre. Here, two grim-faced military men, the one in front grasping his pike, march implacably onwards. In *Candle Dancers* of the same year Nolde returned to a favourite theme, that of the human body in ecstatic movement. In this version, candles have been set on the floor and the dancers' legs and short, swinging skirts seem to move in parallel with the flickering flames. Ada often helped him in printing his woodcuts, and together they took great care with this work, wiping some of the ink from areas between the figures so that the grain of the wood showed through, and using blind-stamping (that is, printing with some areas uninked) for their dresses,[30] with only small strips of ink indicating the folds in the fabric. So enthusiastic was Nolde about this work that he produced it in as many as five states, planing down the woodblock between printings.

Nolde produced his first, elementary etchings while studying with Friedrich Fehr in Munich in 1898; it was an art form that he would learn to use with invention and finesse, creating images of which he was justifiably proud. In October 1905, while staying in a pension in Berlin, he worked on a series of eight etchings of fantastical subjects and was delighted as he discovered the technical possibilities of the process. These prints are scarce, and therefore little

Large Bird
1906
woodcut
15.9 × 21 cm
Nolde Stiftung Seebüll

known; they included his *Two Devils*, featuring a pair of creatures who epitomise anatomical ugliness, *Gossip*, in which three sinister figures huddle together, and *Brutal Strength*, again a portrayal of other-worldly beings. Pleased with the results of his efforts, Nolde wrote to his friend Hans Fehr, saying, 'My etchings do not belong to some kind of art that can be enjoyed from a comfortable easy chair – they demand that the viewer leap drunkenly with them.'[31] When he showed them to his acquaintance Max Liebermann, with whom he was to quarrel so bitterly, Liebermann was fascinated, and promised to exhibit them with the Berlin Secession.

The very different etchings that Nolde made in Hamburg in 1910 were greatly admired by Schiefler, who became the artist's firm supporter and confidant, and cataloguer of his printed work. Nolde spent several weeks in the port that spring, fascinated by the activities of its busy harbour, as shipping plied to and fro and wisps of steam and palls of smoke hung over the water. Living in a sailors' hostel, travelling in boats crowded with men and labouring day and night with a printing press he had recently bought and installed in his room, he made a series of etchings of harbour-side views. The etching process involves drawing with a pointed metal tool on a metal plate, usually made of copper or zinc, which is first covered with waxy, acid-resistant ground. The plate is then submerged in nitric acid and water, which bites into the metal where the lines have been drawn, leaving those areas bare. Nolde recounted how, once he had submerged his etching plate in the acid solution, he slept soundly in his hostel bed for precisely the brief length of time required for the process to be completed. After removing the ground, he could ink and print the resulting image. By now he was also experimenting freely with aquatint, a process by which the plate is sprinkled with resin or bitumen granules to create a graininess that generates rich tonal effects. It is likely that, from time to time, Nolde used liquid asphaltum applied with a thick brush.

Nolde's sombre monochrome renderings of the scenes he witnessed in Hamburg are curiously impressive, capturing the harbour's gloomy, forbidding workaday atmosphere. They were, he wrote, 'full of noise and smoke and life'. In his *Hamburg, Free Port* (1910), for example, tall wooden pilings rear up in the foreground, supporting a pontoon where goods are loaded and unloaded, while several working vessels are seen on the water behind. The scene is carefully observed, with the supportive crosshatching visible on the horizontal spars of the tallest pillar, and warehouses standing along the opposite harbour wall. In the starkly dramatic *Wharf, Hamburg*, monumentally tall, dark pillars are placed to the left and right of the composition, towering up above the glistening white planking of the pontoon and the pale, ruffled surface of the harbour waters. In *Hamburg, Reiherstieg Dock* the huge, black stern of a ship looms in the foreground, and several smaller sailing boats are anchored behind, their masts forming sharp verticals against the sky. Here Nolde contrasts not only light and dark, but mass and space.

The mood of *Sailing Boat and Three Steamboats* (1910) is more delicate, its sky lightly streaked with clouds, and small waves moving on the calm and shining sea as a sailing boat draws past the diminutive tugs seen on the horizon. In *Steamboat. Dark Effect* a tugboat is

Wharf, Hamburg
1910
etching on steel
31 × 41 cm
Nolde Stiftung Seebüll

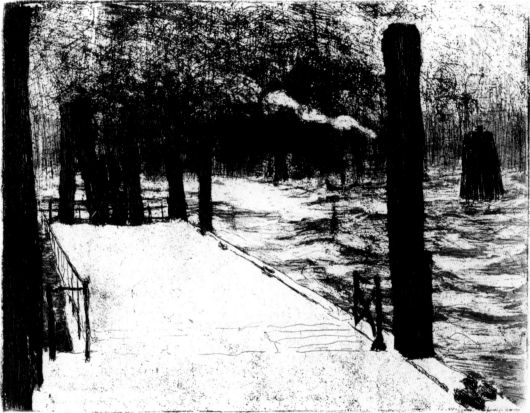

seen powering along below dense clouds of smoke from its boiler, and here diagonal marks across the whole of the etching resemble wind-driven rain. In images like these, Nolde, already adept in his handling of the medium, began to explore its expressive possibilities and to capitalise on his new-found ability to render gradations of tone from dark to light. The methods by which he did so probably included brushing the ground onto the plate unevenly and, as mentioned, applying various aquatint resins, including rosin and bitumen. In the case of *Steamboat. Dark Effect*, he used various tools to draw into its surface, instead of simply outlining contours with a pointed tool or burin. Nolde once bought a length of copper plating used for cladding ships' hulls, intending to use it as etching plates that would incorporate its pitted, corroded irregularities into his designs, but found it workable only when smoothed down by burnishing. Later he often etched on iron, rather than copper, since he found this was cheaper. And like most printmakers, he varied the thickness, colour and quality of the papers on which he printed them.

Nolde's exact contemporary, the Berlin-based artist Käthe Kollwitz (1867–1945), was also known as a fine printmaker. Like him, her great skill enabled her to manipulate the etching plate and lithographic stone to achieve exceptional results. As well as printing on papers of different colours, in some lithographic prints she overworked the print with coloured chalks, or used additional lithographic stones to introduce colour. Believing as she did in an art of realism, though, Kollwitz's ideals were far removed from Nolde's; where his images of Hamburg are aesthetically pleasing as well as realistic, she had no time for 'artistic broodings', as she called the avant-garde and expressionistic. Instead, working in the poorest areas of north Berlin, she aimed to produce art that reached out to its humblest inhabitants, and which would draw attention to their plight. Examples of her work include *Poverty* (1895), *Woman with Dead Child* (1903) and *Out of Work* (1909).

The dance and cabaret scenes Nolde painted in Berlin during the winter of 1910–11 were followed by a small group of etchings of similar subjects, and ballet featured again in the singular *Dance* (1922), in which a lecherous man eyes a naked female dancer. In 1918, a year that saw the production of exceptional, beautifully worked and more philosophical prints, Nolde's etchings included the religious subjects *Saul and David*, *Solomon and his Wives* and *Christ and the Sinner*. Two others from that year are of especial interest: *Great Farmers* and *Friend of the Animals*. Both are given dense, grey backgrounds, against which the finely drawn figures show up to advantage. In the former, three farmers are portrayed close to the picture plane in earnest discussion, their heads seeming almost caricatures. In the latter, which brings to mind St Francis, the tall figure is seen in profile, holding a bird in his hand as he watches two young horses prancing in a distant field. These etched images are delicate, with overtones of fantasy and a refinement that sets them apart from Kollwitz's monumentalism.

If perhaps less impressive than his woodcuts and etchings, Nolde's lithographs were also highly accomplished. Lithography had been developed in Germany in the 1790s, becoming popular in the early nineteenth century. Based on the principle that oil (or grease)

Friend of the Animals
1918
etching on iron
20.8 × 26.5 cm
Nolde Stiftung Seebüll

and water do not mix, it involves the use of a flat, porous, finely grained limestone or zinc plate. The artist draws the design onto the stone with a greasy lithographic crayon or pen, and during the printing process dampened paper is pressed onto the stone. The oily lithographic ink adheres just to the lines of the drawing and the blank areas remain uninked.

In Paris in 1899 Nolde was able to study the lithographic work of Honoré Daumier, becoming fascinated by their large planes of light and dark. In 1907, his interest fuelled by his admiration for Edvard Munch, Nolde made a series of lithographs of his own, including the sombre *Dark Head of Man*. That December Schiefler, who was working on his catalogue of Munch's graphic work, arranged for the two men to meet in Berlin. Sadly, Munch was the worse for wear from alcohol and singularly unforthcoming, so the meeting was brief and inconclusive. Nonetheless, Nolde remained among his many admirers. Munch, too, was from a rural farming community, raised in an ascetic, pious household in south-east Norway. He was an early witness of domestic tragedy, for his mother died at home of tuberculosis when he was five and his sister Sophie of the same illness a few years later. While his mother's last words to her young son instructed him 'to strive for things above, and not for things on earth', his father's religious fanaticism was so extreme that Munch claimed that it sowed in him 'the seeds of madness'. His childhood experience of prolonged illness and death would resound in his art, particularly in the works he produced before 1900, including the melancholy *Spring* (1889), *Chamber of Death* (1894–95) and *The Sick Child* (1895–96).

The year 1896 saw Munch in Paris, a venue that would inspire much of his most famous graphic work, for the city was the centre of a brilliant renaissance in European printmaking. Art nouveau was in the ascendant, with its emphasis on surface pattern and sinuous line, and through the launch of the *Revue Blanche*, Bonnard, Vuillard, Valloton and above all Toulouse-Lautrec conspired to refine and popularise the technique of colour lithography, using more than one stone to print additional colours. Most of all, Munch was impressed by Lautrec's stylish and ingeniously designed music-hall posters, quickly mastering the process himself. Appropriating Auguste Clot, the expert printer used by both Lautrec and Bonnard and also the Impressionists, and sitting with his eyes closed, he dictated to him new variants in the colour reproduction of his designs as they were prepared for the printing press. Munch's lithographic work had a boldness and severity not found in that of his Parisian contemporaries. Whereas Vuillard's designs resulted in a tapestry-like effect, and Lautrec's lively, flamboyant approach to poster design was unmatched, Munch's lithographs, with their bold shapes and economy of line, had a sombre beauty of their own. His *Madonna*, which he printed in many different versions between 1895 and 1902, remains an iconic image. In one of the most attractive printings, her pale, creamy torso and seductively tilted head are surrounded by flowing waves of dark hair, while highlights of blue and red hint at the erotic rather than the divine.

It was not until 1913, when he had the use of a lithographic workroom in Flensburg, that Nolde approached the lithographic process more scientifically, printing in colour with

Young Danish Woman
1913
lithograph
68.5 × 57 cm
Nolde Stiftung Seebüll

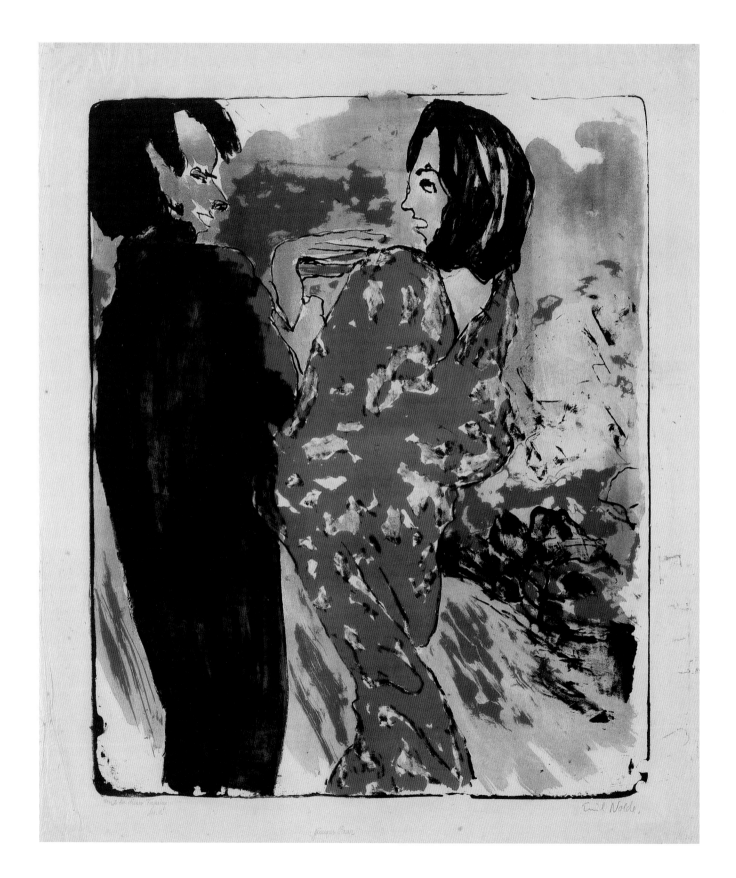

the use of multiple stones in the way pioneered by Toulouse-Lautrec and developed by Munch and Kollwitz. He was excited to have a free rein to experiment, and his skill as a craftsman soon enabled him to exploit the properties of the materials with which he was working. Seized by a mood of feverish creativity, drawing freely onto the stone with the brush and applying and removing colour uninhibitedly, he produced a series of thirteen lithographs, some incorporating as many as five colours. Included among these were the dark, smudgy *Three Kings*; *Mother and Child*, in which the mother bends protectively over her young child, and four female portraits, including one of a young Danish woman into which he introduced a dense green in one of the printings. Two further subjects explored a theme that often recurs in Nolde's output: that of meetings or confrontations. These are the highly animated *Discussion*, with its wildly gesticulating figures, and the famous *Young Couple*, where a young man grasps a woman's arm and they look uncertainly at each other. This he printed more than a hundred times, most notably in black, grey-violet and red on Japan paper.

Among the largest lithographs, and the last he made that year, was Nolde's *Dancer*, measuring 53 × 69 cm and printed in black, red-brown, carmine, grey-violet and grey-green. The image demonstrates his fascination with the subject of the human figure in uninhibited movement, and was intended 'to express emotion and joy': it portrays a dancer lost in ecstasy, her long dark hair tossed to one side, her flesh hot and red, with the diminutive figures of her audience just visible behind. As with earlier drawings made of dancers in Dresden in 1908, while Ada was convalescing nearby, here Nolde succeeds in making the viewer 'feel the dust and hear the music' of the dance floor.

Nolde's prints of fantastical subjects were perhaps those of which he felt most proud; they were among his most cherished prints, and rather than selling them he kept many of them in an archive in his apartment in Berlin. Disastrously for lovers of his work, most of this collection was lost when the Allies bombed the city in 1944. Had this not been the case, his working procedures and his thoughts while creating his compositions would have been accessible to us and better understood. Nonetheless, the beauty and refinement of much of his graphic work is widely admired and the innovative nature of his working methods commended. As he himself wrote to his friend Hans Fehr: 'Every true artist creates new values, and a new beauty...'[32]

Young Couple
1913
lithograph printed in black, red, violet-grey
62 × 50.5 cm
Nolde Stiftung Seebüll

10 Watercolours

It could be said that there was a certain affinity between Nolde's own slightly wayward personality – although he formed lasting friendships, he did not fit easily into society, and in general he found it impossible to work closely with others – and the medium of watercolour, with its far less governable capabilities than oil paint. Since watercolours are much more portable than oil paint, he habitually used them to record people and places when on his travels. And for many of his later compositions, he often chose watercolour with which to portray the sultry, brooding landscape of North Schleswig, with its frequently blurred, rain-swept contours, and to give form to the fantastical, near-mystical visions that, when he allowed them to, filled his imagination.

As a young man, working as a teacher in Switzerland and walking and climbing in the mountains in his free time, he painted the *Bergpostkarten*, his lucrative postcard views of the country's famous mountains, in a combination of watercolour and gouache, in 1895 and 1896. He also made occasional mountain views in watercolour, the most successful being the dramatic *Sunrise* (1896), where a burning red sun, partly obscured by streaks of white cloud, seems to struggle to rise into the sky above a fringe of dark conifers. As we have seen, he later chose to work in watercolour for reasons of expediency, to record performances at Reinhardt's Deutsches Theater in Berlin in the winter of 1910–11, and to hastily capture his impressions of the people and places he saw during his long journey to the South Seas in 1913–14.

While staying at Cospeda, near Weimar, in 1908, Nolde began to use watercolour rather differently. In a series of landscapes made there he used thin washes of paint that sometimes allowed the paper to show through, as for example in *Trees in Snow*. Nolde himself believed that his mastery of watercolour began with these works, for which he used sheets of paper about 35 × 50 cm – indeed, this would become the size of the majority of landscapes he painted in this medium, while for the majority of his landscapes in oil he used canvases sized approximately 73 × 88 cm. His Cospeda landscapes use gentle, appealing colours: while in *Fields under Snow* the snowy land is indicated in soft tones of blue, in *Trees in March* the sprouting leaves of the early spring trees are shown as swathes of orange below a pale aquamarine sky.

Animal and Woman
1931–5
45.4 × 60.8 cm
Nolde Stiftung Seebüll

Gypsy Dancer I
1921
48.5 × 35 cm
Nolde Stiftung Seebüll

In August 1941, following a series of altercations with the National Socialists and in spite of his insistence that his art was German, he received a letter from Adolf Ziegler, president of the Reichskunstkammer, forbidding him to work in a professional capacity, or to sell his paintings. In May 1942 Nolde attempted to contest this ruling, making the difficult journey to Vienna to seek an audience with the newly appointed governor of the city, whom he believed held more enlightened views, but he failed to gain an interview. Chastened and somewhat traumatised by the state of affairs, he withdrew to his home at Seebüll, living there quietly for the remainder of the war.

Political considerations aside, Nolde seems never to have understood why his paintings, by that time hanging in many of the country's museums, were singled out for condemnation. Later he would write of the essentially German character of his art, 'strong, austere and proud'.[33] In his home at Seebüll he would soon begin to paint once more in secret, working in a small room looking out over the surrounding countryside from where he could keep watch for Nazi patrols. Since supplies of other materials could not be obtained, he used watercolours, occasionally combined with pastel or opaque paint, with contours often outlined in pen and ink, and small, easily concealed pieces of Japan paper cut from supplies he already had. This long series of paintings numbered almost 1,300; almost without exception undated and usually without titles, they have become known as the 'Unpainted Pictures'.

Nolde frequently painted couples, usually a man and a woman; they evidently fascinated him, and often figured in these wartime pictures. At times the pairs are very much 'together', at others they seem sharply opposed, with one looking away from the other. Among these later, 'unpainted' watercolours, his *Two Ladies*, for instance, seems to imply a mood of jealousy, as one woman, seen in profile, looks calmly ahead, while the other glances at her angrily. *Friends*, meanwhile, shows the subjects' faces close together, with the woman leaning her head on her companion's shoulder. *Blue Couple in Sidelight* shows the couple's heads looking in the same direction in sharp profile, almost like an ancient Egyptian portrait. In the tender, more finished *Flirting*, in which the watercolour is carefully outlined in pen and ink, colour is used to differentiate the two characters: the man, leaning towards the woman and gently touching her hands, is painted in shades of blue, while she is shown in red and green.

Among the Unpainted Pictures were a limited number of both landscapes and seascapes. In general, owing to their small size (usually around 18 × 23 cm),[34] these were unremarkable, but there were exceptions such as the extraordinary *Landscape in Red Light*, where the watery land reflects a bank of deep-rose-pink clouds, and the tempestuous *Sea with Red Sun*, where stormy, cobalt waves rear up below a sky lit by a fiery, late evening sun. The appealing, delicately coloured *Dark Sea (Green Sky)* is a symphony in blue and green, as the waves of a heavy, greenish sea are shown beneath a dull turquoise sky overhung by dark clouds.

Some of Nolde's most appealing watercolour landscapes, although undated, were probably painted during the years immediately before 1941, when he was forbidden to work. They are larger than the watercolours described above, mostly measuring 35 × 50 cm. Like

Sea with Red Sun
undated
18 × 22.8 cm
Nolde Stiftung Seebüll

his oils, they portray the countryside of North Schleswig, with which Nolde was so familiar. The luminous *Two Mills* relies for its effect on brilliant, reflected light from a wide channel cut through the marshland: a deep-blue sky is mirrored in the water, while in the background the dark sails of the two mills rotate on the green banks. In *Red and Violet Clouds*, painted on a stormy evening, the tall cloud formations take on exaggerated hues. An exception to these local landscapes was a group of three mountain views. Of these, *Berglandschaft I* is an interesting example of Nolde's more experimental output, its greatly simplified forms and constrained colour range giving it a semi-abstract character. The two chunky mountains, seen as blocks of blue, stand on either side of a narrow valley, through which the distant horizon is visible. In the foreground the forms of a forest, and perhaps a range of low hills, are represented in deep, dense blues, greens and browns, while threatening, misty clouds

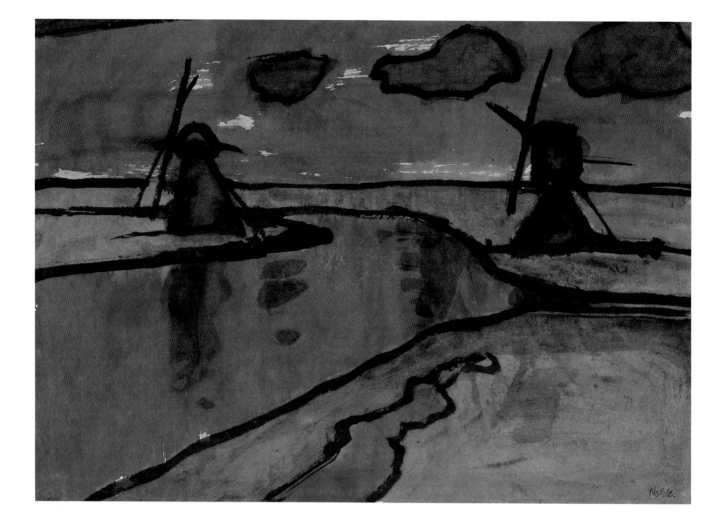

sweep across the sky. Among the seascapes, too, there are works with a distinctly modernist feel: *Sea (Violet, Yellow, Green)* lacks any defined forms and is awash with colour, admirably representing the visual chaos of the ocean's heaving, watery mass.

We are fortunate to have descriptions of how exactly Nolde worked with watercolour in his later years, since at the end of his life his young second wife, Jolanthe, watched him carefully as he painted, and recorded the process. For these highly individualistic pictures he chose from a supply of lightly sized, absorbent Japan paper of different thicknesses, some almost transparent, some as thick as blotting paper. Adapting the system of working he had devised when painting in the semi-darkness of the theatre and nightclubs in Berlin, he used a tray that held seventeen aluminium cups filled with pre-mixed colours, each with its own brush. He worked quickly, at times furiously, his brushes so saturated with paint that it sometimes soaked through the paper, creating blurred outlines. Often he painted with wet paint onto an already damp surface, undisturbed by the fact that the two or more paint layers would run into each other; when the paint dried on the Japan paper it often had a silky, luminous

Two Mills
undated
35.6 × 49 cm
Nolde Stiftung Seebüll

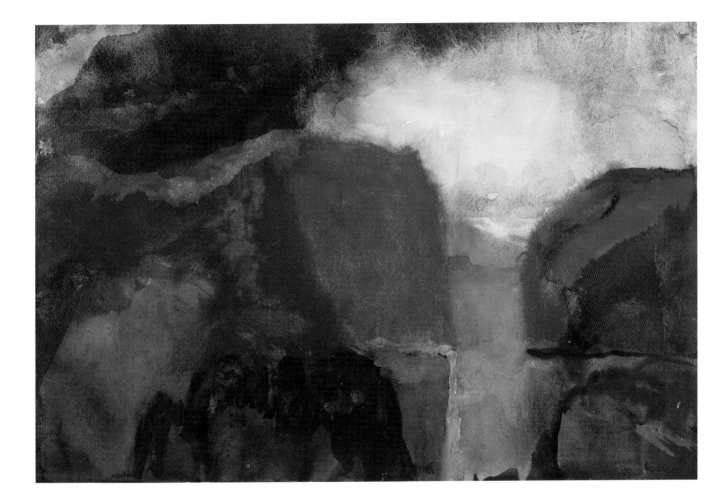

Berglandschaft I
undated
30.9 × 45.8 cm
Nolde Stiftung Seebüll

appearance, and dark, muted areas were sometimes shot through with flashes of intense, pure colour. Unusually, Nolde sought not to control the watery paint but to seize on the vagaries that occurred as he applied it to the lightly sized paper, and, indeed, to treat water itself as a factor in the composition. But behind the apparently random effects he achieved, a skilled artist was at work. As Jolanthe wrote, in describing how they were created: 'The pictures just happened, unfolded like living beings – under guidance, but with a life of their own.'[35]

Thus the medium of watercolour was elevated to one of significance in Nolde's oeuvre. Rather than a secondary resource, as it was for numberless other artists, for him it was a primary tool in his painterly armoury, and one he used to create many inimitable compositions.

Legends and Sailors

At the turn of the nineteenth century there was, throughout northern art, and in a way that differed from the art of western Europe and the Latin south, both an embodying of ancient national myths and an openness to the unknown and the indeterminate. In a region with a long legacy of legend and folklore, Scandinavian paintings often hinted at a natural scene that was animated, where Nature bared its soul. By Nolde's lifetime, the mythology of these countries had been recorded in printed versions, for instance in the *Kalevala*, a collection of old Finnish and Karelian folk stories in verses and song, recorded by Elias Lonnrött and published in 1835 and 1849. Telling of the creation of the world from an egg and ending with an account of the Virgin birth, the stories recounted in the *Kalevala* inspired, among others, the composer Sibelius and the Finnish painter Akseli Gallen Kallela.

Icelandic myths, surviving from as early as Viking times, had been written down in the Edda in the thirteenth century and were available in both poetry and prose. There were also less well-known collections of German folktales, and an account of the sayings and folklore of Nolde's own region, North Schleswig, had been edited by Karl Müllenhoff and published in 1845 and 1922. And Nolde spoke of Denmark, the country that so closely bordered the village where he was born, as a little frontier land with its own tender and beautiful character, and spoke of it as 'a land of idylls'. With his imagination nurtured by the fairy tales and ghost stories of his childhood, and later a knowledge of writings such as these on Nordic mythology, he contributed to this tradition in many arresting and intriguing works. The composer Debussy spoke of Turner as 'the finest creator of mystery in art', yet Nolde, too, created beguiling compositions whose strange content leaves us with a distinct sense of the other-worldly.

In the first volume of his autobiography, in which he describes his childhood, Nolde recalled sitting by the fire on innumerable winter evenings listening to stories of eerie happenings in the countryside, when small, strange creatures ran along the ditches and rattled at farmhouse doors – the nearby villages of Bombüll and Foggebüll were especially prone to such visitations – and of mysterious phantoms, sometimes draped in seaweed, coming ashore

Before Sunrise
1901
oil on canvas
84 × 65 cm
Nolde Stiftung Seebüll

from the sea. The simple, superstitious people among whom his family lived, some God-fearing, others no doubt rascally, would have set great store by these strange tales. Nolde's fascination with the more famous Nordic myths began soon afterwards; he describes being overwhelmed by the power of these accounts descended from generations of storytellers, when Ada read them to him on winter evenings. By 1913, long before she gave him a finely bound three-volume German edition of the tales in the 1920s, he was evidently familiar with collections such as the *Heimskringla*, a volume of sagas of the Norwegian kings written down by the Icelandic historian Snorri Sturlason. Although Nolde's paintings of grotesque and fantastic subjects do not usually derive directly from specific myths or legends, there are occasional examples of such borrowings: his *Gaut the Red*, painted in oil in 1938 and in watercolour between 1938 and 1945, was a character mentioned in stories of the Norwegian King Olaf.

Nolde spent the summer of 1901, soon after he first met Ada, in the small fishing village of Lildstrand on the North Sea coast. Joining the fishermen at sea during the day, but unable to find subjects to paint, at night-time in his small room he purposefully conjured up imaginary scenes peopled by weird, hybrid creatures emanating from this remote, silent area. Provided that his surroundings were just as quiet and remote, his ability to give free rein to his rich and fertile imagination would remain with him throughout his life. His biographer Werner Haftmann, however, stresses that Nolde found this a troubling experience, referring to 'tormenting images of fantastic scenes and mythical figures... that insisted on coming to the surface'. The night-time drawings made at Lildstrand inspired several paintings, the most remarkable of which was *Before Sunrise* (1901). In this disturbing but attractive composition a pair of nocturnal creatures inhabits an unearthly, dark, mountainous landscape: one sits on its nest on a high mountain peak, the other, perhaps its mate, flies off into the dawn that is already illuminating distant mountain valleys with orange light. Meanwhile, the figures peopling the eerie *Encounter I* (1904) seem to have reappeared from one of the folk stories of Nolde's childhood. Here a burly peasant woman and her little girl come upon a pair of terrifying apparitions on the seashore: an elderly, white-haired male figure who gazes intently at them, all the while fondling his black dog, together with a skinny, gaunt old woman who also peers at them malevolently, her long hair flying behind her in the wind.

Nolde's ventures into the realm of caricature have already been noted, and in his portrayals of some subjects this could tip over into the sinister. *Farmers* (1904), which shows a group of sober-faced country people drinking around a table, smoking and talking in a measured way, was probably a portrait of people he knew, but *Robbers* (1902) was very different. In a small room at dusk, with the last light of day visible through a diminutive window, flickering candlelight exaggerates the shapes of the heads of a group of conniving peasants, giving them a skeletal appearance: it is easy to conclude that they have evil designs. Nolde evidently found such conspiratorial groupings an absorbing subject, and painted two further examples: his *Peasants (Viborg)* (1908), which was based on drawings made in the

Encounter I
1904
oil on canvas
63 × 100.5 cm
Nolde Stiftung Seebüll

small market town of Viborg where Ada had been in hospital a few years before, and the scary *Robbers at Bombüll* (1917). The delicate and accomplished etching *Large Farmers* (1918) continued the theme of groups of people in discussion, with the figures of three landowners of substance, with large hands and extraordinary faces, shown in animated conversation.

It is clear that certain compositional ideas such as these remained in Nolde's mind over the years. One of his best-known fantastical works, the *Child and Great Bird* (1912), was preceded by a woodcut of the same subject as early as 1906. In the version painted in oil, a huge, dark bird is confronted by a little girl with a shock of red hair; rather than threatening her, the dusky avian creature seems intimidated, and turns away from her as if to vanish back into the night. With its attractive colouring – a soft twilight blue, the red of the little girl's hair and the deep-brown feathers of the bird – this remains one of Nolde's most memorable and appealing fantastical subjects.

In Easter week 1919 Nolde went to the tiny island of Hallig Hooge in the North Sea. The weather was cold, and he encountered no one in this remote, little-known location – as on other occasions, he chose these circumstances because they were ones in which he could work hard without being interrupted. At night, when there was silence except for the movement of the nearby sea, he once again let his imagination race wildly, conjuring up 'magical fantasies'

crowded with demons and devils. As on other similar occasions, the fantasies stayed with him as he walked on the shore in the daytime. Giving himself up to them, he began to sketch and paint, and produced, along with many watercolour sketches, the oil painting *The Devil and the Wise Man*. Here, under a dark, starry sky, a bearded man sits reading, while a large, fantastical creature occupies the foreground. Painted in dark red, with a scarlet beard and blue nails, this devil has a wide smile and seems friendly rather than threatening – perhaps because he has succeeded in interrupting the scholar. But in the extraordinary *Encounter on the Beach* (1920), where a woman walking on the seashore in front of surging green waves is confronted by a large, strange, child-like creature, she appears not a little disturbed.

Sea Woman
1922
oil on canvas
86.5 × 100 cm
Nolde Stiftung Seebüll

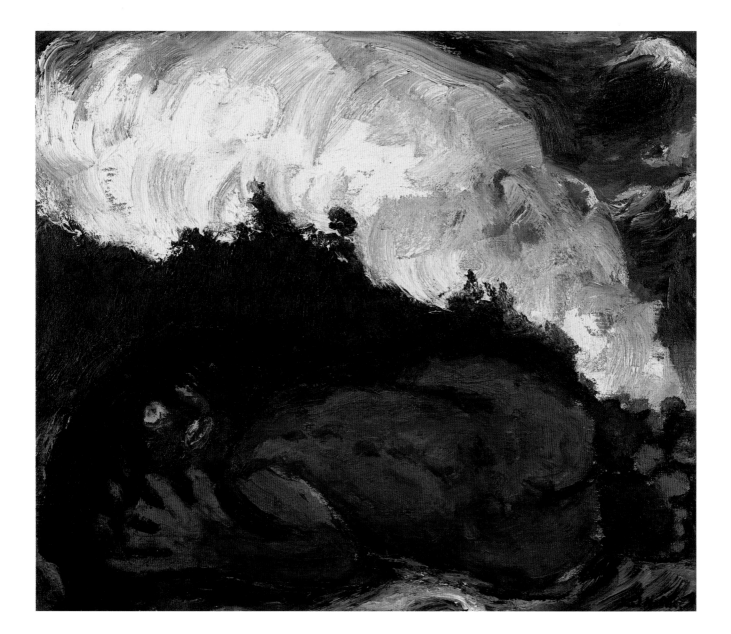

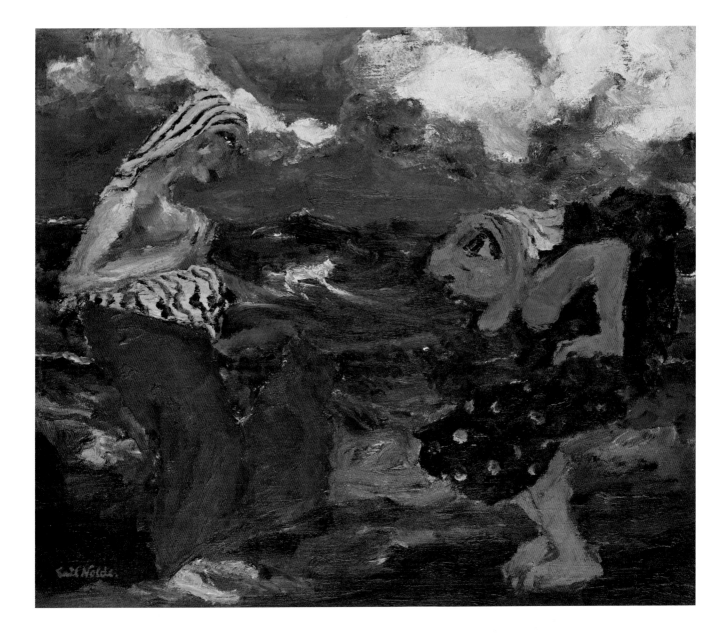

Encounter on the Beach
1920
oil on canvas
86.5 × 100 cm
Nolde Stiftung Seebüll

A number of paintings made around 1920 show that Nolde retained vivid memories of his journey to the South Seas shortly before the outbreak of the First World War. In 1921 he painted several works featuring strange, hybrid animals roaming in jungle settings, while the subject of his beautifully coloured *Sea Woman* (1922) is a dark-skinned woman. Perhaps recalling Böcklin's inclusion of erotic marine creatures in some of his sea pieces, Nolde shows her cowering on the seabed, seemingly about to be devoured by a huge, white-crested wave. With these varied works, and the dozen or so watercolour *Phantasien* painted between 1938 and 1945, Nolde's investigation into the fantastic, which formed such an intriguing aspect of his oeuvre, was complete.

Nolde made innumerable paintings of the seas that encompassed his Wonderland. The fisherman's cottage that he and Ada rented on the island of Als was close to the beach; thereafter, except when he was wintering in Berlin or travelling abroad, he was never far from the coast. He loved this northern land's flat, windswept terrain, and his imagination was also stirred by the sight of the often tempestuous oceans that bordered it. In 1903 he built a wooden cabin on Als to use as a studio; from its window he could spend hours watching the sea, and he later wrote that his 'eyes could roam over the water, and see nothing else'. Years spent observing the ocean's appearance and behaviour, and its sounds, from the lapping of small waves on the shore to the crashing of tons of mighty seawater, had made its waters part of his consciousness. His first biographer Max Sauerlandt observed, 'He understood the sea like no other'. In all, he would paint seventy seascapes in oil, including many of the Baltic and North Seas sweeping the edges of his homeland, and a large number of watercolours. Unlike traditional seascapes, where the water is seen from a distance, Nolde's views of the sea are often much more close-up and personal.

As with his landscapes, in painting seascapes Nolde followed his own, singular vision, deferring to no other artist in particular. His coastal pictures could hardly have been more different from seventeenth-century Dutch artists' calm marine views, with their displays of fine shipping, but Nolde may nonetheless have been aware of other works, such as Courbet's rough-hewn sea pictures that were exhibited in Munich when Nolde had studied there, and also in Berlin and Hamburg. In 1921, following his visit to London, he expressed a profound admiration for Turner. His early seascapes, like his other early works, may also have owed some debt to Van Gogh's lively and brilliant technique.

In 1906 Nolde made an unusually rough and stormy crossing of the Kattegat, the wide strip of sea that lies between north Denmark and the south of Sweden. The experience of this journey in a small boat, and of being tossed, in fear of his life, on huge, heaving green waves, with only a narrow strip of sky visible above them, became fixed in his memory. Even though he would sometimes paint it on calmer days, for Nolde the sea very often presented a threatening, ever-moving primordial force. To quote Peter Selz, in his paintings of the sea 'no safe shore beckons': the ocean fills or almost fills the picture plane, sometimes seen below ominous clouds. Most of his sea pictures were painted in a comparatively square format, and he varied their mood by means of different colouration.

Nolde began painting the sea in earnest during the spring he spent in Hamburg in 1910. Finding the port and its busy dockyards curiously absorbing, he painted several views of sailing boats and tugboats setting out to sea. The vigorous brushwork of *Smoking Tugboat* and splintered colours of *Steamer on the Elbe* are echoed in *Sailing Boat in the Wind*, with its roseate sky and grey-blue sea. In painting his working vessels, Nolde uses a much harsher colouration, for instance the darkest of greys and bright yellow. His tugboats battle through stormy waters, belching out steam and smoke as they confront the heaving, wind-tossed waves that reflect the livid tones of the sky. In two other works, cobalt and reds are used to

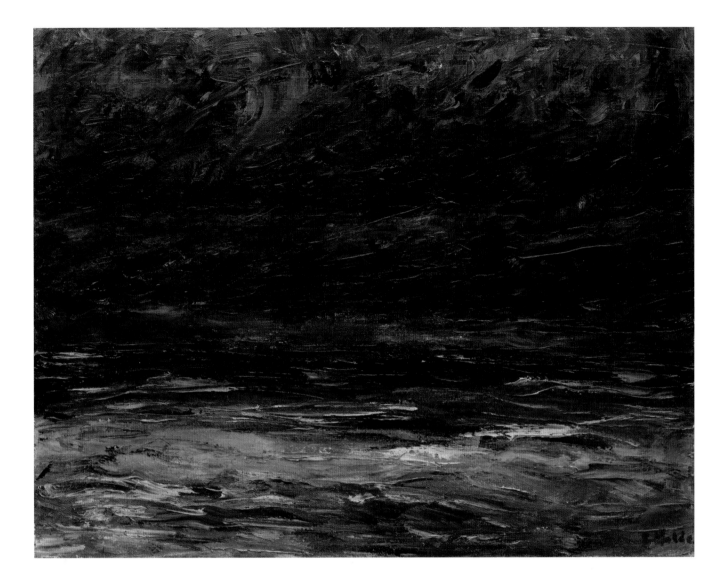

Autumn Sea IX
1910
oil on canvas
65 × 85 cm
Sprengel Museum, Hanover

describe harbourside views: *Ships in Dock*, which is also painted with extraordinary vigour, features two vessels whose deep-red hulls are reflected in a sea of splattered blue and white, while in *Seascape with Horses*, two red horses plough through the waves towards the vessels anchored behind, perhaps to collect their cargo.

These Hamburg pictures were followed by more than a dozen highly charged seascapes painted on the coasts of his home region that autumn. Nolde grouped these into a series called *Autumn Sea*, and they seem to reflect his troubled state of mind at the time of his break with the Berlin Secession. Characterised, again, by a highly distinctive use of colour in each case, and exceptionally vigorous, horizontal brush strokes, they portrayed the wild, ungovernable autumn seas, overhung by equally tumultuous skies. In other works, again grouped into series, there is little else except the ocean: *Sea III*, painted in 1913, simply focuses

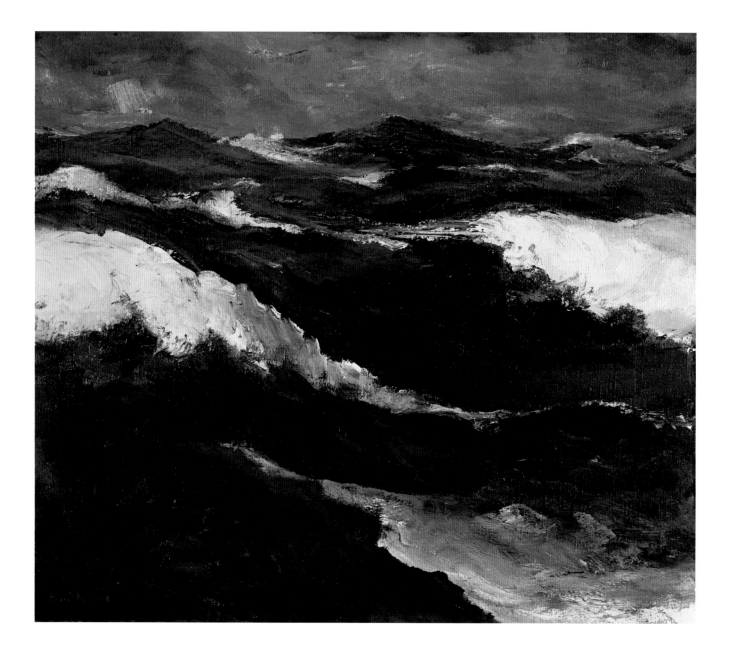

Sea III
1913
oil on canvas
87 × 100.5 cm
Nolde Stiftung Seebüll

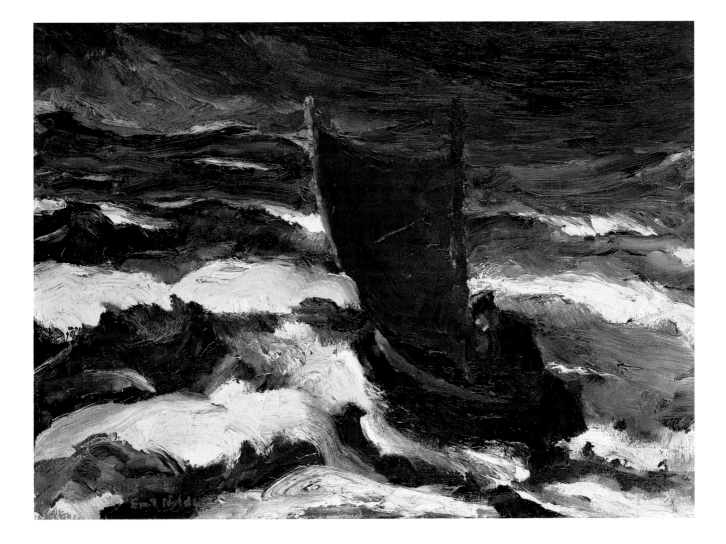

Boat at Sea
1921
oil on canvas
73.5 × 100.5 cm
Nolde Stiftung Seebüll

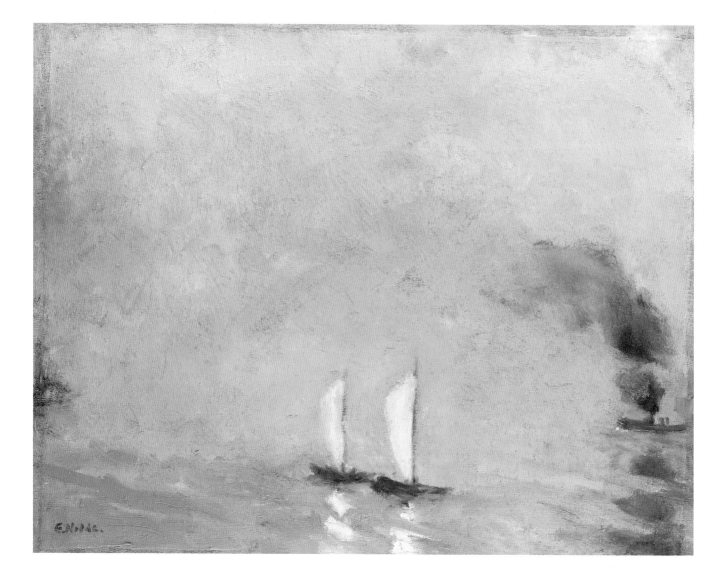

on surging, dark blue, white-crested waves, seen below a small strip of greenish sky on the horizon; the much later *Sea I*, dating from 1947, shows rather calmer, inky blue waves on the point of breaking beneath a deep-red sky.

Sometimes a small, seemingly very vulnerable fishing boat appears: Nolde well knew the risks taken by local fishermen. *Boat at Sea* (1921) features a simple, single-sailed craft with a lone sailor, making its way across a choppy sea; the waters in *Sea at Evening* (1919) are more benevolent, as the small boat edges its way home across a calm, dark sea lit with patches of deep-orange light from the setting sun. The watercolour *Sea with Red Sun*, painted during Nolde's exile between 1938 and 1945, is one of his most expressive sea pictures. In this visual cacophony, inky, tumultuous waves surge gently below a sky of fiery red, in which the sun appears among scattered black clouds. There were, too, occasional scenes of bathers, including the sensuous *Woman of the Dunes* (1920), which shows a naked woman lying in the sunshine among sandy dunes. Nolde continued painting the ocean until his last years, and some of the works made as he grew older seem to reflect a mellowing personality and acceptance of his decreasing energies. In one of his last paintings, the Turneresque *Luminous Sea* (1948), two small sailing boats and a steamer float on a sea of pastel blue beneath a hazy, iridescent yellow sky. Here the calm mood, and the fusion of sea and sky, seem somehow to suggest the eternal.

Luminous Sea
1948
oil on canvas
69 × 85.5 cm
Nolde Stiftung Seebüll

Notes

1 Among the Wanderers were Ivan Shishkin (1832–98), who spent his life commemorating Russia's fertile plains and the great oaks and conifers inhabiting her forests; Arkhip Kuindzhi (1842–1910), whose later landscapes brilliantly evoked the hazy romance of distant steppelands; and, most significantly, Isaak Levitan (1860–1900), known for his 'mood landscapes'.

2 Like the Australian Aborigines, Nolde retained an intimate sense of place, conscious of 'the pulse of every sentient creature, the rhythm of every breath of wind'. See Davis Wade, *The Wayfinders* (Perth, 2010).

3 Peter Christian Skovgaard (1817–75), who admired the work of Ruisdael, contributed to the Golden Age of Danish art, painting landscapes in which the play of light on trees and clouds was beautifully rendered.

4 See Robert Pois, *Emil Nolde* (Washington, 1982), pp. 41–2.

5 Fauvism derived from the French word *fauve*, or wild beast, a name occasioned by the use of exceptionally bright, luminous colours in the works of Matisse, Derain, Vlaminck and Rouault from around 1905.

6 In their many paintings of bathers in the Moritzburg Lakes made from 1909 onwards, the Brücke artists' real concern was to portray their models disporting themselves in an idyllic way of life untrammelled by everyday concerns. In contrast, the prime concern of the New Objectivity artists was to relay the banality of everyday life, which they did with near-brutal realism.

7 Nolde would later admit to his admiration for 'the ice-breakers – the great Frenchmen – Manet, Cézanne, Van Gogh, Gauguin and Signac', who had broken with convention and moved art forward. (From a letter to Rosa Schapire. See *Letters, 1894–1926* (Arles, 2008).)

8 David Platzer in his review of the exhibition *Emil Nolde 1867–1956* at the Galeries Nationales du Grand Palais, 2009 (*Apollo Magazine*, March 2009).

9 The inspired name of the group, Die Brücke, or the Bridge, was taken from Nietzsche's *Thus Spake Zarathustra*, in which man's life is seen as a pathway to a better future. It also reflected the geography of the city in which the artists lived, namely Dresden, with its many fine bridges crossing the river Elbe.

10 It is thought that an older sister of Fränzi's may also have posed for the Brücke, but Kirchner is known to have used both names for Fränzi herself.

11 Johann Wolfgang von Goethe (1749–1832), regarded as the genius of modern German literature, whose writings were well known among the early twentieth-century Germans. His early work, *Die Leiden des jungen Werthers* (*The Sorrows of Young Werther*), published in 1774, is a founding text of Romanticism.

12　The Nazarenes were a group of German and Austrian painters working in Italy in the early nineteenth century. Inspired by late medieval German painting, they aspired to revive Christian content and symbolism in art.

13　Biedermeier was a fashionable trend in painting, furniture-making and decorative crafts practised by German and Austrian artists between 1815 and 1848. With its highly stylised, meticulously detailed appearance, it appealed strongly to the bourgeoisie.

14　Jugendstil was the German form of art nouveau, taking its name from the journal *Die Jugend*.

15　This reference to Holbein is from Nolde's letters, published in Max Sauerlandt's *Emil Nolde* (Munich, 1921).

16　Although at the time he painted his *Crucifixion* Nolde would have known the *Isenheim Altarpiece* only in reproduction, he later visited Colmar on two occasions (in 1927 and 1933) in order to view it.

17　St Anthony's fire, now known as ergotism, is caused by eating contaminated wheat.

18　Joris-Karl Huysmans (1848–1907), French critic and novelist who wrote extensively on art and religion. An early advocate of Impressionism, he also admired the symbolist artists Moreau and Redon.

19　Wilhelm von Bode (1845–1929) became general director of the Berlin museums in 1905. A pillar of the art establishment and a friend of Kaiser Wilhelm II, he succeeded in reinstating Berlin, rather than Munich or Dresden, as the centre of German painting and sculpture.

20　For instance Richard Benz (ed.), *Alte Deutsche Legenden*. Such collections of legends were popular in Germany at this time.

21　See Peter Selz, *Emil Nolde* (New York, 1963), note 18.

22　Nolde had expressed this ambition in a letter to Rosa Schapire, the Hamburg art historian, in August 1908. See Manfred Reuther (ed.), *Emil Nolde: Die Religiösen Bilder* (Seebüll, 2011), p. 129.

23　Werner Haftmann, *Emil Nolde* (New York, 1959).

24　Carl Georg Heise, *Emil Nolde: Wesen und Weg: Seiner Religiösen Malerei* (*Genius 1*, 1919).

25　See Libby Tannenbaum, *James Ensor* (New York, 1951).

26　Professor Külz wrote an account of the expedition that was published in a German paper relating to colonial affairs, the *Deutsches Kolonialblatt*, in September 1914.

27　Fortunately there are photographic records of some of Pechstein's drawings, and his memoirs, written in 1945–6, were published posthumously in 1960 in Wiesbaden.

28 See Pois (ibid), p. 69, quoting from Nolde's *Jahre der Kämpfe.*

29 Pointillism was a system originating in France in which small dots of pure colour were applied to the canvas. From a distance they fused in the viewer's eye to give particularly vibrant colour effects.

30 For description of the printing of *Candle Dancers* see Clifford Ackley, *Nolde: The Painter's Prints* (Boston, 1995), pp. 243–45.

31 Letter to Hans Fehr, 26 May 1908, quoted in Felicity Lunn and Peter Vergo, *Emil Nolde* (Exhibition Catalogue, Whitechapel Gallery, London, 1995).

32 See Ackley (ibid.), p. 37.

33 Quoted in Tilman Osterwald (ed.), *Emil Nolde: Unpainted Pictures* (Ostfildern, 2000), p. 143.

34 Many of the Unpainted Pictures were painted on slips of Japan paper 'smaller than the painter's hand', i.e. as small as 15 × 20 cm.

35 From Jolanthe Nolde, *Emil Nolde: Gemälde, Aquarelle, Graphik* (Villingen-Schwenningen, 1974), quoted in Lunn and Vergo (ibid.), p. 170.

Ada and Emil Nolde punting
in a boat
1920s
photograph
Nolde Stiftung Seebüll

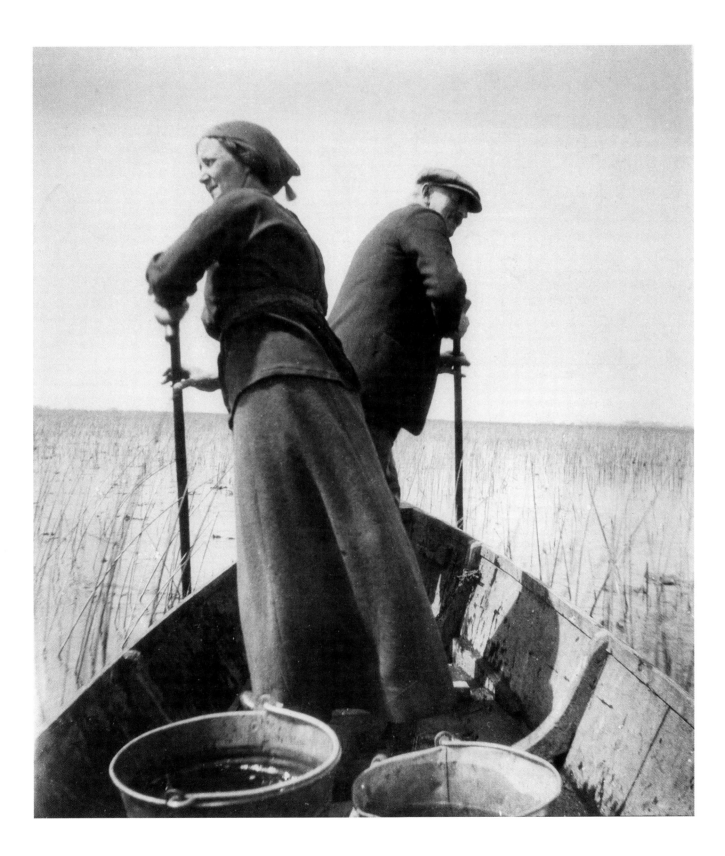

Bibliography

Ackley, Clifford S (ed.) *Nolde: the Painter's Prints* (exhibition catalogue, Boston, 1995)

Amic, Sylvain (ed.) *Emil Nolde 1867–1956* (exhibition catalogue, Grand Palais, Paris, 2008)

Bradley, William *Emil Nolde and German Expressionism: A Prophet in his own Land* (Ann Arbor, 1988)

Heller, Reinhold (ed.) *Brücke: the Birth of Expressionism in Dresden and Berlin, 1905–1913* (Ostfildern, 2010)

Lloyd, Jill *German Expressionism – from Primitivism to Modernity* (New Haven, 1991)

Lorenz, Ulrike *Brücke* (Cologne, 2008)

Moeller, M. *Emil Nolde in Berlin, 1910/11* (exhibition catalogue, Brücke Museum, 1988–89)

Osterwold, Tilman (ed.) *Emil Nolde Unpainted Pictures* (Ostfildern, 2000)

Pois, Robert *Emil Nolde* (Washington, 1982)

Reuther, Manfred (ed.) *Emil Nolde: Die Religiösen Bilder/The Religious Paintings* (Cologne, 2011)

Reuther, Manfred (ed.) *Emil Nolde: Die Südseereise/The Journey to the South Seas, 1913–14* (Cologne, 2008)

Reuther, Manfred (ed.) *Emil Nolde: Mein Garten Voller Blumen/My Garden full of Flowers* (Cologne, 2009)

Reuther, Manfred (ed.) *Emil Nolde: Mein Wunderland von Meer zu Meer/My Wonderland from Sea to Sea* (Cologne, 2008)

Reuther, Manfred *Emil Nolde: Naturaleza y Religión* (exhibition catalogue, Fundación Juan March, Madrid, 1997)

Reuther, Manfred (ed.) *Nolde in Berlin* (Cologne, 2007)

Reuther, Manfred and Ring, Christian (eds) *Emil Nolde: Die Graphik des Malers/The Painter's Prints* (Cologne, 2012)

Selz, Peter *Emil Nolde* (New York, 1963)

Selz, Peter *German Expressionist Painting* (Berkeley, 1957)

Tonneau-Ryckelynck, Dominique *Nolde Oeuvre Gravé* (Musée du Dessin, Gravelines, 1988)

Urban, Martin *Emil Nolde: Aquarelle und Handzeichnungen, 1893–1956* (exhibition catalogue, Museum Folkwang, Essen, 1966–67)

Urban, Martin *Emil Nolde: Catalogue Raisonné of the Oil Paintings* (Vol. 1, 1895–1914, London, 1987; Vol. 2, 1915–51, London 1990)

Vergo, Peter and Lunn, Felicity *Emil Nolde* (exhibition catalogue, Whitechapel Art Gallery, London 1995–96)

Weikop, Christian (ed.) *New Perspectives on Brücke Expressionism* (Surrey, 2011)

Wolf, Norbert *Expressionism* (London, 2004)

Emil Nolde's four-part memoirs were re-published (in German) in Cologne in 2002, as follows:

Das eigene Leben (1867–1902)

Jahre der Kämpfe (1902–14)

Welt und Heimat (1913–18)

Reisen – Ächtung – Befreiung (1919–46)

Nolde's letters were published as follows:

Briefe aus den Jahren 1894–1926 (Hamburg, 1967)

Lettres 1894 1926 (Arles, 2008)

Early biographies of Nolde were published as follows:

Fehr, Hans *Emil Nolde Ein Buch der Freundschaft* (Cologne, 1957)

Sauerlandt, Max *Emil Nolde* (Munich, 1921)

Index of Artworks

References to illustrations are indicated by *italics*.

General Index

References to illustrations are indicated by *italics*. References to notes are indicated by n.

Unforgettable
places to see
before you die

Unforgettable
places to see
before you die

Steve Davey

12 ANGKOR WAT, CAMBODIA

18 ST PETERSBURG, RUSSIA

36 GRAND CANYON, ARIZONA, USA

42 TAJ MAHAL, AGRA, INDIA

60 AITUTAKI, COOK ISLANDS

66 PYRAMID OF KUKULCÁN, MEXICO

84 IGUASSU FALLS, BRAZIL AND ARGENTINA

90 PETRA, JORDAN

108 RIO DE JANEIRO, BRAZIL

114 TAMAN NEGARA RAINFOREST, MALAYSIA

CONTENTS

132 MANHATTAN ISLAND, NEW YORK, USA

138 LAKE TITICACA, BOLIVIA AND PERU

156 SANTORINI, GREECE

162 DRAKENSBERG, SOUTH AFRICA

180 LALIBELA, ETHIOPIA

186 MACHU PICCHU, PERU

204 GREAT BARRIER REEF, AUSTRALIA

210 LHASA, TIBET

228 EPHESUS, TURKEY

234 THE BUND, SHANGHAI, CHINA

144 MONET'S GARDEN, GIVERNY, FRANCE

150 NGORONGORO CRATER, TANZANIA

168 ZANZIBAR, TANZANIA

174 MAKALU, HIMALAYAS, NEPAL

192 ULURU, AUSTRALIA

198 THE GHATS, VARANASI, INDIA

216 YANGSHUO, GUILIN, CHINA

222 DUBROVNIK, CROATIA

240 SAMARKAND, UZBEKISTAN

246 KILLARY HARBOUR, IRELAND

What is an unforgettable place? A place you will remember for the rest of your life, certainly, but to me an unforgettable place is more than that. It is the sort of place that is so special that as soon as you discover it exists you just know you have to go there. While you might remember many things about daily life from time spent in India, for example, it will have been the desire to gaze upon the timeless beauty of the Taj Mahal that prompted you to make the journey. This book contains my own selection of 40 unforgettable places.

Certain places around the world, such as the Taj Mahal, Uluru (Ayers Rock), the Grand Canyon, Manhattan and Machu Picchu, have entered our collective consciousness. All of these crop up on most people's lists of places they would love to see, and not to include them just because they are so popular would have been silly. I hope their appearance here will act as a reminder that these places really should be seen at least once in a lifetime.

I have also tried to highlight some places that are less well known and that you may never have thought of visiting. Hopefully, featuring them here will prompt you to put them firmly on your 'to do' list. The mystical city of Samarkand, the majestic hidden stone churches of Lalibela, and even the warren that is the town of Zanzibar are all places that deserve to be more widely appreciated. (The map on pages 252–3 shows the locations of all the places featured.)

I have also included what I consider to be the best of a number of 'generic' places. How many of us have said that we would love to see 'the rainforest' or a truly phenomenal waterfall? Well, this book looks at places that I consider to be the very best of their kind: the Sossusvlei National Park is in arguably the most amazing desert in the world, Taman Negara is the oldest rainforest in the world, the Iguassu Falls has to be the best waterfall in the world, and the Ngorongoro Crater is the single most spectacular place to view wildlife in Africa.

Many of the places I have chosen are exceptional in any terms. But will you agree with my choice? I honestly doubt it. By its very nature this book is judgemental and invites disagreement. Several people have asked why Paris, for example, is not in the book, but if you had to include just one romantic European city in this list then, for me, a wintry Venice beats Paris hands down any day of the week. Everyone will have their own favourite places; their own 'unforgettables'. But these are mine – a selection based on many years of travelling.

I have tried to give this book immediacy. Thousands of pictures are available of many of the locations in this book, but instead of using existing, often out-of-date, images, or views that cannot be seen by the average traveller, my co-photographer, Marc Schlossman, and I decided to photograph them afresh. So we captured most of the images you see here in a period of just nine months, spending only a few days in each

location. We therefore saw these places in the same way that you might see them. This is not a book of unattainable sights – if you spend three or four days in the Galapagos, or Rio, or even Venice or the Ngorongoro Crater, this is what you can expect to see. Sometimes the skies have a few more clouds than they do on postcards, but remember that we criss-crossed the world taking these pictures on a frenetic schedule. I have tried to keep some of that excitement and enthusiasm in this book.

I also wanted to provide a sense of place. Wherever practical, I have avoided sweeping generalizations and focused on one, sometimes quite specific, location. The sort of view, for example, that you could lead someone to, blindfolded, then reveal to them the world in its splendour. For New York City, this has to be Manhattan Island. For the 2000-km-long Great Barrier Reef, it has to be Heron Island – one of the few coral cays that lies directly on the reef that you can actually stay on.

Although armchair travellers will love this book, I hope it will inspire people to hit the road themselves. At a time when there is concern about terrorism, disease and all manner of political instability I have constantly had my sanity questioned for going to so many places around the world. However, in all of my flights and solo wanderings around places noted for their bad reputations, not once have I been robbed or threatened, had a bag lost by an airline or had any particularly close shaves – except literally, by a barber in the old town of Godaulia in Varanasi. I have walked on my

own down Copacabana Beach at sunrise with a brace of cameras, hiked alone through rainforest, visited a Middle East virtually deserted by western tourists at the height of a war, and received nothing but courtesy and unceasing hospitality. Sure, bad things do happen when you travel, but they happen far, far less than you might expect. And, anyway, on the road you should have insurance to cover most mishaps.

Travelling brings memories, and lots of them. There will be the big, 'blockbuster' memories – the kind that friends and family will clamour to share through your photographs and postcards: sunrise at Angkor Wat, sunset at Uluru, that first view of Piazza San Marco as you arrive in Venice by boat from the airport. These are experiences you will remember, quite literally, till you die. But your search for them will also bring you smaller, personal memories that can't be replicated: joining Bedouin for a barbecue in the mountains around Petra, haggling for spices in an Uzbekistan bazaar, picnicking with an extended Tibetan family after a festival in the stunning city of Lhasa. These experiences cannot be bought. You won't get them on a commuter train or in a supermarket. The addictive quest for sights, smells, feelings and experiences will make you feel truly alive. I hope that this book inspires you to travel to at least some of these unforgettable places, and to create some indelible memories of your own.

Steve Davey, 2004

Angkor Wat
Cambodia

Although the trees that surround Angkor have been tamed, it is still possible to imagine how this ancient city was 'lost' to the outside world for centuries until the French explorer Henri Mahout discovered it smothered in the jungle in 1860.

Angkor was the capital of the Khmer civilization, which spanned some 500 years, until it was sacked by Thai invaders in 1431. It reached its zenith in the 12th century, first with the building of the temple that came to be known as Angkor Wat and later with the construction of Angkor Thom, a royal city-within-a-city.

The temple was built by King Suryavarman II as a representation of Mount Meru, the mythical holy centre of Hinduism. Surrounded by a large moat bridged by a stone causeway, it is a west-facing rectangular stone structure comprising three levels. The uppermost

level, formerly open only to priests and the king, is topped with four corner towers and a central sanctuary 65 metres from the ground. Originally devoted to the Hindu god Shiva, the temple later became a Wat, or Buddhist monastery, and is now accepted as a spiritual monument by the predominantly Buddhist Cambodians. Images of the Buddha can be found among its vaulted galleries.

Even after more than 800 years of plundering and erosion the carvings of Angkor Wat remain exquisite and the wealth of detail is bewildering. Galleries of bas-reliefs – the longest in the world – depict scenes from the Hindu religious epic, the *Mahabharata*, battle scenes from Khmer history and warnings about the tortures of hell.

The temple is best seen in the golden light of early morning when the rays of the sun pick out the *apsaras* (celestial nymphs)

Novice monks on the terrace of the first level of Angkor Wat

Bas-relief of a marching army

carved into its walls, seeming to breathe life into them. Amid the quiet beauty, it is hard to imagine that this place was one of the final refuges of the notorious Khmer Rouge communist movement – until you notice scars from the impact of bullets on the stone of the building.

Direct flights from Bangkok in Thailand have made the temples of Angkor more accessible, and they are now visited by more tourists than ever. Most tend to gather at the north pool to photograph the reflections of the rising sun, but those seeking peace and tranquillity should head straight to the principal sanctuary of Angkor Wat. This is reached by one of four flights of steep and worn stairs, signifying just how difficult and arduous is the path to heaven. It was once the

Looking out from the third level to the second level and surrounding trees

exclusive preserve of Hindu priests, but now you too can have it to yourself – providing you get there early enough.

The top level of Angkor Wat seems to have been designed for the sunrise. Golden fingers slide through the unique, stone-pillared windows and illuminate details that quickly recede in the brilliant light of the day, and some of the most beautiful *apsaras* – which can be found in the central sanctuary – are uncovered by the rising sun, only to be hidden in shadow again just 20 minutes later.

It can sometimes be half an hour before the first few explorers from the sunrise party reach here. Most don't bother; they go back to their hotels for breakfast, and return here later in the day, when the sun is intense and energy-sapping, and the atmosphere far from spiritual.

Other parts of the Angkor complex not to be missed are the Bayon and Ta Prohm. Built later than Angkor Wat, the Bayon is a small temple covered with giant, impassive stone faces reminiscent

Apsaras carved into the principal sanctuary of Angkor Wat

Sun shining through the pillared windows of the cloisters on the third level of Angkor Wat

of Lord Buddha, and perhaps marking the transition from Hinduism to Buddhism in the Khmer civilization. Ta Prohm is a largely ruined temple complex, with roots of banyan and kapok trees growing out of the stonework – and sometimes so much a part of it that neither would survive any attempt at separation.

ⓘ ⋯⋯⋯⋯⋯⋯⋯⋯⋯⋯⋯⋯⋯⋯⋯⋯⋯⋯⋯⋯⋯⋯⋯⋯⋯⋯

Siem Reap, the nearest town to Angkor (10 km away), can be reached by plane from Bangkok, Thailand (Bangkok Airways has several flights a day in both directions) or from the Cambodian capital, Phnom Penh. Alternatively, you can get there by boat across Tonle Sap. This lake trip takes most of the day but is an interesting journey. A wide range of accommodation is available in Siem Reap, from inexpensive guest houses to the exclusive Amansara Resort. Tickets for the ruins can be bought for one, three or seven days. Three days is a good amount of time – it will cost £35 (US$50) and you will need a passport photograph. The site is very spread out, but the better hotels can organize a guide with a car, or you can hire a bicycle, motorbike or motorbike-taxi from many places in town.

St Petersburg
Russia

If the mention of a place can bring to mind a season, then St Petersburg conjures up winter – deepest winter. Snow-covered statues, breath rising in clouds and the Winter Palace seen through mist across the frozen River Neva.

Winter is not an easy time to visit Russia – the biting cold might restrict your sightseeing – but it is the time of year that defines both the city and the Russian people. It is also the season when the tsars used to visit St Petersburg. The Winter Palace was built to house and amuse the Russian royal family during the long dark winter months. From inside you can gaze out upon the same frosty scenes that Catherine the Great once saw, the views distorted by a covering of ice on the windows.

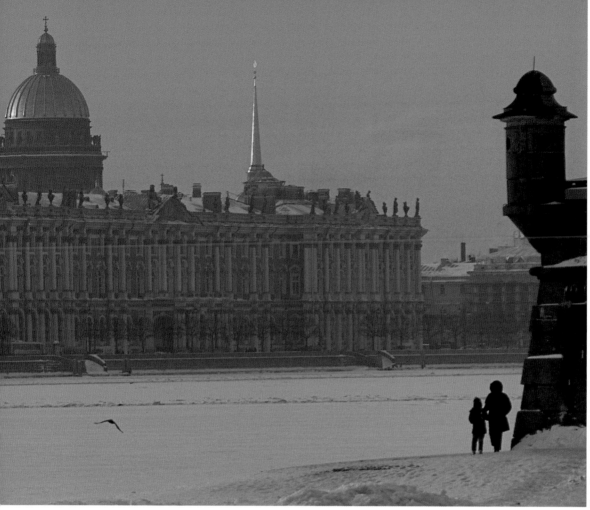

St Petersburg was founded by Peter the Great in 1703, and the Winter Palace was completed in 1762. The founding of a European-style city on the western border of the country, and the moving of the capital from 'Asiatic' Moscow in the east, marked a Europeanization of Russia. The House of Romanov became one of the great ruling dynasties of Europe, rivalling even the Bourbons and the Habsburgs. The Winter Palace is probably their greatest creation.

St Petersburg itself has been at the centre of European history for 300 years. Revolution was fermented in the city, and the tsars were overthrown when the Bolsheviks stormed the Winter Palace in 1917, ushering in more than 70 years of Communism for Russia. St Petersburg was renamed Leningrad by the new regime and became

The gate from the river jetty into Peter and Paul Fortress, with the River Neva in the background

Winter Palace

Tikhvin cemetery

one of the bulwarks that held up the spread of Nazism during the Second World War; a heroic defence that saw the city all but destroyed. Reverting to the old name of St Petersburg following the fall of Communism was a gesture that marked the demise of the old Soviet Union and the re-emergence of Russia.

Throughout all this history, the Winter Palace has endured. It is a massive structure, stretching some 200 metres along the riverfront. Other buildings, notably the Hermitage and the Hermitage Theatre, were added by Catherine the Great, a ruler whose excesses and love of power were to help to bring about revolution and the end of a dynasty.

A palpable sense of history pervades every part of the Winter Palace. It is easy to imagine the Russian royal family residing here, cocooned from the harsh realities of daily life experienced by most of their subjects. Or the monk Rasputin, who held such sway over Tsar Nicholas's wife, Alexandra, that he was poisoned the year before the dynasty fell. One can also imagine the amazement of the Bolsheviks who stormed the palace in 1917, seeing for the first time the opulence in which their rulers lived.

The Hermitage is notable among the riches of the Winter Palace, housing one of the greatest collections of art in the world – an astonishing 2.8 million exhibits. Get there early and you could have works by Monet or Picasso all to yourself.

Despite the Byzantine paperwork required to get a visa, St Petersburg is a relatively easy city to visit. Seemingly unaffected by the long years of Communism, it retains the atmosphere of imperial Russia, especially during the long hard winters when, like the tsars of old, you can seek refuge from the cold amid the warmth and grace of the Winter Palace.

(i) ⋯⋯⋯⋯⋯⋯⋯⋯⋯⋯⋯⋯⋯⋯⋯⋯⋯⋯⋯⋯⋯⋯⋯⋯⋯⋯⋯⋯⋯⋯

Although Communism has long since gone, the visa application process has changed little. It is time consuming and there is a lot of paperwork. A visa agency will help to smooth the process. A number of European airlines fly to St Petersburg. Alternatively, you can take the train through Europe. The city is well served by rail connections and it is possible to get a train all the way to Vladivostok or even Beijing. Try to book a central hotel – the city is big and spread out and you will maximize your sightseeing by minimizing travel time. Intourist, the old state travel company, can organize hotels and tours. The metro is an interesting experience and very efficient, but keep track of where you are – station signs are difficult to read and it is easy to miss your stop.

Pavilion Hall, Gallery 204, the Hermitage

Ceiling of the Jordan Staircase, the Hermitage

Havana
Cuba

Buildings on the Malecón

Hotel Inglaterra and the Parque Central

A place to be experienced as much as seen, Havana lives up to all the clichés that have characterized it for so long: the people really do dance the rumba, drink rum and smoke cigars. And everywhere you look, classic American cars – Buicks, Dodges and Chevrolets – cruise along streets that seem to have changed little since the revolution.

The old part of the city, Habana Vieja, appears caught in a 1950s time warp. It looks like a film set, while the people who inhabit it resemble casually positioned extras: the elderly man sitting on the waterfront at sunset playing the trombone to his friend, another carrying a double bass across a square and the young woman dancing by herself to the music of the band on the terrace of El Patio restaurant. And over it all, making the scene unmistakably Cuban, is the scent of cigar smoke.

25

At the centre of old Havana is the cobbled Plaza de la Catedral. Ringed on three sides by low colonial buildings, its focal point is the ornate cathedral, its Cuban baroque style reminiscent of melted wax on a candle. Having been spared from tourist development, the square is much as it used to be in the 1950s when pre-revolution Havana was a playground for the rich and a haunt of the Mafia. El Patio, a restaurant housed in an 18th-century mansion, has witnessed many changes in the city, and is the perfect place to watch from as the colour drains from the sky and the cathedral is floodlit. If you are lucky and there is a service on, you can look straight through the open door of the cathedral to the altar as you sit in the square.

Parts of old Havana have been renovated and restored into sanitized shadows of their former selves. The buildings in the Plaza Vieja and Mercaderes now house international shops and dollar restaurants too expensive for most Cuban people. It is the run-down backstreets that have the real atmosphere. Everyone seems to exist

Cuban musicians busking in the Plaza de la Catedral

Catedral de la Habana

outdoors, whether on a rickety balcony, in a shady courtyard or just on the front step. People laugh, talk, eat and smoke, and, most importantly, all the boys seem to play basketball – a national obsession.

Although Cuba has the highest literacy and lowest child mortality rates in all of Latin America it still has great poverty, which some attribute to 50 years of Communism and others blame squarely on the long-running US boycott. Certainly, there is limited political freedom, and everyday life can be hard. Most Cubans live in small, one- or two-room apartments, and if you look through the elaborately barred windows on the ground floor you might see the whole family gathered round an old TV set, watching a South American soap opera or a live baseball game. You will know which windows to look through: TVs are a rarity here, so there will often be a small crowd in the street outside watching as well.

Plaza de la Catedral

Paseo de Marti

Sometimes it seems that most of the population of Havana congregates on the Malecón at sunset. This stretch of the waterfront, lined on one side by crumbling buildings and on the other by the sea, is a magnet for people of all ages. As the once-elegant façades are bathed in golden evening light music is played, a little impromptu dancing breaks out and people sip rum cocktails as they watch the sun sink slowly into the sea.

Door of the Capitolio Nacional

ⓘ

Travel to Cuba is complicated by the travel ban imposed by the United States. The national carrier, Cubana, flies from several European and South American airports. There are also a number of flights from Cancún and Mexico City. Visas are easy to obtain and although the US State Department forbids most of its citizens from visiting, the Cuban authorities are happy not to stamp their passports. Accommodation is plentiful in Havana, but for convenience you should stay in Habana Vieja. One of the most atmospheric hotels is the newly refurbished Ambos Mundos, where Hemingway used to stay before he bought a finca (an estate) on the island.

Typical street in Centro de la Habana

Prasat Phra Dhepbidorn [the Royal Pantheon]

Gable of the Temple of the Emerald Buddha

It is easy to lose yourself in the fairy-tale mystique of Wat Phra Kaeo. Shimmering gilt towers, or stupas, vie for your attention with golden buildings topped with soaring arched roofs of multicoloured tiles. Small shrines give out clouds of sweet-smelling incense, and their fearsome stone guardians tower high above your head. But this is no fantasy palace: this is the most sacred place in Thai Buddhism – home to an Emerald Buddha statue so precious that nations have gone to war over it.

Wat Phra Kaeo is a Buddhist monastery inside the Grand Palace in central Bangkok, and although it looks shiny and new it actually dates from 1792, soon after the Thai army captured the Emerald Buddha from Laos. The most important building of Wat Phra Kaeo is the Temple of the Emerald Buddha. This massive prayer hall is built on a marble platform, and surrounded by effigies of gilded *garudas* (mythical divine birds) to ward off evil spirits. The inside of the temple is covered from floor to ceiling with incredibly detailed murals showing the life and teachings of the Buddha.

Guardian statue, Toskarith Ravana

The Emerald Buddha – in reality carved jade and only 75 cm high – sits on a high altar surrounded by other Buddha images. At a small shrine just outside the Temple an almost constant stream of worshippers makes offerings of incense, food and gold leaf, before entering the prayer hall to pray.

On one side of the Wat, on another raised platform, are three stupas, the two smaller ones, encircled by statues of mystical guardians, built as memorials to the parents of King Rama I, who founded Wat Phra Kaeo. Nearby is Prasat Phra Dhepbidorn (the Royal Pantheon), where statues of past rulers are enshrined, and a library, both covered in ornate giltwork. Of interest to anyone heading on to Cambodia is a model of Angkor Wat, made almost 150 years ago.

To appreciate the peace and spirituality of Wat Phra Kaeo it is best to arrive before the coach parties. If you hurry straight to the Wat when the gates of the Grand Palace open at 8.30 a.m., you can generally have up to half an hour of total peace until you see your first camcorder. Alternatively, if you can stand the stifling heat of the afternoon, aim to arrive around 3.30 p.m. – about an hour before the palace closes. Find a shady spot and sit quietly as the crowds thin out, and for the last half hour you will be able to enjoy the place in almost complete solitude. One of the uniformed guards will gently inform you when it's time to leave.

Visitors to the Grand Palace must observe a strict dress code, which prohibits shorts and short skirts, sleeveless tops and sandals.

Spires of Wat Phra Kaeo at sunrise

This code is rigidly enforced and can be expanded at whim to include other 'disrespectful' items. 'Decent' clothing may be hired, but appears to date from the 1970s so it is dubious both stylistically and hygienically.

(i) ···

Bangkok (known to the Thais as Krung Thep, or City of Angels) is easily reached from most capital cities in the world, either on the excellent Thai Airways or on other national carriers. Traffic in Bangkok is notorious and the pollution will literally take your breath away. The most pleasant way to travel is on a river boat on the busy Chao Phraya River and there is a stop for the Grand Palace. Many of the hotels are away from the river on Silom Road but, if you can, try to get a hotel near the river. One of the most famous is the Mandarin Oriental. A much cheaper option, just some 15 minutes' walk from the Grand Palace, is the Vieng Thai near the travellers' enclave of the Khao San Road. The Grand Palace and Wat Phra Kaeo open at 8.30 a.m. Take care to observe the dress code.

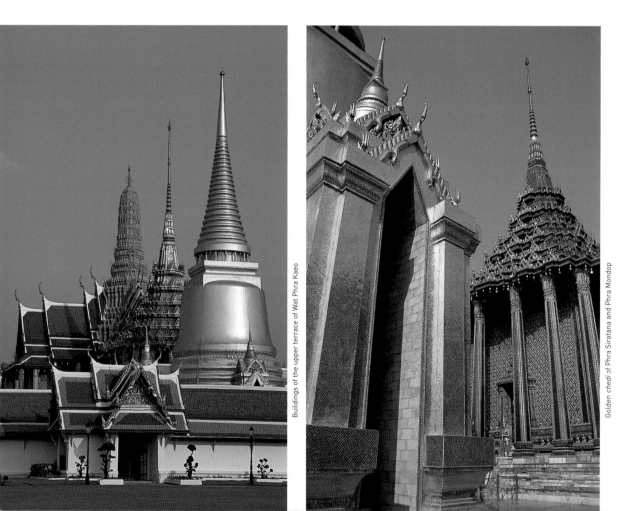

Buildings of the upper terrace of Wat Phra Kaeo

Golden *chedi* of Phra Siratana and Phra Mondop

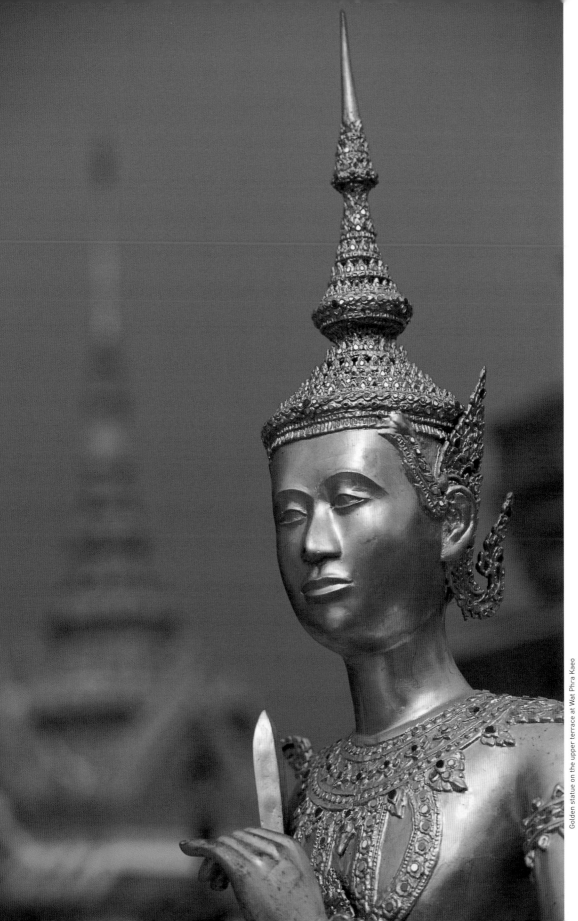

Golden statue on the upper terrace at Wat Phra Kaeo

Grand Canyon
Arizona, USA

As you stand in the cold darkness of an Arizona night, waiting for dawn, you will have no comprehension of the enormity of the landscape in front of you. In the dull early light your first view of the Grand Canyon will be a flat, almost painterly composition. Then gradually the sky turns to blue and red, and golden sunlight starts to pick out details – first the edge of the far ridge, then the tallest pinnacles inside the canyon itself.

Grandview Point

As the sun rises higher, more is revealed. Rock formations sculpted by years of erosion are illuminated, and long, convoluted shadows are cast on to giant screens formed by cliffs.

Only when you notice details, such as a row of trees, or a flock of geese flying overhead, do you come to realize the true scale of the canyon. That far ridge might be 15 km away, and the mighty Colorado River – a mere stream viewed from above – is 1500 metres below.

Consisting of an inner and outer gorge, the canyon is some 450 km long in total, so it is impossible to try taking it all in at once. Far better to spend some time at one or two of the lookout points that punctuate the roads along the rim of the canyon and see the changing light from them. From Hopi Point, a short distance from the Grand Canyon Village, you can look both ways along the canyon, getting

View from Hopi Point

spectacular views of the scenery and watching it change colour throughout the day. You can also see the Colorado River looking deceptively small and tranquil far below.

There are a number of trails down into the canyon. Some of the longer ones will involve camping en route but you can hike down and back up in a day on others, such as Bright Angel Trail – provided you start early enough. However, even for this shorter trail, the park authorities recommend that you break your journey at Indian Garden campsite and spread your hike over two days. Remember, it will take twice as long to walk back up the trail as it took to walk down, and it's

a hard uphill slog. Those not used to exercise can hire a mule to carry them, but the ride is fairly uncomfortable. Trail-walking provides some idea of the scale of the canyon. Distances become more real as you descend, and details of the scenery unfold around you. Soon the walls of the canyon tower above you, and you realize that the landmarks that looked so close from the rim take hours to reach.

View from Yaki Point

View from Yapavi Point

The canyon receives over a million visitors a year, although most stay only a few hours and tend to congregate on the more accessible south rim. To avoid the worst of the crowds, visit in spring or autumn. Although it will be cold at night and in the mornings, the air is clearer and you can observe the canyon in very different conditions. The weather can change suddenly, giving clear blue skies one day and a white-out blizzard the next. However, the great depth of the canyon leads to huge temperature variations between the top and the bottom, so in the course of one day you might walk through heavy snow at the top and hot sunshine at the bottom.

Taj Mahal
Agra, India

The most evocative views of the Taj Mahal are across the Yamuna River, and getting to the Taj is part of the magic. Although it is quicker to take a boat across, taking a cycle-rickshaw through the village of Katchpura is more atmospheric. In the cool of a pre-dawn morning, you will pass villagers sleeping on low charpoy beds outside their small dwellings, often passing so close that they could reach out and touch you.

On arriving at the river you might have to share the view with a fisherman or a small herd of water buffalo, but these merely add to the feeling of timelessness.

From across the river the Taj Mahal is best seen at sunrise, when the light turns from cold misty blue to any variation of pink,

The Taj Mahal viewed from across the Yamuna River The east corner of the Taj Mahal Overleaf: The Taj Mahal from across the Yamuna River at sunrise

pale gold or orange. The Taj mirrors these colours, eventually reaching a soft creamy white, changing, in turn, to a blinding white in the glare of the midday sun. Those who visit at that time of day often come away disappointed. It is worth visiting at different times over several days to appreciate both the might and grace of the structure as it changes with the light. You'll have to pay to enter the Taj Mahal and grounds, but it currently costs nothing to view it from across the river.

The Taj sits on a marble platform with a marble minaret at each corner, and these minarets actually lean out slightly so that they won't fall on the main structure in the event of an earthquake. Each face of the Taj has a giant arch and is decorated with exquisite

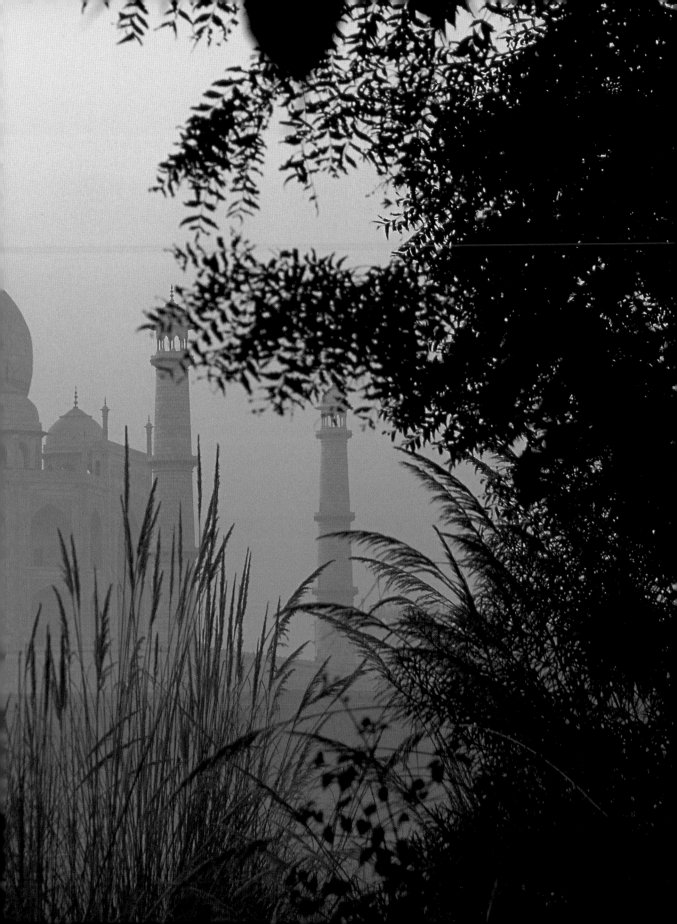

TAJ MAHAL

calligraphy from the Koran and ornate carvings of flowers inlaid with pietra-dura mosaics of semi-precious stones.

The Taj Mahal is set in a relaxed but formal garden complex, with pools of water leading to it from the main gate – a special view that has inspired a generation of photographers. The distance from the gate to the Taj is deceptive and the building seems to grow in both size and stature as you approach.

The Taj Mahal was built in 1632 by Emperor Shah Jahan as a mausoleum for his favourite wife, Mumtaz. Legend has it that he intended to build a duplicate Taj in black marble on the opposite side of the river as his own tomb. In recent years the ruins of foundations and gardens have been discovered there, which seems to support this theory, but the truth will probably never be known. Shah Jahan was overthrown by his son and spent his last days locked up in Agra Fort, just down the river from the Taj.

Western mosque flanking the Taj Mahal

Agra Fort with the Taj Mahal behind

ⓘ ···

Agra can be reached by plane or fast train from New Delhi, although the latter has a reputation for pickpockets. All the rooms in the new luxury Amarvilas hotel in Agra look out on the Taj Mahal so uniquely, you don't have to pay a premium for good views if you stay there. The bustling streets of Taj Ganj, just outside the main gate, were once the home of the craftsmen who constructed the Taj. It is now a backpacker's ghetto with very cheap accommodation. Some of the best views can be had from the roof-top restaurant of the Shanti Lodge. Other attractions include the fort in Agra, which has good views down the Yamuna River to the Taj, and also the deserted city of Fatehpur Sikri a few hours away.

Detail of a door in the pedestal of the Taj Mahal

Detail of the Dome

Eilean Donan Castle
Scotland

Eilean Donan Castle

Situated at the meeting point of three sea lochs – Loch Alsh, Loch Duich and Loch Long – and looking west to the Isle of Skye, the castle of Eilean Donan, or island of Donan, combines spectacular location and colourful history in a way that makes it everything a British castle should be.

The MacKenzie clan held Eilean Donan until the 16th century, during which time it survived feuds with the McLeods and the MacDonalds. It also saw a great deal of action during the 17th and 18th centuries when Jacobites – supporters of the deposed King James VII of Scotland (II of England) – rose up against the English in attempts to take the throne for him and his heirs. In the spring of 1719 the Jacobites garrisoned 46 Spanish soldiers in Eilean Donan. On 10 May three government frigates bombarded the castle. The government force accepted the garrison's surrender and blew up what was not already in ruins with the help of 343 barrels of gunpowder.

EILEAN DONAN CASTLE

The bridge to the castle

Given its long and often violent history, it is not surprising that the castle of Eilean Donan has been rebuilt a number of times. The earliest structure on this site was built in medieval times as a defence against the Vikings, and the most recent rebuilding was by the MacRae-Gilstrap family between 1912 and 1932.

The approach to the castle is understated, and crosses a graceful bridge that was added at the time of the last rebuilding. From this bridge there are views of the lochs, the nearby village of Dornie and the mountains of Skye. Although its outline slightly resembles a broken tooth the castle looks good from almost any angle, set as it is within a fragrant and typically Highland landscape of heather and wild flowers.

The castle approach

Its severe beauty, however, cannot disguise the fact that the castle's primary function has always been defence. There is no retreat from an island battle, and the finality of Eilean Donan's position certainly contributes to its atmosphere.

The end of the bridge is protected by the battlements of the bastion and a wall that extends outwards from the main castle. A doorway leads into the courtyard, which has a sea wall that looks out on to the lochs. Steps lead up to the door of the keep and into the billeting room. Above is the most impressive room, the banqueting hall, complete with beams made from Douglas fir from British Columbia, given by the Canadian MacRaes during the rebuilding. The hall also has a huge fireplace decorated with coats of arms and a table believed to be from one of Admiral Nelson's ships.

At low tide the island is fringed with seaweed and tide pools, but at high tide its exposed position gives it a sense of defiance and it is possible to imagine enemy ships sailing down Loch Alsh, or besieging troops planning to fight their way across to the castle.

Reflected in the waters of the loch and framed by mountains, the castle is now a place of dreams rather than drama.

The billeting room

The banqueting hall

Eilean Donan Castle at night

(i) ..

Eilean Donan Castle is in a fairly remote location 16 km from the bridge to the
Isle of Skye. Driving from Glasgow takes about 7 hours, primarily on the A82, but
the road passes through some essential scenery, including Ben Nevis, Glen Coe,
Loch Lochy and Glen Shiel. Driving from Edinburgh also takes 7 hours, and from
Inverness 3 hours. The nearby village of Dornie is small and has limited hotel
and bed-and-breakfast capacity, especially in the summer months, so booking
ahead is advisable. The road leading up the hill behind Dornie has good
views above the castle, especially at sunset.

Cloister at one end of Patio de los Arrayanes, Casa Real

Patio de los Leones

Overlooking Granada, the Alhambra presents a hard and unyielding face to the world, its square towers displaying martial symmetry. This severity is softened when you approach from the back, as terraces of ornate gardens, interspersed with pools of running water, seek to emulate the shady, cool gardens of the Koranic heaven.

After the heat and dryness of North Africa the Moors must have thought they had reached heaven when they conquered Granada. The Sierra Nevada, snow-capped for much of the year, provided the conquerors with water for the fountains and pools that helped to make this corner of Spain paradise on Earth.

The Alhambra is a product of the wars between Christianity and Islam. The Moors of North Africa conquered Spain in 711, but by the beginning of the 13th century their influence had weakened and their 'kingdom' – just a few independent Muslim states in what is now Andalusia – was under pressure from Christian *reconquistas*. Prince Ibn al-Ahmar, who was driven south from Saragossa, decided to

THE ALHAMBRA

create a new capital at Granada, and began building the fortifications that would keep it safe. For over 200 years the kingdom prospered, and subsequent rulers added to and refined the Alhambra. It was a period of peace that came at a price, however. During this time the Christian kings of Spain were in the ascendancy, and Granada was left in peace only because the Moors paid tributes and sometimes sent troops to fight on the side of the Christians against other, more troublesome, Muslim city states.

At the end of the 15th century the battlements of the Alhambra were called into use when the army of Catholic rulers Ferdinand and Isabella laid siege to Granada. Seven months later this last Muslim stronghold in Spain gave way, and it has remained in Spanish hands ever since.

Typical of Moorish architecture, the palace has a façade that is both commanding and utilitarian, yet hidden within its defensive walls is decoration of enduring beauty. The Alhambra consists of

The Alhambra floodlit at dusk with the Sierra Nevada behind

three main parts: the Alcazaba, or fortress; the Generalife, which was the summer palace and actually lies outside the main defensive walls; and the Casa Real, or Royal Palace. The last of these is without doubt the most beautiful part of the Alhambra, many of its rooms decorated with colourful tiles or richly carved stonework, the patterns based on stylized quotes from the Koran.

Gardens of the Generalife

Within some of these rooms you can still see the fountains or pools of water so prized by the Moors. Numerous small windows overlook shady gardens or the small white houses of the Albaicin district, the old Moorish quarter, parts of which are as old as the Alhambra itself.

Spring is a beautiful time to visit, with clear warm days and cool nights. The trees are newly green, the gardens are in flower and the

Intricate Moorish decoration

Sierra Nevada, still snow-capped, stands watch over the city. Even better, the Casa Real is not crowded and you can generally get in without queueing or waiting for a slot, as you must in the height of summer, when all the timed entrance tickets are often allocated within an hour of the ticket office opening.

You might also be able to get a room at the Parador de San Francisco, a luxury, state-run hotel in a converted monastery within the gardens of the Alhambra – a tranquil retreat in the evenings when the crowds have gone.

There are many vantage points around the city from which you can get a different perspective on the Alhambra. From the Mirador San Cristobel you will see the Alcazaba against the backdrop of the Sierra Nevada. Walk through the rambling, cobbled streets of Albaicin to the Mirador de San Nicolas and you will see wonderful sunsets that bathe the Alhambra in glowing red light. From the top of the Sacromonte (the old gypsy quarter, where some gypsies still live

in caves carved into the hillside) you will see how the Alhambra towers over the town from its perfect defensive position. And from the hill above the Generalife you can appreciate how much the gardens and water terraces contribute to the Alhambra. Also visible is the massive Palacio de Carlos V, built in the 16th century, after the Christian conquest, on the site of many lesser Moorish buildings. The grounds of this palace are so large that bullfights were once held in the courtyard.

Moorish decoration

ⓘ Granada is easily reached by road from Seville or Málaga, two international airports that are well served by the Iberia airline from most parts of Europe. While the Alhambra is seen to advantage from many viewpoints around the city, you can enjoy it at close quarters by staying in its gardens at the luxurious Parador de San Francisco. However, you should book well in advance for the privilege, even in the low season.

Tha Alhambra seen from the hill behind the Generalife

Aitutaki
Cook Islands

No artist's palette could ever conceive of a more perfect, more luminescent turquoise than that of the lagoon of Aitutaki, arguably the most beautiful in the world. Triangular in shape, the lagoon is formed by an atoll that rises some 4000 metres from the base of the Pacific Ocean. Within the lagoon is Aitutaki itself, the main island of the group, and a number of volcanic and coral *motus*, or islets.

The outer rim of the lagoon acts as a natural barrier that calms the sometimes rough waters of the southern Pacific ocean. The meeting point of the waters is marked by a constant white fringe of breaking

Moturakau Island

The lagoon from the air

waves, but the lagoon itself has a glassy smooth surface only
occasionally broken by a solitary breakaway ripple. Its waters are
remarkably clear, and every detail of its flat, sandy base is perfectly
visible, however deep the water. Turtles, rays and even giant clams can
often be seen.

Each *motu* has its own distinct character, and one of the best
ways to witness this is by taking a lagoon cruise. The most well-
known *motu* is Tapuaetai (One Foot Island). Typically tropical, with a
stand of palm trees perched on a thin sliver of dazzling white sand, it
is the only inhabited *motu*. Alongside its small bar and shop is a post

The lagoon

office where you can get your passport stamped to show that you have been to paradise.

The tiny island of Moturakau was chosen as the location for a British reality TV series. It takes only about 10 minutes to walk around, and is another haven of white sandy beaches and palm trees. Here some of the trees lean so far out over the sea that they are almost horizontal.

The newest of the *motus* is Honeymoon Island, which is tucked away in a shallower part of the lagoon. While it hasn't been around long enough to grow any trees, a number of bushes provide shelter for a large population of nesting terns. Every bush seems to have a fluffy white chick crouched beneath it, waiting for its parents to return with food. The restless Pacific carries windfall coconuts from other *motus* and washes them up on the beaches of Honeymoon Island, so it might not be too long before the first palm tree takes root.

The 15 tiny islands that make up the Cook Islands archipelago have a total land area of just 236 square kilometres but are spread over a vast area of ocean. Their inhabitants are of Polynesian descent, and the total population is around 18,000. On Aitutaki everyone appears to know each other, and no task seems so important that

Giant clams in the clear waters of the lagoon

they won't take the time to say hello to passers-by. Try walking anywhere and people will stop to offer you a lift.

Others, apart from tourists, are attracted to Aitutaki – as indicated by the captain's languid announcement on the flight from Rarotonga: 'Passengers on the left of the plane, if you look out of the window, you can see Aitutaki, whereas passengers on the right can see a humpback whale and her calf.'

For such an out-of-the-way place, Aitutaki has a significant claim to fame: Captain Bligh arrived here on the *Bounty* in 1789, shortly before the famous mutiny. He returned in 1792 and introduced the pawpaw to the island, where it remains one of the most important crops.

(i) ···

Air Rarotonga flies from Rarotonga (the capital island in the Cook Islands archipelago) to Aitutaki up to five times a day. It is possible to visit Aitutaki on a day trip from Rarotonga, but it is much better to stay there for at least a couple of days. Accommodation varies from the luxurious Aitutaki Pacific Resort to inexpensive communal beach huts. Any of the hotels will be able to book you on one of the lagoon cruises. Visit www.cook-islands.com for more information on all aspects of the Cook Islands.

Beach on Akitua Islet

Beach on Akitua Islet

Dead starfish

Hermit crab

Pyramid of Kukulcán
Mexico

The stone serpent's head near Kukulcán's pyramid

Sitting at the centre of the ancient Mayan site of Chichén Itzá on the Yucatán peninsula in Mexico, the pyramid of Kukulcán has a pleasing symmetry and an imposing bulk, but perhaps its true majesty lies in the secrets of its construction – over 1000 years ago.

The pyramid is a giant calendar. It consists of nine levels faced with a total of 52 panels – the number of years in the Mayan–Toltec cycle. The staircases on each face of the pyramid have 364 steps. Add the square platform at the top, and you have 365 – the number of days in

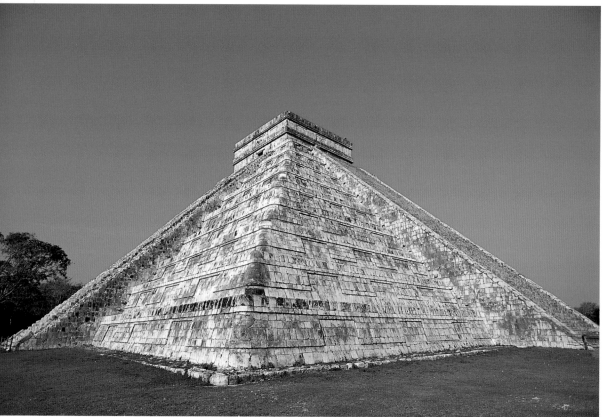

Kukulcán's pyramid

the solar year. Most impressively, at the spring and autumn equinoxes the shadow cast by the sun on the northern staircase appears to cause a massively long 'snake' to crawl down the building and link with the stone serpent's head at the foot of the staircase.

The pyramid of Kukulcán has other secrets too. Hidden deep within it is another, much older pyramid. A small door takes you to a narrow passage that appears to run up what would have been the outside of the original structure. Cramped and oppressive, it leads to the original sanctuary, where a large *chac-mool* – the characteristic reclining Mayan figure – and a jaguar-shaped throne are for ever entombed, the jade inlay of the big cat's coat shining dimly through the gloom.

Detail of cladding on Kukulcán's pyramid

North staircase on Kukulcán's pyramid

You will have to get up early to appreciate Kukulcán properly because by 10.30 a.m. it is swarming with visitors. If you are among the first through the gate at 8.30 in the morning, you should manage an hour of near-solitude. A good way to achieve this is to stay at the Mayaland Hotel, just a few metres from the quiet east gate. Here you will be so close that you can see the ruins of the ossuary, or bone sanctuary, silhouetted by the setting sun and filling the doorway of the hotel bar.

From the top of the pyramid the whole site seems to be completely surrounded by a sea of trees stretching as far as the eye can see, and obliterating almost all signs of human life. Only the tops of some of the lesser ruins and the open grassed ceremonial area are visible.

Relief of Adam and Eve on the corner of the Palazzo Ducale

Gondolas moored in front of the church of Santa Maria della Salute

No city is more romantic than Venice, and no sight more essentially Venetian than gondolas bobbing on a misty Molo, the waterfront where the Piazza San Marco meets the lagoon. In the very early morning the square is quiet, with only a few commuters disturbing the handful of pigeons that strut imperiously on its worn flagstones. Soon the place will be thronged with both tourists and birds, but for now you can be virtually alone.

Piazza San Marco has been at the centre of the city since it was first constructed in the 16th century, although some of the buildings around it date from much earlier. At one end lies the Basilica di San Marco,

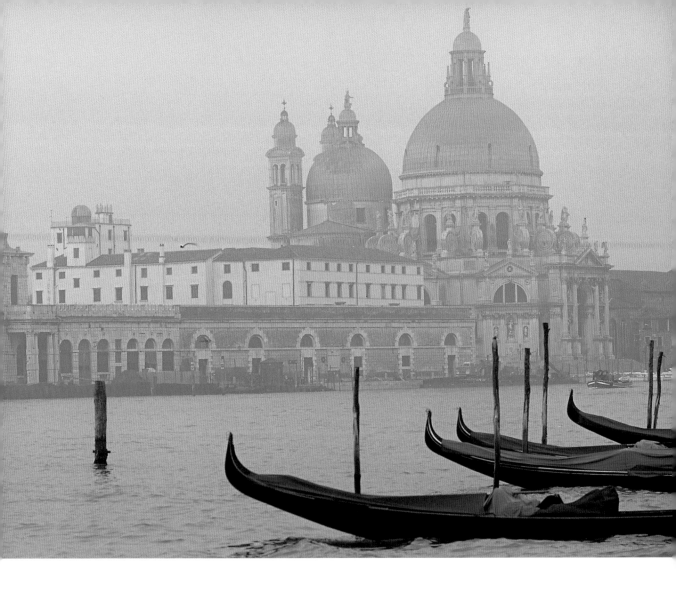

construction of which began almost 1000 years ago. Squat and strangely shaped, its domed roof looks more Islamic than Christian when seen from the soaring heights of the adjacent campanile, or bell tower. At sunset the façade of the basilica seems to come alive as the mosaics, and even the stone itself, glow in the warm evening light.

Stretching from San Marco down to the waterfront is the Gothic white edifice of the Palazzo Ducale, or Doge's Palace. The doges ruled the city from AD 697 until Napoleon's troops deposed the last of them in 1797. Although peppered with moralistic statues and carvings that depict such things as the fall of Adam and Eve, and a drunken Noah, the palace is best appreciated from afar, as it would

have been by visitors arriving by sea in the days of the doges. Seen from a boat on the lagoon, or even from the top of the campanile on the island of San Giorgio, the façade combines elegance with a feeling of fantasy.

If the doges wished to portray an impression of piety with the outside of their palace, the inside shows a much more worldly extravagance. Room after room is decorated with the finest gilding and paintings, including works by Titian and Tintoretto.

The doges were responsible for the judicial side of Venetian life, and many condemned people were led across the two-lane Bridge of Sighs to the prisons opposite.

Although not, strictly speaking, connected to the Piazza San Marco, the Grand Canal is linked with it. A lazy, sweeping 'S' shape, it

Façade of buildings around Piazza San Marco

Piazzetta San Marco

cuts through the city, defining it almost as much as the piazza does. The end of the canal opens into the lagoon where it meets the piazza, and the waterfront here is lined with the ubiquitous gondolas.

As all roads in Venice seem to lead to Piazza San Marco – virtually every street or alley junction has a signpost pointing in that direction – so all canals seem to lead to the Grand Canal. Now used mainly by tourists, gondolas still glide past the palazzos that line its sides.

Venice can be cold and damp during the winter, but this is a perfect time to visit. There are far fewer visitors, hotel prices are lower and, if you are lucky, you might even be there when the water floods Piazza San Marco, forcing locals and tourists on to raised walkways to keep their feet dry. Even in the winter you can experience blue skies and amazingly clear light.

Palazzo Ducale

75

A perfect winter day in Venice has to end with a warming hot chocolate or a typically Venetian spritz cocktail (white wine, lemon peel, a bitter aperitif and seltzer) at Caffè Florian. Founded in 1720, this elegant café, once patronized by Byron and Goethe, is decorated with mirrors and murals cracked by years of damp sea air.

ⓘ ···

From Marco Polo airport you can catch a *vaporetto* (water bus) or water taxi that drops you off at the Molo. Accommodation is expensive and can be hard to find in the peak summer months. The industrial town of Mestre is a short train ride away and offers cheaper options. The Regina and Europa Hotel is a luxury establishment in a converted palazzo, overlooking the mouth of the Grand Canal. A network of *vaporetti* ply the main canals and are a good way to get around. Otherwise, just walk and enjoy the experience of getting lost.

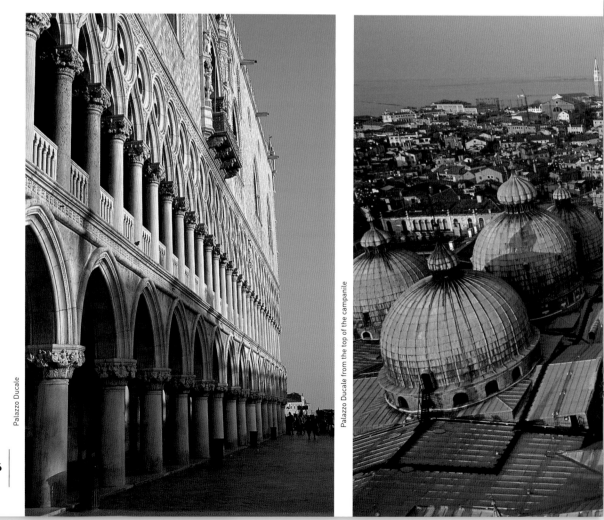

Palazzo Ducale

Palazzo Ducale from the top of the campanile

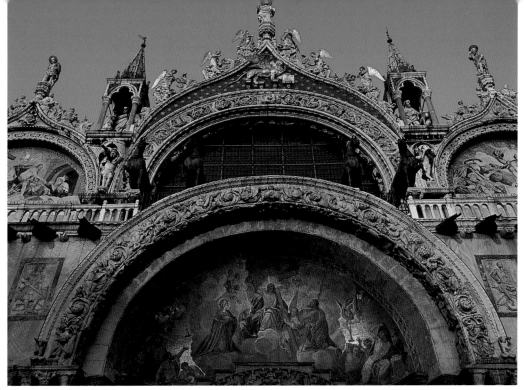

Façade of the Basilica di San Marco

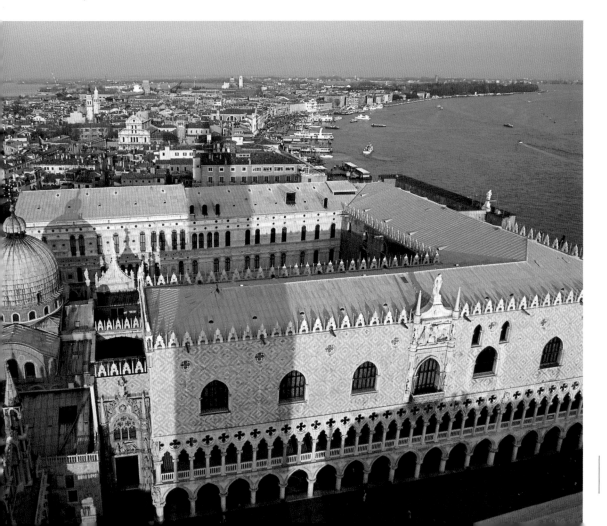

Dead Vlei

Sossusvlei National Park, Namibia

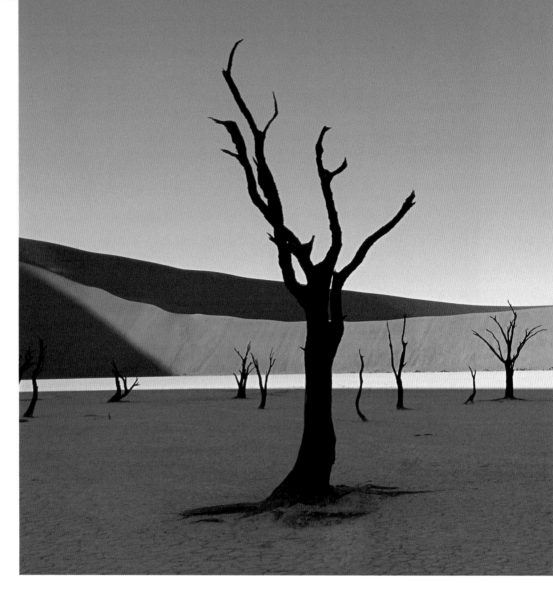

In the parched landscape of the Namib Desert, the golden-orange light of dawn starts by illuminating the very tips of the dead camelthorn trees that point skeletal branches at the lightening sky. It then moves down their trunks and onwards, just as it has done every morning of their 600-year existence, until it reaches the drought-crazed white surface of Dead Vlei. Then everything appears to speed up, as the sunlight pushes aside the shroud of shadow and sweeps across the pan of the former lake. The contrast between the cracked white of Dead Vlei and the red sand dunes that surround it is stark. There is literally a hard line where one finishes and the other begins.

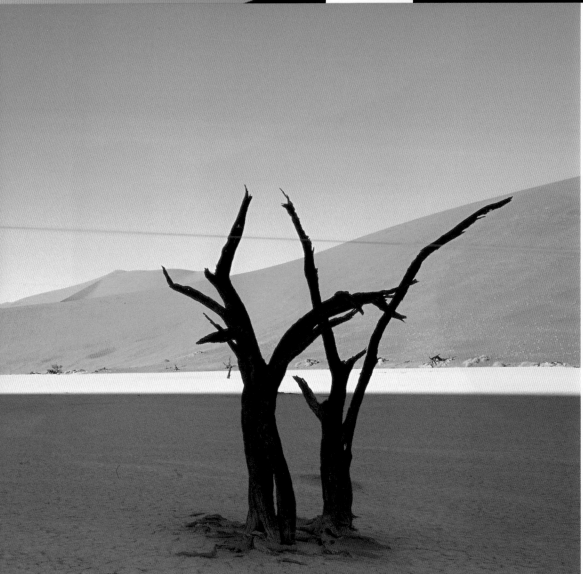

Shadows sweeping across Dead Vlei at sunrise

A vlei is a lake pan, and there are three in the Sossusvlei National Park. Although Dead Vlei is smaller than the more famous Sossusvlei that gave the park its name, it is more atmospheric and has a more impressive location. (The third is the even smaller Hidden Vlei.)

Sossusvlei is part of the great Namib Desert from which Namibia takes its name. As public transport links to the park aren't good, travellers generally find it much easier to stay at one of the luxury camps that run their own transport into the park. If your budget won't stretch to this, cheaper accommodation is available near the park gate at Sesriem.

Drivin
for four-w
However,
situated a
a shuttle b
20-minute
Despite
Sossusvlei v
living memo
stalk around
for the day to
down at the
beetles.Thes
sand, and sur
sometimes s
Atlantic coast
that forms on

The natior
reputed to be
Sossusvlei, is d
which is especi

You should
make sure you t
experience. Fr

Iguassu Falls
Brazil and Argentina

If you were to design the perfect waterfall then Iguassu would have to be it. Straddling the border between Brazil and Argentina, where it is known as Saltos do Iguaçu and Cataratas do Iguazú respectively, it comprises a range of cataracts.

One such is the Devil's Throat (Garganta del Diablo), which has a classic horseshoe shape and drops into a deep chasm. A walkway runs from the Argentinian side to the edge of the cataract, allowing you to stare directly at the wall of water as it drops into the void below.

Spray over Iguassu Falls at sunrise

Salto Tres Mosqueteros on the Argentinian side

The Devil's Throat (Garganta del Diablo) and the top of Salto Santa Maria

There are flights to Foz do Iguaçu, the town on the Brazilian side of the falls, from both Rio de Janeiro and Saõ Paulo. Though many people do day trips from these cities it is better to stay for at least a couple of days to allow time to visit the Argentinian side. This is very easy – most local hotels arrange trips – and you won't even need a visa. You can also raft on the river, explore the surrounding forest and even take a helicopter ride. The Tropical Las Cataras hotel on the less-developed Brazilian side will give you privileged access to the falls – especially on Monday mornings when the park is officially closed to non-guests.

Petra

Jordan

The city of Petra was carved from red sandstone in the 3rd century BC by nomadic Arabs known as Nabataeans. The only entrance is through a *siq* – a long, narrow gorge. This channel, eroded by thousands of years of floods, forms a twisting and convoluted pathway through solid rock that looms up to 100 metres on either side.

At some points along its 1.2-km length the *siq* is wide enough for the sunlight to flood in and lift the dark and oppressive atmosphere, but at others it is no wider than a couple of metres, and the walls appear to close above your head. An early morning visit can be an eerie experience, with just the wind whistling through the gorge and the strangely tinny echo of your own footsteps.

The royal tombs seen from the High Place of Sacrifice

Looking down the *siq* to Al Khazneh (the treasury)

At one time the *siq* would have been crowded with camel trains laden with wealth, and even the invading Romans, who finally conquered the city in AD 106, would have had to fight their way down its entire length.

Rounding the final and narrowest corner of the *siq* you are confronted by the towering façade of Al Khazneh (the treasury), which is the enduring image of the city. Although the carvings on the treasury have been damaged by Bedouin, who once lived among the deserted ruins and used the statues for target practice, there is still much to be seen. This includes the large urn on the top of the structure, that the Bedouin shot at in the belief that it contained the lost treasure of King Solomon.

The façade of Al Khazneh (the treasury)

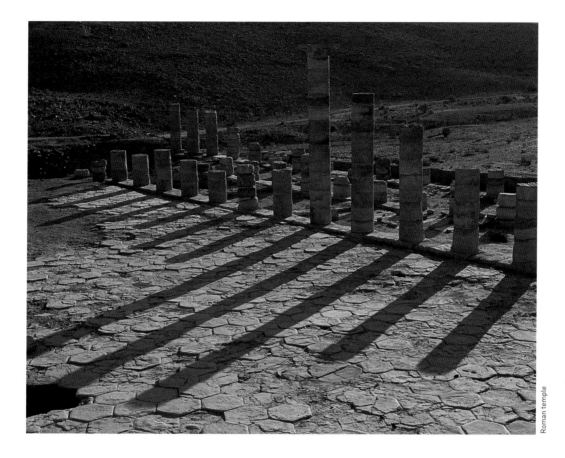

Roman temple

Excavations taking place in front of the treasury seem to indicate
that it had another storey below the current structure, which is now
buried under debris washed down by the annual flash floods that
created the *siq*. The treasury is fully bathed in sunlight for a couple of
hours from around 9.30 in the morning, but looks pinker and more
atmospheric when in shadow. A good, though officially unsanctioned,
view can be had by climbing the rock face to the right of the *siq*, to a
ledge level with the top of the treasury.

All the great façades, including the treasury, are, in fact, tombs.
Dwellings have long since disappeared, but you can still see the
7000-seat theatre carved out of rock, and a temple built by the
Romans when they governed the city. There is also a major stretch of

Nabatean road running past an old market area that would once have been thronged with shoppers and merchants trading goods and treasures brought to Petra from all over the Middle East.

It is no wonder that, tucked away in the middle of the desert, the city remained hidden and forgotten for 300 years after it was finally deserted, with only Bedouin living in its caves and tombs. It was 'rediscovered' for the West by Johann Burckhardt in 1812.

Although the Bedouin no longer live in the city they are still much in evidence, having been given sole rights to the various tourist concessions on the site in return for moving out to a nearby village.

Eroded carving of a man with a camel in the *siq*

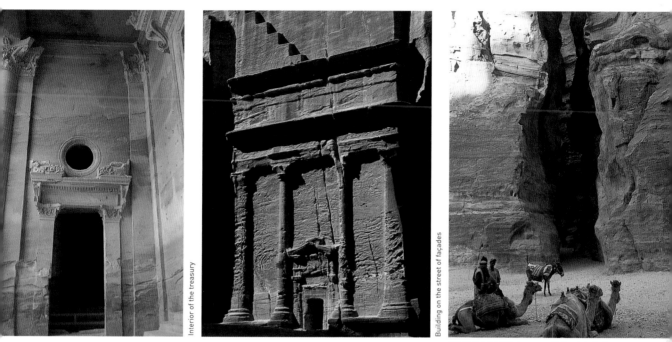

Interior of the treasury

Building on the street of façades

Camels in front of the treasury with the *siq* behind

Petra is huge, and you will need a good few days to do it justice, especially if you are planning to visit some of the more outlying places, such as the monastery up in the adjacent hills. A good way to appreciate the size of Petra is to climb the steep steps to the High Place of Sacrifice, where you can see over most of the city and watch as the sun slides behind the camel-shaped mountain on the far side of the valley, before making your way back to your hotel through the rapidly darkening *siq*.

ⓘ ··

Petra is just a few hours' drive from the Jordanian capital Amman and is easily reached by bus or by car. There are a number of hotels in Petra, but the five-star Movenpick is just a few minutes from the site gate, making an early start a little easier. There are places inside the site that sell food and drinks but you should carry adequate water with you to avoid dehydration. The site is open from dawn till 6 p.m., although you can often linger longer to see the sunset. Passes for one, two or three days are available from the visitor centre. You can also hire a guide there.

Glacier flowing down from the Chugach Mountains

Face towards one of the 16 glaciers that carve their way down the Chugach Mountains of College Fjord and even though the ambient temperature is low, you will be able to feel a wave of cold air coming from these solid walls of ice.

College Fjord was discovered in 1898 by an expedition looking for a way to get to the goldfields of the Klondike without having to pass through the Yukon. The fjord runs for 30 km and the glaciers in it are named after American Ivy League colleges. The furthest point is Harvard Glacier, one of the few that is still advancing towards the cold waters of the Gulf of Alaska. Although others are still grinding down steep-sided valleys towards the sea, they are melting faster than they are moving, which gives them the appearance of retreating.

The most convenient way to reach College Fjord is on a cruise, which will generally take in Prince William Sound to the south-east, and for the more adventurous there are opportunities to kayak in close to the glaciers. Aim to be up for sunrise, when the clouds that

Fog over College Fjord with the Chugach Mountains in the background

COLLEGE FJORD

often flow over the Chugach Mountains and sometimes blanket the waters of the fjord are stained orange and purple by the early morning light.

The colour of the ice ranges from a clean, stark white at the top of a mountain through to a range of turquoise and blue at the hard ice face. (No wonder the languages of many native peoples from cold regions have many different words for ice and snow.) The glaciers are also stained by earth and rocks picked up as they carve their way down the steep-sided valleys. They move in geological time and there is a distinct line at the point where the rock and forest on the mountain meet the snaking ice flows.

The size and scale of the fjord and glaciers are difficult to estimate. Viewed from a ship the solid walls of ice meeting the sea seem perhaps as high as a house, but in reality they could be 10 times that. The compression of scale also obscures the structure of the glaciers. From afar, they look merely ridged and pitted, but as you get closer you will be able to make out great cracks, sheer spikes and deep ravines formed by the incredible pressure as millions of tonnes

Orcas (killer whales)

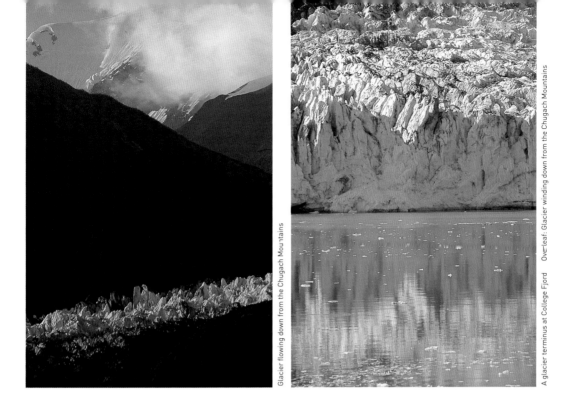

Glacier flowing down from the Chugach Mountains

A glacier terminus at College Fjord Overleaf: Glacier winding down from the Chugach Mountains

of ice scour down the mountains, gouging out rock on either side. As each wall of ice reaches the sea it plunges into the water, causing large chunks to break off and float across the fjord. This process is known as 'calving'. Some of the falling chunks can be the size of a house, and the noise of them splitting from the glacier and then hitting the water is phenomenal. At sunrise and sunset these chunks of ice catch the light, making the sea look like a giant sheet of cracked and pitted glass.

For such a seemingly inhospitable environment there is a surprising amount of wildlife in College Fjord. If you are particularly lucky you might see stark black-and-white orcas on your cruise, or even pure white beluga whales, although you are more likely to see sea otters or seals in the icy waters.

ⓘ ···

College Fjord's remote location means it is practically impossible to reach it by any means other than a cruise ship. Cruise lines such as Norwegian Cruise Line or Princess Cruises make a seven-night one-way journey from either Seattle or Vancouver up to Seward (which is 3 hours from Anchorage), usually stopping at Ketchikan, Juneau, Skagway and Glacier Bay. There are also round trips from Seattle or Vancouver, or one-way cruises southbound from Seward. The best time to go is between June and August, as the winters are long and bitter.

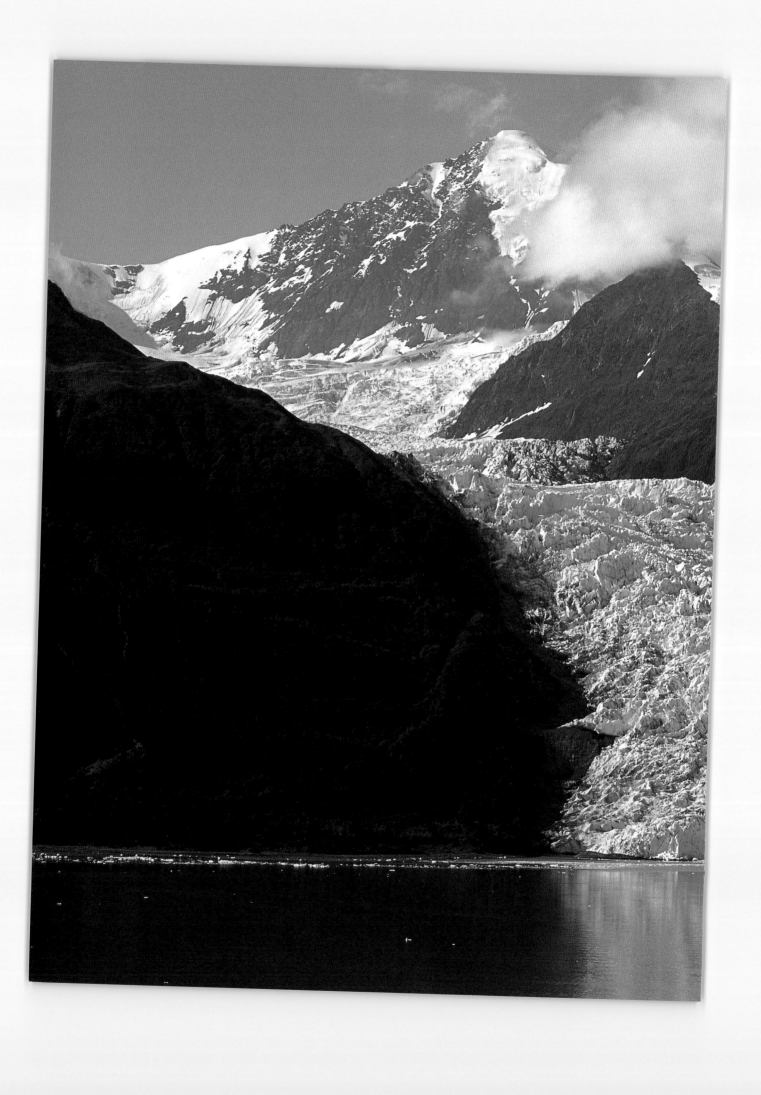

Statues in front of the seventh pylon of the Precinct of Amun

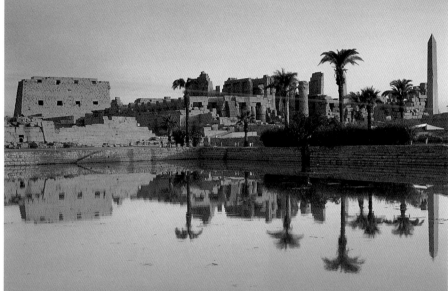

The Precinct of Amun reflected in the Sacred Lake

Karnak Temple is a lasting tribute to the ancient Egyptian pharaohs' quest for immortality. And as a powerful religious institution it is arguably more representative of life in ancient Egypt than the Giza pyramids which, despite their impressive size, are ultimately tombs for the dead rulers of the Old Kingdom. The temple's influence, which lasted for more than 1300 years, was central to the power of numerous New Kingdom pharaohs, including Seti I and Rameses II.

The Great Hypostyle Hall, which is more than 3500 years old, covers an area of 6000 square metres and contains a forest of 136 stone pillars, each 23 metres tall and 15 metres in circumference. Many of these have been extensively renovated, but are still covered with deeply carved hieroglyphics and elaborate bas-relief depictions of Egyptian gods, especially Amun to whom this precinct of the temple is dedicated. Some of the pillars still bear traces of the original colouring, dating back to around 1300 BC.

In the days of the pharaohs the whole of the hall would have been roofed over, and the remains of some of the lintels that supported the roof can still be seen. The interior would have been in semi-darkness, punctuated by shafts of light from grilled windows along the central aisle. It is easy to imagine processions of priests passing through its hallowed halls, and even Pharaohs coming to admire the bas-reliefs of gods in their own image.

The Precinct of Amun is the largest and most complete of the three enclosures that make up Karnak Temple. The other enclosures, the Temple of Mut and the Precinct of Mont, are largely ruins.

Defaced bas-reliefs in a sanctuary in the Precinct of Amun

Whilst the Great Hypostyle Hall is Amun's most impressive structure, there is a great deal more to see in the complex. From the entrance, an avenue of ram-headed sphinxes leads up to the first pylon, a 43-metre-high wall with a gap in the middle to allow entry. Inside the courtyard beyond the wall is a colossal statue of Rameses II, and a small temple devoted to Rameses III. There are a number of sphinxes outside this temple and more tall statues inside. Beyond the next pylon lie the pillars of the Hypostyle Hall, and beyond that the rest of Karnak Temple, which you could easily spend a couple of days exploring. I would recommend employing the services of a local guide, if only to save you from the temple guards and their constant demands for baksheesh, a small tip.

Karnak tends to get very crowded during the day, but if you arrive as it opens at six in the morning it is often deserted. Take the correct entrance money as the gate seldom has change at this time, and leave by 9 a.m. to avoid the worst of the crowds. If you can cope with the afternoon heat, it's worth returning after 3 p.m. when the tour

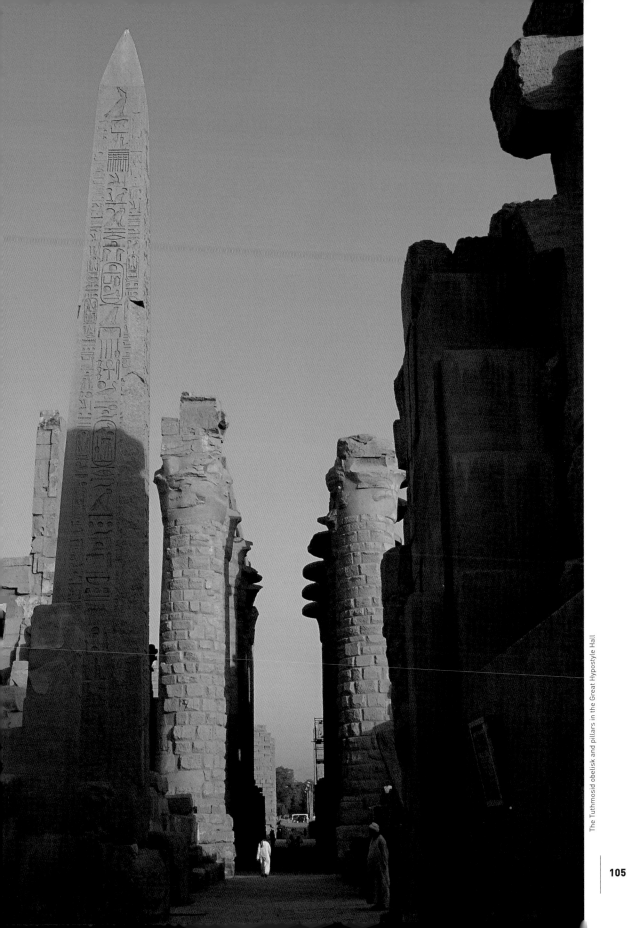

The Tuthmosid obelisk and pillars in the Great Hypostyle Hall

KARNAK TEMPLE

Pillars in the Great Hypostyle Hall

Bas-relief on the exterior wall of the Great Hypostyle Hall

groups have left and the temple is quiet again. You can sometimes use the same ticket in the morning and afternoon, especially if you mention at the gate when you leave that you will be returning.

You can return to town by walking along the Avenue of Sphinxes, once the route of a procession in honour of Amun. Nowadays, many of the sphinxes are missing and the avenue disappears briefly on the outskirts of Luxor. It can be picked up again at the back gate to Luxor Temple, where it joins a more impressive avenue of sphinxes linking the temples of Karnak and Luxor just as they were linked in the time of the pharaohs.

Luxor is easily reached by internal flights from Cairo or you can catch the very comfortable night train from the capital. The most famous hotel in Luxor is the old Winter Palace in the centre of town, but the Nile Hilton Hotel is more convenient for Karnak. Official guides can be hired from the ticket office but agree the price first. Taxis are very cheap but, as with everything in Egypt, haggle hard. You can also take a horse-drawn calèche, but choose only healthy-looking horses and stop the driver from galloping them. Do not leave Luxor without visiting the Valleys of the Kings and Queens across the Nile.

A sanctuary in the Precinct of Amun

The feet of the colossus of Rameses II in the Precinct of Amun

Rio de Janeiro
Brazil

View from Corcovado Mountain to Sugar Loaf Mountain at dusk

The mountain of Corcovado, topped by a 32-metre statue of Christ the Redeemer facing out over Guanabara Bay, has to be the great enduring image of Rio de Janeiro. From up here, on a clear day, you can see almost the whole city, from the downtown business district to the internationally famous beaches of Ipanema and Copacabana. It also has one of the best views of Sugar Loaf Mountain, another of the city's great landmarks.

Rio is arguably the most stunning harbour city in the world, pipping
both Sydney and Hong Kong in my estimation. While the last two are
amazing in their own way, Rio has the advantage of being built on a
series of hills, some of which are still covered by virgin forest, and
looks out over the most beautiful natural scenery of the granite
islands in Guanabara Bay. Corcovado, set within a park that opens at
8 a.m., can be reached either by taxi or by a creaking old tram that

Looking down from Corcovado Mountain

Christ the Redeemer

winds its way up to the summit. You should really make the effort to reach the top early in the morning when misty clouds, backlit by the rising sun, sometimes fill the bay, with just the tops of the islands peeking above them. It's also well worth visiting at sunset, when the sun sinks into the hills behind Rio and the city lights up.

Similarly, the view of both Rio and Corcovado from Sugar Loaf Mountain is worth seeing at both ends of the day, when the city assumes quite different appearances.

Ipanema Beach

If you want to see the actual sunrise you will have to take a taxi to San Cristobel Point, which lies outside the park. Although not as high as Corcovado, it still enjoys a commanding view over the bay.

From the top of Sugar Loaf Mountain it is possible to take a very short helicopter ride that flies you up and around the statue of Christ the Redeemer for less than £30.

Rio, however, is about so much more than sights or even natural beauty. No other city in the world epitomizes the 'Life's a Beach'

Copacabana Beach

philosophy more than Rio. And where better to see this than at
Copacabana and Ipanema? Both immortalized in song, these beaches
mirror the character of the cariocas, as the citizens of Rio call
themselves. As the clubbers who congregate there to wind down after
an all-night party give way to the first of the morning's joggers, the
next 24 hours will see everything from holidaymakers to beach boys,
from volleyball players to bodybuilders – all set to a background of
bossa nova music and perhaps accompanied by a cocktail.

Rio has endured a bad reputation for street crime over the years,
but has gone a long way to clean up this problem. As with most major
cities, drugs and poverty make certain parts of the city riskier than
others, but if you stick to the main areas (which include all the
principal tourist sites) and don't carry valuables conspicuously, you
will probably find Rio far less threatening than many European

Santa Teresa tram

capitals. In fact, the biggest annoyance I suffered – though totally well meaning – was that the locals constantly warned me to be careful with my possessions.

ⓘ ..

Many airlines fly to Rio from all over the world. Most of the hotels are out along the beaches of Copacabana and Ipanema. The most famous hotel is the Copacabana Palace, run by the Orient Express Group. Even if you do not stay there you should visit the terrace bar for a sundowner. When on the beach, leave all your valuables in your hotel or with the guards posted on the beach by most of the top hotels. The downtown area is quite a way from the beaches, but taxis are cheap and plentiful. The stunning views from Sugar Loaf Mountain and Corcovado are not to be missed.

View from Corcovado Mountain

Taman Negara Rainforest
Malaysia

Looking down from the canopy walkway at Kuala Tahan

View from Bukit Teresek

Dating back over 130 million years, Taman Negara is the oldest rainforest in the world. Home to elephants, the Sumatran rhinoceros and even tigers, as well as 14,000 species of plants and 300 species of birds, the forest is just three hours' drive from the city of Kuala Lumpur, the capital of Malaysia.

The best way to reach the national park that surrounds the forest is to take a bus to Kuala Tembeling, from where you can catch a boat down the river to the park gate at Kuala Tahan. This boat journey is a major part of the Taman Negara experience, and makes you realize just how isolated it is from the outside world. Skirting the border of the park, the trip offers breathtaking views of the forest overhanging the water.

At Kuala Tahan is the Taman Negara Resort, which offers all sorts of accommodation, from cheap hostel beds to luxurious suites. Moored along the river bank opposite are several floating restaurants selling cheap local food. The resort is inside the park and the rainforest starts where the resort stops, although monkeys and birds are no respecters of this and can be seen all over the grounds.

Take just a few steps into the rainforest and it closes around you, cutting off the outside world. The trees muffle external noise, obscure the horizon and even change the weather, masking out the sun in a way that can be both sheltering and oppressive. It takes a while to get used to the sound of the rainforest. The continual white noise of insects is punctuated by the shrill shrieks of animals or birds. At night this sound magnifies, and its intensity can sometimes prevent sleep.

With elephants, tigers and poisonous snakes roaming around, and biting insects filling the air, the rainforest can be a hostile environment. Watch out too for the leeches that appear after the regular downpours of rain, littering the paths and ready to latch on to any animal or human that happens to brush past. For many visitors, walking through the rainforest can arouse primeval fears and bring a state of awareness that has been long since lost in normal daily life.

Cascade of Lata Berkoh on the Sungai Tahan River

Visitors to the rainforest divide into two types: those sensitive to the majesty, fecundity and minute beauty surrounding them, and those who quite literally can't see the wood for the trees. There are, of course, 'sights' at Taman Negara, such as the waterfall at Lata Berkoh and the hill-top view out over the trees from Bukit Teresek, but the real marvels are all around you: lianas hanging from soaring trees, giant buttress roots that you could hide half a dozen people behind, flashes of colour from darting birds, patterns of dappled light and slow-moving rivers littered with dead vegetation.

Looking up towards the canopy

A short walk from Kuala Tahan is the longest canopy walkway in the world. Not for the faint-hearted, it leads 430 metres from giant tree to giant tree, sometimes over 50 metres in the air, giving you a bird's-eye view of the plants, and sometimes the wildlife, of the canopy. As the biggest tourist attraction at Taman Negara, the canopy walkway can get very crowded. Most days it is open from 10 a.m. to 3 p.m., but on Friday (the Muslim holy day) it opens at 8 a.m. and shuts at lunch time. An early start will give you the canopy to yourself for up to an hour, and a much better chance of seeing bird or animal life on the walkway itself.

The resort is quite big, and is best avoided at weekends when it fills up with visitors from the capital. That said, most people don't stray far from the resort, which means that you can still find all the

View from Bukit Teresek with the Sungai Tahan River in the foreground

isolation you want by following one of the many trails into the rainforest. You can either hike out and back in a day or stay at one of a network of very basic wildlife hides positioned at watering holes or salt licks. Spending at least one night in a forest hide is an experience. Amid the cacophony of insect noise you wait in both hope and fear of seeing some wildlife, and learn a new appreciation of the environment you are in and the one you have left behind. More intrepid visitors can take a seven-day trek to climb Gunung Tahan

volcano, the tallest mountain on the Malaysian peninsula, although it is necessary to organize a guide for this.

Buttress roots

ⓘ ··

Taman Negara rainforest is just three hours by car from Kuala Lumpur. You travel the last stretch by boat and enter the forest by the gate at Kuala Tahan. The Taman Negara Resort has a range of accommodation, but is best avoided at weekends when it can get crowded. The extraordinary sights and sounds are best appreciated from the canopy walkway. Take a trek or spend a night in a forest hide to get the best chance of spotting some of the more elusive wildlife.

Trees silhouetted at sunset

Jaisalmer Fort
India

The fort at dusk

Gadi Sagar tank flooded after the monsoon

Jaisalmer Fort sits in the Thar Desert in the westernmost part of Rajasthan. Located on a former trade route used to transport spices and silks between Arabia and India, Jaisalmer, more than anywhere else in India, appears to have stepped out of the *Tales of the Arabian Nights* – a collection of ancient folk tales. This is partly due to its location in a remote and inhospitable desert, and partly because of its appearance. Made rich from trade, its merchants built havelis, or merchants' houses, with finely detailed windows and balconies that owe more to Arab style than Indian.

There are bigger and more impressive forts in Rajasthan – such as that at Jodhpur – but few have such an isolated and atmospheric location. Jaisalmer is also reputed to be the only inhabited fort in the world. The maze of tiny streets still rings with daily life, and visitors

will often have to push past sacred cows which, unsurprisingly after generations of veneration, act as if they own the place.

The fort, built when the city was founded in 1156, is made up of 99 bastions (projections) linked by battlements that are two walls thick in places. It has seen action a number of times in its history and stone missiles – intended to be hurled down on besieging armies – still sit on top of the battlements. Various city states seemed always to be at war, but the fort was first sacked by Muslim invaders in 1294. Rajput warriors would never surrender, preferring to ride out to their inevitable death in battle – an act of mass suicide known as *johar* – while their women and children threw themselves on to fires to preserve their honour.

Although the main attraction of Jaisalmer is the fort itself, there are several things you should aim to see before leaving. Taking up

two sides of the main square of the fort, the Rajmahal (city palace) of the former maharaja is seven storeys high and from the top you can look out over the town below and far out into the desert.

There is also a group of exquisitely carved Jain temples, some dating back to the 12th century when the fort was built. Within those it is possible to enter there is a subtle play of light and shade on the carvings, making them even more impressive than those on the outside.

Detail of balcony carvings

Built almost 700 years ago, the Gadi Sagar tank used to be the sole source of water for the town. Now often completely dry, it sometimes fills during the monsoon season (around September), and you might be rewarded with the rare sight of the fort seemingly perched above a vast lake.

Although it has endured for nearly 900 years Jaisalmer Fort is currently in danger of collapse. The city authorities blame this on soil shrinkage arising from the excessive use of water by the guest houses in the fort. Hotcliers deny this claim and blame the city authorities for using drainage pipes that are too small for the job. Whatever the cause, there are moves afoot to ban all business from the fort, which will

Havelis in Jaisalmer town

mean that tourists must stay in the town outside and pay to visit the fort for sightseeing. Whether or not you agree with this strategy, it will certainly change the atmosphere of the place for ever.

Although the camel trains have long gone Jaisalmer remains a trading town, and people come to its market from the villages nearby. Camels, however, still contribute to the town's prosperity as a number of tourist operators offer camel safaris into the surrounding desert.

On the outskirts of the town are the Barra Bagh *chatris* (royal cenotaphs). These have commanding views over to the fort and offer

Detail of carvings in a Jain temple

Jain temples inside the fort

good vantage points from which to watch the sun set, its last rays turning the town and the fort from the uniform yellow of daytime to a glowing golden hue.

ⓘ ···

During the peak tourist season (November to January) you can fly to Jaisalmer direct from New Delhi. Outside of these times the airport is closed and you will have to take a night train or a bus from Jodhpur. (There are at least three flights a day from Delhi to Jodhpur.) There are two Heritage hotels in Jaisalmer, the Jawahar Niwas and the Naryan Niwas Palace. The latter has phenomenal views of the fort from its roof. If you fancy a camel safari, you should book with Mr Desert – the face of Jaisalmer.

Sacred cow in the narrow streets of the fort

Elephant statue outside Nathmal ki Haveli

Galapagos Islands
Ecuador

Nesting pair of blue-footed boobies, North Seymour Island

Marine iguanas, Bartolome Island

It was on the Galapagos Islands, off the coast of Ecuador, that the process of evolution was first understood. Charles Darwin (1809–82) arrived at the Galapagos in 1835 and stayed for just five weeks, observing and collecting specimens of fauna and flora.

The diversity of life forms he encountered in this small area, and the adaptations they had made to local conditions, led him to formulate his theory of evolution. This was eventually published as *On the Origin of Species by Means of Natural Selection* in 1859, and remains one of the most influential books ever written.

As there are no natural predators on the islands it is still possible to see the diversity of wildlife that so inspired Darwin. Human interference has also been minimal, so the animals and birds seem quite unconcerned by the presence of visitors.

Each species has evolved to exploit the character of individual islands. The blue-footed booby on North Seymour Island, for example, feeds close to the shore, whereas the red-footed booby on more outlying islands, such as Genovesa, feeds a long way out to sea. These two birds are fine examples of related species adapting separately to their environments.

Pinnacle Rock, Bartolome Island

Sea lions playing, Isla Lobos

The 'signature' animal of the Galapagos for most people is the giant tortoise, which can be seen lumbering around the highlands of Santa Cruz, the second-largest island in the archipelago. Some of these creatures are so old that they might have been seen in their youth by Darwin himself.

Your time in the Galapagos will be remembered as a series of unique wildlife vignettes: snorkelling with sea lions that swim and play within inches of you, and continue leaping in and out of the water long after you have tired and headed for dry land; seeing dozens of sea iguanas clinging haphazardly to a rock; watching from just a few feet away the elaborate courtship ritual of the blue-footed booby; feeling small sharks touch your feet as you wade ashore; noticing a

Isla Lobos at sunset

sea turtle cruising majestically along the edge of a coral reef; and, most magically, seeing a humpback whale and her calf surface with a great gout of exhaled air.

The archipelago, which consists of 12 main islands and several smaller ones, is difficult to visit independently. The most practical way to get around is on a cruise of four, seven or even more days. The contrasts between the islands make them very special.

Cruising between them, just as Darwin did nearly 200 years ago, you will feel as though you are getting a privileged insight into an untouched world. At night you will sleep on board the cruise ship, leaving the wildlife in sole occupation of the islands, which are as unspoilt now as they have been since the beginning of time.

ⓘ

The only practical way to get around the Galapagos Islands is on a short cruise. Metropolitan Touring run a variety of trips but the most popular last from four to seven days. Tame Airlines flies to the islands from Quito, the capital of Ecuador, via Guayaquil, the country's largest city. Be sure to check that your tour operator's fee includes the US $100 park fee (your ticket will be stamped if it does) – if not, you will not be allowed to leave the airport until you pay *in cash*. Access to the islands by boats and tourists is strictly controlled by the government of Ecuador to minimize the environmental impact of tourism. You cannot wander freely on the islands and the planning of activities and timing is quite rigid. Despite these controls, each day is spectacular. The busiest times are Christmas, Easter and August.

Young great frigate, Genovesa Island

Sally Lightfoot crab

Giant tortoise, Santa Cruz Island

Marine iguanas, James Island

Sea lion, North Seymour Island

Manhattan Island
New York, USA

The Statue of Liberty at sunset

Brooklyn Bridge at sunset

From the imposing figure of the Statue of Liberty to the flashing neon signs of Times Square, from the green oasis that is Central Park to the canyon-like streets full of yellow cabs, everything about New York seems familiar, even if you have never been there before. Like no other city, it has entered into our collective consciousness through a lifetime of images, yet no superlative can really do justice to its aggressive boldness.

Of course it would be churlish not to mention another image of Manhattan burnt into the world's memory: the sight of crashing planes and burning, tumbling buildings irrevocably affected more than just the skyline of a city.

Wall Street, with the New York Stock Exchange in the background

133

Sitting at the mouth of the Hudson River, New York is divided into five boroughs, and Manhattan is the one that forms the heart of the city. Actually an island, Manhattan is much smaller than the first-time visitor might imagine, and can be circled in just two to three hours on the famous Circle Line boat trip. Its isolation and compactness have given Manhattan a self-sufficiency and character quite distinct from the rest of the city. Its people, too, are just as they appear in the movies – a cosmopolitan melting pot of larger-than-life characters, treating each other and visitors with sometimes alarming frankness. Each borough of New York is made up of neighbourhoods, often where various immigrant communities have congregated over the years and coloured the city with the particular feel of their homeland. Chinatown and Little Italy, for example, feel like opposite ends of the world, but in Manhattan they are separated by just the width of a street.

Navigating the city's grid is relatively easy and the subway is simple to use – keep a subway map handy. Streets run east–west,

Midtown cityscape

134

Times Square

avenues run north–south and the length of a block between two streets is usually much shorter than that between two avenues.

Ironically, Manhattan's high-rise landscape is best seen from above to really appreciate the block after block of skyscrapers that all but fill the island. The famous viewing platform on the 86th floor of the Empire State Building offers undoubtedly the best views of the whole city.

New York throbs with energy – commercially, socially and culturally. Not for nothing is it described as the 'city that never sleeps'. From the moment you arrive, whether by air, sea or road, you will feel that energy and be infused with it until you must reluctantly tear yourself away.

Six per cent of Manhattan is taken up by Central Park, which is a haven from the traffic noise and commotion although it's in the heart

The Chrysler Building

The Chrysler Building and the United Nations Building

The Empire State Building (left) and the Chrysler Building from the Hudson River

of the city. From its south-east corner you get a great view of the park against a backdrop of characteristic New York buildings on bustling Fifth Avenue – just one more contrast in this city of extremes.

ⓘ ···

There is a wide range of hotel accommodation in Manhattan and you should work out which area you fancy staying in and then pick a hotel. Getting around Manhattan is easy. The subway is inexpensive, although the maps take some getting used to. Taxis are cheap and plentiful, and part of the whole experience. Tipping has reached near-epidemic proportions in New York, and you should expect to add at least 15% to restaurant and bar bills, and taxi fares.

View across the pond to Central Park South and Fifth Avenue

Chase Manhattan Plaza (the building at the lower left) and surrounding buildings

Lake Titicaca
Bolivia and Peru

View of the Bolivian Cordillera from Isla de la Luna (Island of the Moon)

Lake Titicaca has a haunting and desolate beauty. The intensity of the rich, dark blue of the water is unique among freshwater lakes and makes the wide expanses of sky and landscape look even more stark and exceptional. At more than 3800 metres above sea level, Lake Titicaca is the highest navigable lake in the world. The clarity of the air at this altitude, combined with the hues of the lake and its islands, produces a colour palette of intense vibrancy.

The lake, which is 176 km long and some 50 km wide, and straddles Bolivia and Peru, is considered to be sacred by many of the local people, who believe that spirits live in its deep waters. In Andean creation myths Lake Titicaca was the birthplace of civilization, and the sun, moon and stars rose out of it.

To really appreciate the lake and the people who live on it, you have to go out on to one of the islands, where the scenery and culture

Sailboat at the island of Taquile

LAKE TITICACA

The high altitude makes the hike up to Pachamama strenuous, but the views across to the mountains of the Cordillera Real on the Bolivian side of the lake make it all worthwhile. The hill is also a perfect place to watch the sunset when the colours of the lake and the sky become even more vibrant and intense.

The snow-capped Cordillera Real is visible from most of the lake and forms a distinct border between the stark expanses of water and sky. Sometimes the vista is softened by a flock of flamingos strutting imperiously across the shallows of the lake. This incongruous smattering of pink brings some relief from the unyielding colours of Lake Titicaca.

Puno is the gateway city on the Peruvian side of Lake Titicaca. The train journey from Cuzco to Puno takes a day and passes through some beautiful high-altitude terrain. The town of Copacabana in Bolivia, on the southern half of the lake, can be reached from La Paz. The famous views of the snow-covered Bolivian Cordillera are best seen from the islands accessible from Copacabana: Isla del Sol and Isla de la Luna. Do not underestimate the effects of the altitude here, especially if you are planning strenuous activities such as hiking on the islands. The ferry that crosses the lake between Peru and Bolivia takes just 12 hours.

Island of Amantani, with the Bolivian cordillera in the background

Reeds at the edge of the Uros islands

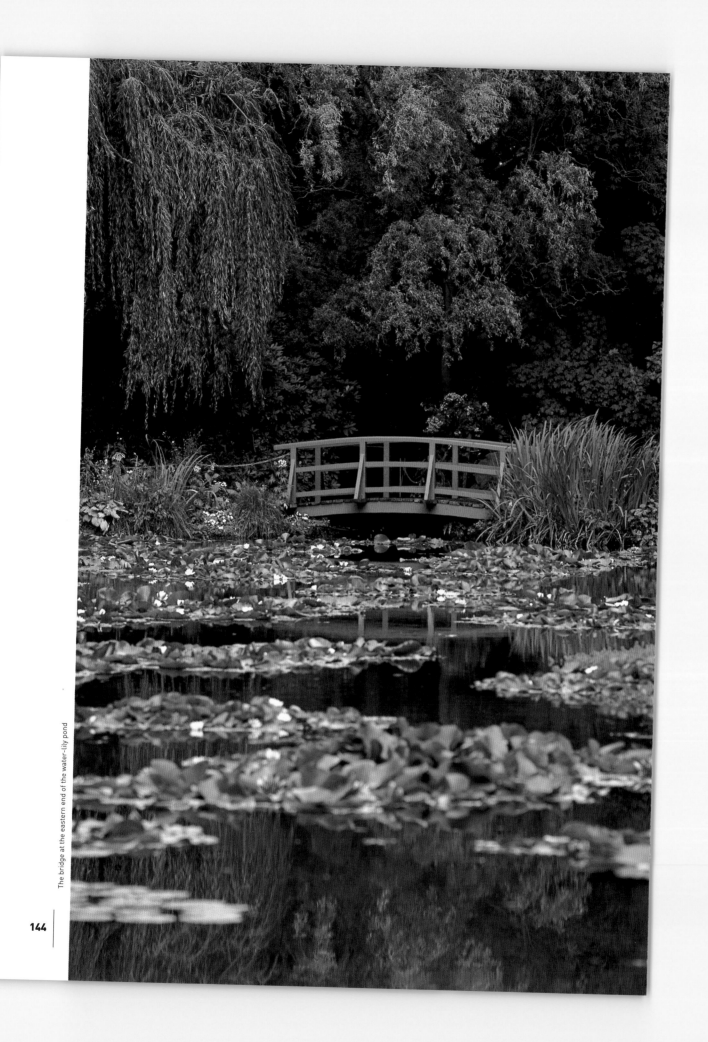

The bridge at the eastern end of the water-lily pond

Monet's house

For anyone with even a passing knowledge of the work of Claude Monet (1840–1926), his gardens at Giverny in Normandy, France, will be instantly familiar. The tranquil pond of water lilies inspired some of the greatest paintings of the 19th century.

Monet first saw Giverny from a train window. He moved there in 1883 and started to create the gardens, which he came to regard as his greatest achievement. They are places of light and shadow, where subtle reflections of foliage and flowers in the cool green waters are fleetingly transformed by the fluctuating light of the changeable Normandy weather.

The gardens, intersected by many small gravel paths, slope gently down to the lily pond, which is surprisingly small but very atmospheric. A path skirts their perimeter, offering a range of views and variations in light as you walk along it. Some of the views are open, others punctuated by weeping willows.

Monet's house at Giverny is large and rustic, and visitors can walk around it and look out on to the views that inspired him so much. He watched the colours gradually change as the seasons passed and woke up each morning to look at them from his bedroom window.

The largest of the garden paths – the Grande Allée – leads from the house to the Japanese bridge, well known from Monet's numerous depictions of it. The gardens are now divided by a road, but both parts are connected by a tunnel.

Since his earliest days as a painter, Monet worked in the open air rather than a studio. He believed in trying to 'capture the moment' in his paintings, which meant that he had to work fast. This technique created an impression of the subject matter, rather than a detailed description, and led to its exponents being called 'Impressionists'.

A painter at the water-lily pond

The water-lily pond

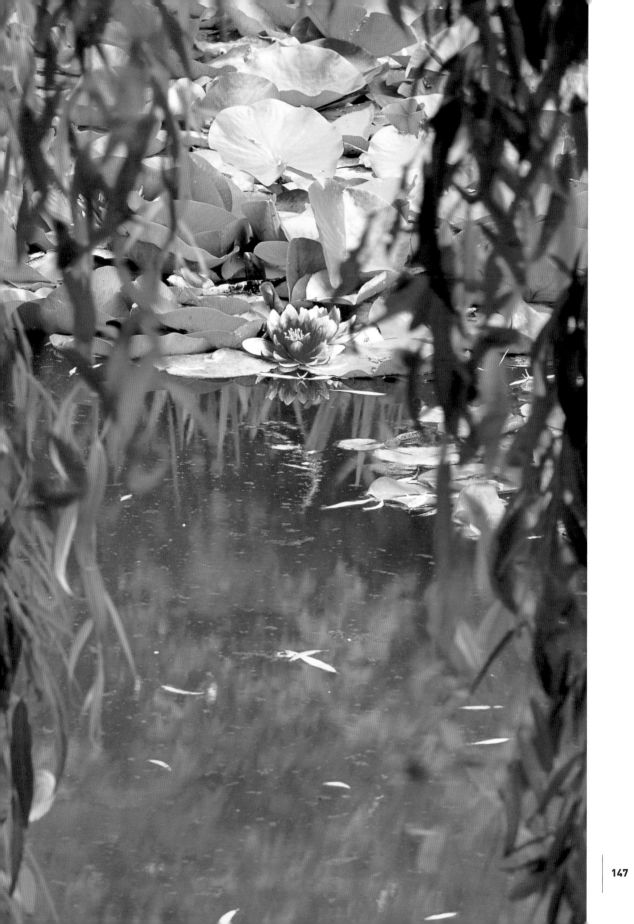

During his time at Giverny Monet was often visited by his artistic contemporaries, including Cézanne, Renoir, Matisse and Pissarro, few of whom enjoyed recognition during their lifetimes. It is now staggering to imagine so much talent gathered in one small place. Monet died at Giverny in 1926 at the age of 86.

ⓘ ..

Monet's gardens in the village of Giverny are 65 km north-west of Paris, off the A13 motorway. The nearest English Channel ferry ports are Le Havre and Dieppe. Vernon, 8 km from the A13 and 5 km from Giverny, is the nearest useful town and has good accommodation and restaurants. The gardens get extremely crowded in the middle of the day, so aim to arrive as early as possible. They are open daily except Mondays (to allow select artists to paint) from 9.30 a.m. to 6 p.m. from 1 April to 1 November. The most popular months to visit are July and August, when the water lilies flower. Accommodation in Giverny itself is limited. A website (www.giverny.org) has information about where to stay, transport and flowering times.

Monet's bedroom

Water lily

Poppy seed heads

149

Common zebra Opposite: Looking down into the caldera

The Ngorongoro Crater feels so cut off from the outside world that you almost expect to see long-extinct dinosaurs, not just teeming wildlife, roaming within its steep, forbidding walls. Veined by the forces that created them, these walls rise 600 metres above the flat floor.

Ngorongoro is actually a caldera, not a crater, formed when a volcano collapsed millions of years ago. At more than 20 km across, it is the largest complete, unflooded caldera in the world. As you look down from the rim you could be forgiven for thinking that Ngorongoro is completely deserted and rumours of its bounty exaggerated. But closer inspection through binoculars reveals signs of life. Those ant-like dots moving slowly across the caldera floor are actually bristling Cape buffalo, arguably the most dangerous animal in Africa. Only then does the true scale of the caldera become apparent.

Ngorongoro is so large that it has its own distinct weather patterns. Mist and cloud often coat the densely forested flanks of the

caldera, sometimes spilling over the edge. Occasionally, these clouds are so dense that they fill the bowl of the caldera. Leaving the comfort of your lodge and journeying down to the caldera floor in these conditions can become something of a leap of faith. The weather can be quite localized. It can be cloudy, even raining, on one side while the other side is bathed in bright sunshine.

Clouds rearing up over the walls of the caldera

For all the beauty and majesty of Ngorongoro, it is the wildlife that is the greatest draw. The walls act as both refuge and restraint, trapping and protecting a surprising amount of big game. The caldera is home to some 30 black rhino – the largest concentration of the species left on the continent. In the dry season they can be remarkably difficult to spot, as they spend much of the day asleep in the long grass; but when the grass is short and green they virtually litter the caldera floor, bringing back memories of a bygone age when they used to stomp and snort their bad-tempered way across the whole of Africa.

Ngorongoro is also famous for its lion population, much filmed for television documentaries, but apparently chronically inbred. The isolation of the caldera prevents fresh blood from wandering in from the nearby Serengeti.

In the middle of the caldera lies Lake Magadi, a vast soda lake frequented by flamingos. The population fluctuates from a few

Wildebeest on the caldera floor

Female ostrich on the caldera floor

thousand to literally hundreds of thousands in June, when the flamingos flock back from their migration to the Great Rift Valley.

Most common African wildlife is found in the caldera, with the notable exception of giraffe which find the walls too steep. Most of the animals are permanent residents, although elephants and buffalo are often to be found feeding on the upper rim, especially at night.

The caldera officially opens just after dawn. The tracks on the north rim are vertiginous, requiring a four-wheel-drive vehicle. The track on the south rim, servicing the Sopa Lodge, is much less steep, allowing quicker and safer access to the caldera floor.

Wildebeest

Don't be surprised if you see Masai *morani* (warriors) bringing cattle down into the caldera. Although the Masai often come here to make money by posing for tourist photographs, they also have grazing and watering rights for their cattle. If you wonder at the wisdom of bringing a potential food source into lion territory, you will be told that after generations of experience the lions have a healthy fear of the Masai, and tend to disappear as soon as they arrive – much to the chagrin of the safari guides.

ⓘ ···

The Ngorongoro Crater is about six hours' drive from Arusha in northern Tanzania. You can fly to Arusha from Dar es Salaam or Zanzibar with Air Excel. Accommodation can be found in lodges overlooking the caldera. Most are on the relatively crowded north side but Sopa Lodge, which offers fine views of the sunset and uses the much safer access road, stands in splendid isolation on the south side. Safari guides can be hired from Abercrombie & Kent, the oldest established travel company in Africa. For the full safari experience you could combine Ngorongoro with the nearby Lake Manyara National Park, or even the world-famous Serengeti National Park.

Elephants on the caldera floor

Santorini
Greece

Church bell, Fira

Blue-domed church, Oia

Sitting in the peaceful town of Oia on the island of Santorini (known as Thira to the Greeks), watching the sun slip quietly into the sea, it is hard to imagine the colossal forces of nature that blew the island apart around 1550 BC.

This volcanic eruption is believed to have devastated an outpost of the advanced Minoan civilization, which had been established on the island before 2000 BC, leading to many theories that Santorini is in fact Plato's lost city of Atlantis.

The present-day island of Santorini is formed from the circular caldera of the volcano. The circle is incomplete in places and, flooded by the sea, forms a natural harbour so vast that visiting ferries and cruise ships are dwarfed by it.

A small island in the middle of the caldera is actually the centre of the volcano and can be reached by boat. You can even walk around its rocky 'moonscape' and stand next to the still-steaming mouth of the volcano that created Santorini in the first place. Like most smoking volcanoes, it seems to hold the threat of erupting at any

time. (The last eruption happened in the 1920s and an earthquake devastated the island in 1956.)

The jagged walls of the caldera rise up to 300 metres above the sea. The highest cliffs are at Fira, the capital of Santorini, and the adjacent town of Firostefani, now all but swallowed up by Fira. These towns are built on the very rim of the caldera, overlooking the waters far below.

Each town has its own harbour at the foot of the cliffs, reachable by a zigzag path from the top. Fira now has a modern cable car, and it is only the tourists from cruise ships and ferries who make the long hike up. If you can't face walking, you can rent a donkey from one of the irascible old men who spend the day leading their mounts up and down the path. Come sunset, the donkeys leave Fira at a gallop, glad to be on their way home, and you have to take care not to be knocked over in the rush.

Santorini is renowned for its white-walled, blue-domed churches, which are often photographed against the dark blue waters of the

Aegean. In fact, there are so many churches on this island that you have to wonder who on earth goes to them. Is there some feud that prevents all the islanders attending the same one?

Many of the churches are still in use, and you will often see grey-bearded priests, dressed entirely in black, hurrying from church to church, presumably trying to find their flock in one of the numerous possible locations.

Like so many other places Santorini has been comprehensively taken over by the tourist trade, and most of the fishermen's cottages have now been converted into hotels, restaurants or guest houses. Despite this, however, the island still retains much of its original character. Oia, especially, still has a sprinkling of locals living among all the tourist places, and outside some of the cottages, hung with

Cross on top of a church, Fira

Small chapel, Firostefani

SANTORINI

baskets of brightly coloured flowers, fishing nets await repair and scraggy cats doze in tiny front yards.

ⓘ ··

Santorini is easily reached by ferry, or internal flight on Olympic Airways, from Athens. There are even some direct flights from European airports during the summer season. Accommodation can be hard to find during the summer months, so it is advisable to book in advance. One of the best hotels in Fira is the Santorini Palace, which overlooks the caldera. The bus service around the island is fairly limited but there are taxis and car hire is quite easy. Most of the beaches are outside the main towns and, although the sand is volcanic black, they are ideal spots to while away the day.

Traditional houses in Oia

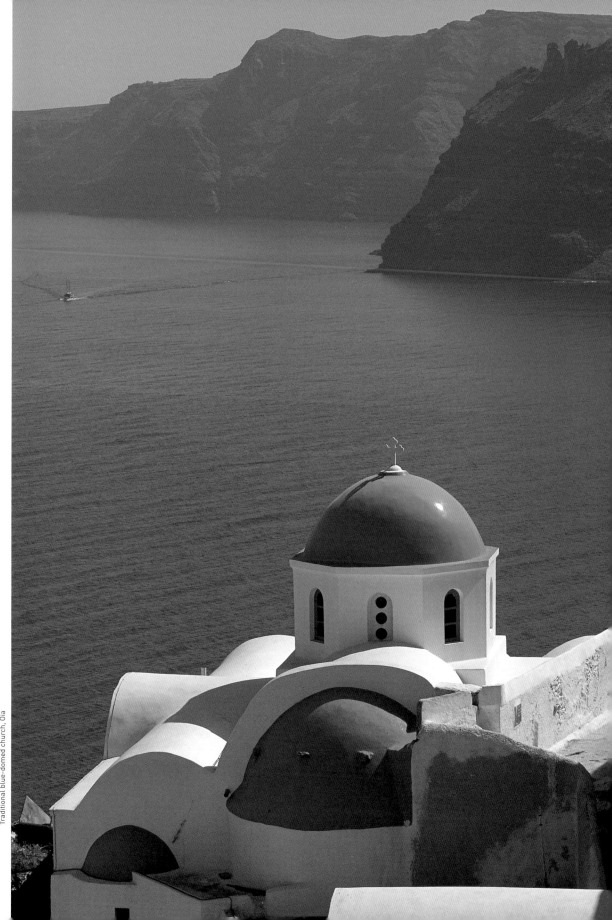
Traditional blue-domed church, Oia

Hills in the Giant's Castle area

Sunrise near Cathedral Peak

Stand by the edge of the 850-metre cliffs of the amphitheatre of the uKhahlamba-Drakensberg Park and you will be dwarfed. The cliffs are a massive horseshoe of rock, often filled with swirling clouds that appear to change their mood as you watch. Sometimes they fill the basin, making the view of a few seconds ago seem like a mirage. At other times they just disappear, revealing the valley below.

The cliffs of the amphitheatre drop vertically down to a green valley and offer commanding views of the Devil's Tooth rock formation. Part of the way along the upper rim of the amphitheatre the 'bridal veil' Tugela Falls spills 850 metres over the edge to form the source of the Tugela River.

Drakensberg is Afrikaans for 'dragon mountain' and uKhahlamba is Zulu for 'barrier of spears' – fitting names for the 320-km escarpment of harsh and jutting rock that forms the border between Lesotho and the Republic of South Africa.

THE AMPHITHEATRE

At the top of the escarpment is a tableland plateau. In Lesotho, the 'Kingdom of the Sky', this is a unique and fragile habitat for wildlife and many rare plant species. In the beautiful alpine landscape of mountain streams and lush grasses are small wild flowers that have adapted to the climate, which can turn from fine and bright to cold and stormy in minutes. In fact, the plateau's great height means that the temperature there can be freezing while the parklands at the bottom can be warm and sunny.

The best way to reach the plateau is to drive to the Golden Gate Highlands National Park (a park within the Drakensberg area). From here there are two ways to reach the top of the escarpment: a two- to three-hour hike up a steep trail, or a climb up a notorious chain ladder. Whichever route you choose, it is wise to make a very early start as mists often sweep in during the late morning and can completely obscure the view.

View of Devil's Tooth from Golden Gate Highlands National Park

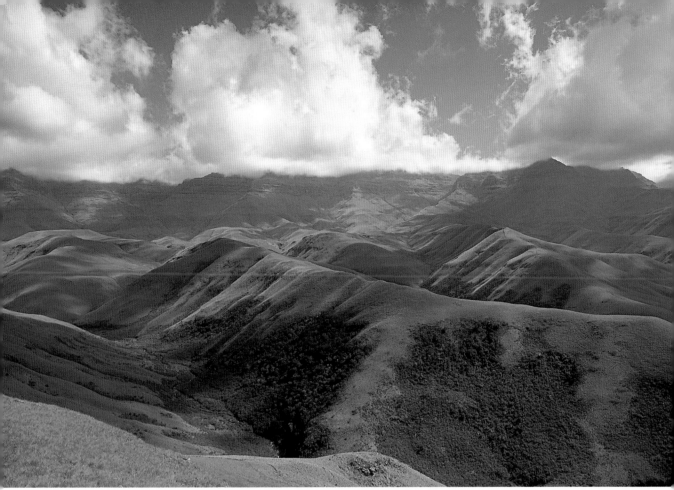
Hills in the Giant's Castle area dappled with shadow

Tucked away in numerous caves around the Drakensberg are some of the finest examples of rock art in Africa. In the Drakensberg area alone there are hundreds of sites with thousands of rock paintings. They were painted by the San people who used to roam over much of southern Africa but are now confined to a few pockets around the Kalahari Desert in Botswana. Diminutive in stature, they are often (erroneously) known as the Bushmen of the Kalahari. Their rock paintings, which are usually found in shelters or overhangs, record the life and history of the San people but, more importantly, are thought to have a spiritual significance as openings to the spirit world. The oldest paintings are about 25,000 years old and the most recent may be just 200 years old. Pigments were ground from iron oxides for the reds and yellows, manganese oxide or burnt bone for black and fine clay for white. The artists often painted over earlier images or added to existing ones.

THE AMPHITHEATRE

A variety of terrains in the park are worth exploring, and you could also visit the Cathedral Peak and the Giant's Castle, the latter involving a five-day trek along the escarpment, or a day's drive.

ⓘ ··

The Drakensberg escarpment is about two hours' drive from Pietermaritzburg and a scenic five hours' drive from Johannesburg. The various locations and lodges along the escarpment are relatively close to one another as the crow flies but you should use the main roads. Do not be tempted to use more direct routes as these are rougher, carry very little traffic and have no services. The parks are administered by KwaZulu-Natal Wildlife, which runs a number of lodges and camps that make access to the various sections of the park easy. Getting to the top of the uKhahlamba escarpment involves an arduous hike from the Golden Gate Highlands National Park. You should make a very early start to avoid the late morning mists that often obscure the views.

View of Devil's Tooth from Golden Gate Highlands National Park

View below Giant's Castle; the Giant's Castle formation is in the background, towards the left

San rock art at Main Caves, Giant's Castle

Traditional Arab dhow

Buildings on the waterfront

Zanzibar. Even the name is exotic, conjuring up images of sultans and explorers and of wooden Arab dhows redolent with the aroma of spices.

Arriving by boat from Dar es Salaam, you will see the waterfront of Zanzibar town looking much as it did in the days when Victorian explorers used the island as a staging post for their expeditions into the interior of Africa. (David Livingstone, who discovered the Victoria Falls, started out from here, as did Henry Morton Stanley, the journalist dispatched to find him.)

Right in the middle of the waterfront is the Sultan's Palace. Built in the 19th century, it was called the House of Wonders because it had electricity and the first lift in East Africa. After years of neglect, it has now been restored and houses a fine museum.

Zanzibar has a colourful history. Omani sultans ruled much of the Swahili coast from the island, establishing the trade routes that

Zanzibari carved wooden door

still lead from here to the Middle East. Their domain dwindled in the days of the British Empire, and finally ceased with the bloody revolution of 1956.

The long history of Zanzibar has its darker side. During the 18th and 19th centuries it was the main base for the trade in African slaves brought from the interior by Arab traders, who often purchased their captives from warring tribes. The slaves were sold to European and American merchants, and shipped in appalling conditions to the Americas and the Caribbean.

It is still possible to visit the old slave pens, but an Anglican cathedral has been built on the site of the slave market. The altar is on the very spot where the whipping post once stood, and the cross beside it is made from the tree under which Livingstone died. During his time as a missionary Livingstone became a tireless crusader for the abolition of slavery, but the trade continued illegally for some years after it was banned.

The heart of Zanzibar town, built of stone, is a tangle of narrow winding streets that seem to lead everywhere and nowhere. Look out for the ornate, carved wooden doors, many of which date from the

St Joseph's Catholic cathedral, built by the French in 1898

Cooked food at Jamituri Gardens

time of the sultans. They were designed both to display and protect the wealth of the house-owners.

In the early morning, when the tourist shops are closed, life in the town seems to continue much as it has for hundreds of years. It is not difficult to imagine explorers combing its streets, looking for supplies and porters.

Everywhere you go you will be greeted with shouts of *jambo* (hello) and *karibu* (welcome). Take a walk to the old dhow harbour and you can watch fishermen haggling with locals over their catch. You can also get a close-up view of the remarkable sailing boats, held together entirely with wooden pegs, that have been used along the Swahili coast ever since the Arabs first arrived from Oman. Although still used to move goods between East Africa and the Middle East, their use is dying out.

While the town has a number of top-quality restaurants, the nicest place to eat is at the Jamituri Gardens on the waterfront. From sunset every day locals set up open-air stalls to cook and sell some of

the freshly caught fish landed every morning. You can get crab and lobster for just a few dollars, and wash it down with a glass of freshly squeezed sugar-cane juice, while chatting with the friendly Zanzibaris about everything from politics to football.

(i) ··

Zanzibar lies off the coast of Tanzania, a few hours by ferry boat from Dar es Salaam. There are a number of morning departures, returning mid-afternoon. Details are posted on the ferry dock but steer clear of touts and buy your tickets directly from the ticket office. Alternatively, Air Excel fly from Dar es Salaam to Zanzibar and sometimes from Zanzibar to Arusha. Although Dodoma is the new official capital of Tanzania, many flights arrive at Dar es Salaam. There is a wide range of accommodation in Zanzibar town, the best of which are the Serena or the Tembo House. The northern and eastern coasts of Zanzibar have a number of beautiful beaches, with accommodation ranging from simple beach huts to luxurious resorts. Local travel agents will arrange reservations and transfers.

Makalu

Himalayas, Nepal

High in the Himalayas, amid mighty peaks encrusted with glaciers, is Makalu, the fifth-highest mountain in the world. Although less well known than other peaks in the region, notably Everest and the Annapurna range, Makalu has arguably the most stunning scenery. Set in the remote Makalu Barun National Park, it has the added advantage of being away from current centres of political unrest.

Like many of the peaks in the Himalayas, Makalu is considered a holy mountain. Its name is said to be derived from the Sanskrit word 'Mahakala', the personification of death and rebirth, which, for Tibetan Buddhists, represents the power of the Lord Buddha's protection. The mountain is believed to be the kingdom of Mahakala.

The Himalayas are built on a massive scale, and there is little to prepare you for their immensity and beauty. But it is not a stationary beauty. Distant avalanches can occasionally be heard, thundering like

View of Everest from the glaciers at the foot of Makalu

Opposite Lake scene on the Makalu trek

express trains, and the mountains appear to alter in shape, colour and mood as the light and cloud formations change throughout the day. This is a transfixing sight that you can sit and watch for hours. Sometimes whole sections will be illuminated by the golden afternoon light, casting great shadows into valleys and crevasses. At other times vast swathes of mountains will turn blue or be completely obscured by swirling clouds.

The air is so clear at this height that it is always possible to make out the shape of the snow-capped peaks, and you can almost read by the light of the stars that fill the night sky.

To visit the beautiful and remote Makalu takes both time and effort, as the trek is not easy and takes nine days from the airstrip at Tumlingtar. Much of the trek is done at altitude, which is debilitating until you become acclimatized.

The trek takes you over many passes, through verdant farmland and past many steeply terraced hillsides. *Khambas* (farms) within just a few hours of the base camp remind you that people actually live

Makalu peak

Mountain seen from Makalu base camp

High mountain lake on the Makalu trek

177

Makalu peak

in this harsh environment – a humbling thought when you grow weary of the regular downpours that leave the paths littered with leeches. However, along these ancient and well-travelled routes are a number of tea shops and it is easy to meet and talk to the local farmers and porters over a refreshing cup of chai (tea).

From the Makalu region you should be able to see four of the five highest mountains in the world: Everest (8848 metres), Kangchenjunga (8586 metres), Lhotse (8516 metres) and, of course, Makalu itself (8463 metres). (The world's second-highest peak is K2 on the Pakistan border.)

If you have the energy you could trek to the Everest base camp which lies just west of Makalu. It is also possible to follow the

Glacial ice

View from the glaciers at the foot of Makalu

standard Everest trek back to Lukla and then catch a flight back to Kathmandu. Although it follows a much more well-trodden route and doesn't enjoy the quiet solitude of the direct route to Makalu, it does at least avoid trekking back the way you have come.

ⓘ ----------

The trek to Makalu starts from the airstrip at Tumlingtar, which can be reached from the Nepalese capital, Kathmandu. From here it is an arduous nine-day trek to the mountain and, of course, nine days back again. Unless you are an experienced trekker you would be wise to organize this with a local trekking company in Kathmandu and take a guide with you. Nepal is currently suffering from a Maoist insurgency and you should make yourself aware of local conditions before undertaking the trek. The best times to trek are April and May, and late September through October.

metres, is the largest carved monolithic structure in the world. Its great bulk is supported by a total of 72 pillars, half of which are inside and half outside.

Although the churches would be evocative as deserted ruins, they are still in constant use and each has a resident priest who, with a little prompting, will bring out a church treasure to show you. Sometimes this might be an ancient Bible, perhaps 700 years old, handwritten in the ancient religious language of Ge'ez on goatskin pages. More usually, the priest will produce the church cross. In various intricate shapes, some crosses date back to the days of King Lalibela himself.

Looking down into the courtyard around Bet Giorgis

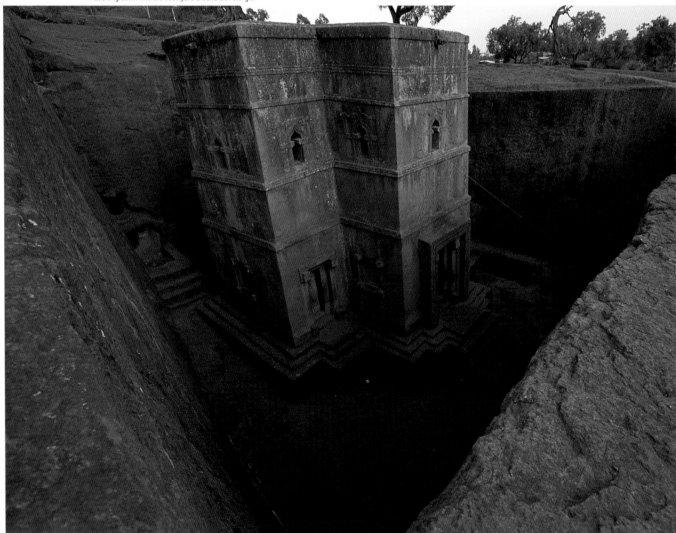

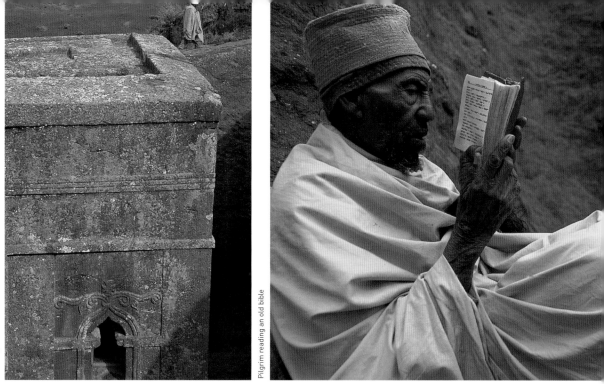

Bet Giorgis

Pilgrim reading an old bible

Pilgrims seem to come to Lalibela from all over Ethiopia, and can often be seen praying in the churches. There are also a number of semi-permanent ascetics, who stay in Lalibela praying and can be seen sitting around the churches reading well-worn bibles.

On 19 January Timkat (Epiphany) is celebrated at Lalibela. This is a tremendously colourful festival when the holy *tabots* (which are believed to be replicas of the Ark of the Covenant) are taken from each church and paraded through the town.

The official religion of Lalibela is Ethiopian Orthodox, a form of Christianity that the country adopted in the 4th century. This choice was freely made by the people, unlike in the rest of Africa where Christianization was the result of missionary work, centuries later.

Although synonymous in the West with famine and disaster, Ethiopia is steeped in ancient and biblical history. The Queen of Sheba is believed to have come from here, a native of the northern city of Aksum, at that time the centre of a great and powerful civilization. It was the break-up of the Aksumite Empire that caused King Lalibela to flee south and set up a new capital, where he built his churches.

Many Ethiopians believe that Haile Selassie, Emperor of Ethiopia from 1930 to 1974, could trace his lineage directly to the illegitimate

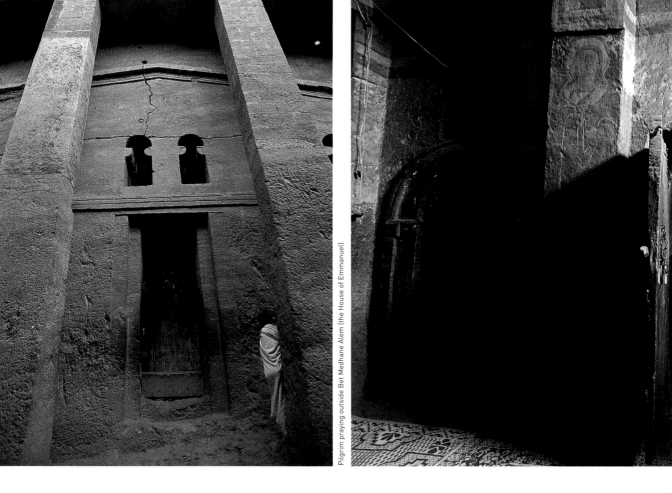

Pilgrim praying outside Bet Medhane Alem (the House of Emmanuel)

son of King Solomon and the Queen of Sheba. This son was said to have brought the Ark of the Covenant back to Ethiopia, and it is believed to reside in Aksum.

A worthwhile excursion from Lalibela is up to the Asheton Maryam monastery carved into the rock on a desolate, windswept plateau a couple of hours' walk from Lalibela. Here you can see a fascinating collection of paintings and relics, and also observe the harsh conditions in which many local people live.

ⓘ ..

Ethiopian Airlines flies from airports around the world to the Ethiopian capital, Addis Ababa and offers internal flights to Lalibela. (The alternative is a hard two-day drive.) It is also possible to get a flight pass on the so-called 'historic route' service that takes in Aksum, Bahar Dar, Gonder and Lalibela. Accommodation in Lalibela can be basic. One of the best hotels is the Roha, part of the government-run Ghion chain. Book in advance, especially during the Timkat celebrations. A ticket costing about £8 will get you into the site and is valid for the duration of your stay. A local guide is useful – especially to translate when you meet priests. Most hotels can provide guides, but make sure their English is up to the job.

Painted interior of a church at Lalibela

Priest of Bet Giorgis

Pilgrim at Lalibela

Machu Picchu with Huayna Picchu in the background

Ruins seen from the summit of Machu Picchu peak

Everything about Machu Picchu makes you marvel that it ever came to exist. The lost city of the Incas is built on a saddle-shaped ridge slung between two giant peaks. Near-vertical slopes drop away on either side, down to a massive bend in the Urubamba River. What could have motivated the Incas to undertake such a construction at this remote location in the Andean cordillera?

Machu Picchu, built over 700 years ago and hidden by jungle since the 16th century, was rediscovered in 1911. It consists of about 200 buildings, which include dwellings and temples, a central plaza and a royal palace, all flanked by terraces for farming.

The stone for the buildings was mined from a quarry and shaped using bronze tools, then smoothed with sand in order to fit tightly together. No mortar was used in the construction. Even after many centuries of wear and tear, the precision is amazing; it would be impossible to slide a piece of paper between many of the blocks.

MACHU PICCHU

Machu Picchu is notable for the way that existing rock features were incorporated into the design. Inevitably, the craftsmanship on sacred buildings is the finest.

For spectacular views, make the steep climb up to Wayna Picchu, the mountain behind Machu Picchu. Alternatively, climb to the top of the less crowded Machu Picchu peak, which catches the first rays of the rising sun. Both mountains overlook the entire site, down to the river below, which puts the Incas' great achievement of construction into perspective.

The Incas worshipped the sun god Inti, so the summer solstice was the most important day in their calendar, and the Temple of the Sun their most important building. In fact, all their temples and

Royal Tomb, a cave under the Temple of the Sun

Double doorway

Sunrise over Machu Picchu

sacred sites were designed to mark solar and astrological events. A stone, Intihuatana ('Hitching Post of the Sun'), is the focus of a major religious site where a ritual was performed, in the shortening days before the winter solstice, to prevent the sun disappearing. Similar stones were at other Inca sites, but were damaged or destroyed by Spanish conquistadores. The one at Machu Picchu survived because the site was never discovered.

The population of Machu Picchu is believed to have numbered over a thousand, and the people were so distant from other settlements that they would have produced much of their own food. This accounts for the intricately terraced fields, which have survived remarkably intact thanks to the care and skill that went into their construction. Maize and potatoes were grown, and advanced irrigation techniques were used to ensure that rainwater didn't just run off down the hill to the Urubamba River far below.

No-one knows for sure why Machu Picchu was built. Some surmise that it was a royal or religious retreat for one of the Inca rulers. Certainly its remote location and altitude of nearly 2500

MACHU PICCHU

Dwellings near the Temple of the Sun

Terraces below the Intihuatana

metres would seem to rule out any trade or military function. Whatever its use, the obvious effort that went into its construction indicates that it was considered important and held in high regard by those who created it.

ⓘ ···

All trips to Machu Picchu begin and end in Cuzco. The train journey from Cuzco to Aguas Calientes, the town in the river valley below the ruins, takes four hours. Buses go to and from the town to the ruins from 6 a.m. until 5.30 p.m. The trains from Cuzco arrive mid-morning and leave late in the afternoon, so the least crowded times at the ruins are the beginning and the end of each day. The fitter and more adventurous can take the three-day Inca Trail to reach Machu Picchu. There is plenty of accommodation in Aguas Calientes. However, the best place to stay for access and proximity to the ruins is the Machu Picchu Sanctuary Lodge, an Orient Express Hotel. It is the only hotel next to the ruins and a stay there is a unique experience.

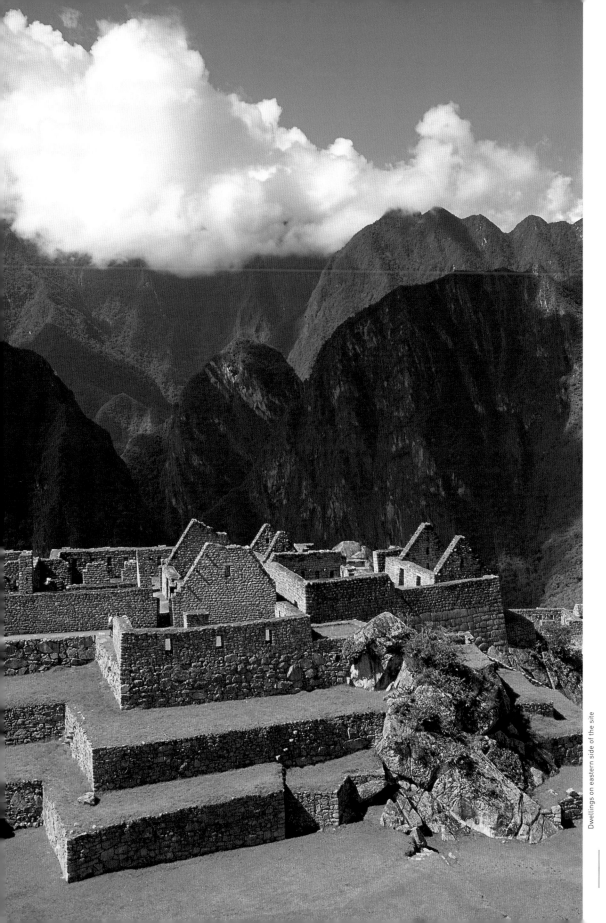

Dwellings on eastern side of the site

Uluru
Australia

Uluru at sunset (Uluru-Kata Tjuta National Park is a World Heritage area)

From whatever angle you look at it, Uluru (commonly known as Ayers Rock) dominates the surrounding landscape. Seen from afar, it is the only feature that breaks an otherwise flat horizon, while up close – such as on the approach road from the cultural centre – it looms above you, completely filling your vehicle's windscreen.

Uluru is the largest monolith (single piece of rock) in the world. Composed of sandstone, which is normally grey, it has become red through a process of oxidization (in effect, rusting).

As you get closer to Uluru, its brooding mass yields up a wealth of detail. Follow the walk that skirts the base of the rock and you will see great flutes that spawn torrential waterfalls when it rains, which

The western side of Uluṟu

Mutitjulu waterhole

Uluru from the south

is quite often despite the parched landscape round about. Elsewhere are caves and crevices eroded into the rock – many of which have been woven into Aboriginal creation tales – and right up close the rock is stippled and textured in a variety of ways.

Anangu (local Aboriginal people) are the Traditional Owners of Uluru, which has great cultural significance to them. Two of the walks on the rock illustrate Aboriginal respect for natural places, and pass by apparently insignificant features in the landscape that they hold deeply sacred.

The Mutitjulu Walk takes you through an area that has been inhabited by Aboriginal people for thousands of years to the Mutitjulu waterhole. Various features along this walk are said to have resulted from a great fight between two ancestral snakes, Kuniya and Liru.

The Mala Walk takes you around some of the places used by the Mala (hare-wallaby) people for a religious ceremony (Inma), which involved their menfolk climbing to the top of Uluru. At one time, following a route to the top was a 'must' for tourists. Though many still do, this is now discouraged because it causes offence to Anangu.

The southern side of Uluru near Mutitjulu Walk (Uluru–Kata Tjuta National Park is a World Heritage area)

The Ghats

Varanasi, India

Reputed to be the oldest living city in the world, having been continually inhabited for more than 4000 years, Varanasi (formerly Benares) is also one of the holiest places of Hinduism. It is so revered that the devout believe that just by dying there they can be freed from the endless cycle of rebirth.

The old Hindu name for Varanasi is Kashi – City of Light – and the quality of light here is truly spectacular. It is one of the few places in the world where this has inspired artists with its clarity and texture. It is best appreciated at sunrise as the faithful come down to the sacred River Ganges to bathe.

The narrow, tangled streets of the old town, Godaulia, all seem to lead to the Ganges. Flanking the river and leading down to the water

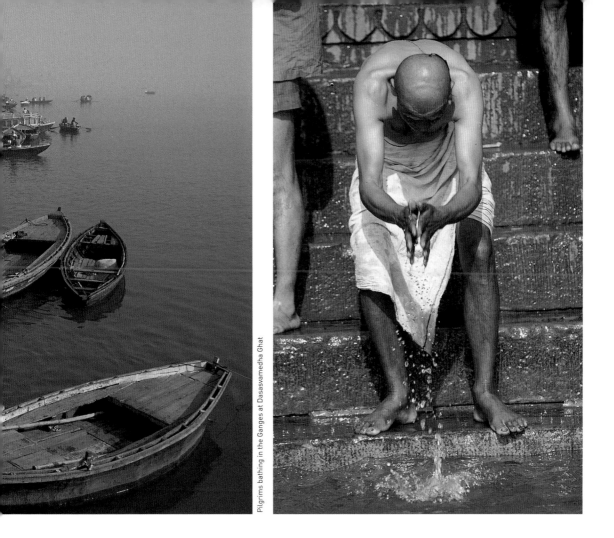

Pilgrims bathing in the Ganges at Dasasvamedha Ghat

are flights of stone steps called ghats. Many of these are hundreds of years old, some built by the maharajas whose palaces still tower over them.

The ghats teem with life: stalls sell everything from vegetables to religious icons, *pandas* (pilgrim priests) preach to the faithful, barbers shave the heads of pilgrims and mourners, sadhus (holy men) meditate and perform feats of yoga, boatmen ply for trade, dhobi-wallahs (washermen) beat laundry against the steps and small boys play enthusiastic games of cricket. Streams of pilgrims from all over India make their way through this activity to bathe in the river, believing that by doing so they can wash away their sins.

The best way to observe the bathing ritual is to take a rowing boat down the Ganges. This will involve haggling with a boatman the day

Rij Rama Palace on Darbhanga Ghat

Pilgrims bathing in the Ganges

before you want to go, so ask at your hotel to get an idea of the correct price. Make sure you specify whether the price is per person or for the whole boat. (You might want to get this in writing to avoid the almost inevitable arguments later.)

Next morning, as you make your way to the river in the cold pre-dawn light, stumbling through the alleys of the old town and pushing past sacred cows that wander around freely, it will seem like a strange way to get to paradise. However, as soon as you are floating down the Ganges and the sun rises over the far bank, driving away the cold and bathing the ghats in soft golden light, you will forget the discomfort.

Hindus try to visit Varanasi at least once in their lifetime, and have to bathe at five different ghats to complete the pilgrimage. Hinduism is a joyful religion, and although bathing has great spiritual

significance, the pilgrims laugh, splash, dive and push each other into the water.

It takes a few hours to travel the length of the river, fighting the current and stopping to watch the pilgrims and sadhus along the way. Get your boatman to drop you off at Manikarnika Ghat and walk back along the river to Dasasvamedha Ghat where most boat trips start.

Manikarnika is the cremation ghat. (Being cremated at Varanasi is yet another way to guarantee salvation, so many Hindu families go to great lengths to ensure their deceased loved ones undergo this ritual.) Bodies are brought from far away – sometimes on the roofs of buses – to be burnt here. Once at Varanasi, they are carried down to the ghat to chants of 'Ram Nam Satya Hai!' ('The name of god is truth!'). Firewood is haggled over, prayers are said, then the body is burnt and the ashes swept into the Ganges.

Rowing down the Ganges

A jewellery stall, Dasasvamedha Ghat Road

Varanasi is easily reached by air from New Delhi or Kolkata (formerly Calcutta). There are also comfortable express trains, although you should try to take at least one old-style Indian train just for the experience. Accommodation boils down to a choice between quality and location. Hotels near the ghats are generally cheap but shoddy. Those of better quality, and therefore more expensive, tend to be in the new town. As with most things in India, the contrast between the two is often extreme. The better hotels organize day trips to Sarnath, the town about an hour away from Varanasi where the Lord Buddha gave his first sermon, and where there are a number of monuments and temples.

Sadhu running down the steps of Bhairavi Ghat

Heron Island
Great Barrier Reef, Australia

The Great Barrier Reef is a series of interlocking reefs and islands that stretch for over 2000 km in the waters off the coast of Queensland, Australia. It is the most extensive coral-reef system in the world, and the largest structure made completely from living organisms: tiny coral polyps.

Between 50 km and 300 km away from the shore, the reef comprises more than 2500 individual reefs (strips of rock or coral) and 600 islands. There are basically three types of island: continental islands

Heron Island from the air

(the peaks of sunken mountain ranges), sand islands and coral cays. Many of these islands have coral reefs nearby, or even mini-reefs fringing them, but Heron Island and the nearby Wilson Island are unique in that they are true coral cays that offer accommodation and actually form part of the reef. This means that you can simply swim from their beaches to dive or snorkel on the Great Barrier Reef itself.

The diving around Heron Island is reputed to be some of the best on the whole reef, attracting people from all over the world. The island has been leased out to the Heron Island Resort, which

Wilson Island fringed by reef

provides a range of accommodation, as well as diving and snorkelling excursions. Wilson Island is administered by Heron, and just 10 people are allowed to stay on it at any one time. Those with a scientific interest in the reef can stay at the research centre on Heron Island, which is run by the University of Queensland.

From ground level, the barrier reef appears unexceptional. The sea might be a luxurious blue and the islands' sandy beaches creamy white, but little else is revealed unless you go up or down. From the air the true extent and colours of the Great Barrier Reef become apparent. Within waters of the purest turquoise, reef after reef seems to stretch away as far as you can see, and dotted around are tiny, white-fringed coral cays surrounded by their own reefs.

Diving or snorkelling on the reef is a truly magical experience, and no superlatives can do it justice. It's like experiencing a completely new world, where sight is the only sense you need and

The reef near Heron Island

Underwater coral

gravity seems irrelevant. Stick to shallow waters if you want to see the colours clearly, as deeper water filters out most of the red and green wavelengths, giving everything a deep blue tinge.

The coral is home to a wealth of life forms: multicoloured fish dart around at lightning speed, while green turtles and loggerheads take things at a more leisurely pace. At the top of Heron Island, in the aptly named Shark Bay, you will have a very good chance of being able to swim with the small and relatively friendly reef sharks.

If you don't fancy getting wet, the Heron Island Resort has a semi-submersible – basically a boat crossed with a submarine – where you can sit in the glass keel and view this underwater world in comfort.

You don't always have to go beneath the waves to see marine wildlife. Coming back from Wilson Island by boat, I came across a couple of migrating humpback whales. In the shallow waters of this part of the reef they were unable to dive deep, so I could hear them

communicating with their haunting 'songs'. You are most likely to see migrating whales in September, while January and February are good times to see turtles laying eggs and the young eventually hatching.

ⓘ ..

Qantas offer regular flights from Brisbane to Gladstone. From there, you can reach Heron Island by ferry or helicopter transfer – a good way to combine travel and seeing the reef from the air. There is one ferry daily, but it is available only to guests of the Heron Island Resort or to those staying at the research centre. Prices at the resort include all food and the quality is exceptional. Try to be there for the Saturday night seafood buffet. If you are not staying on the island the only way to visit it is by charter boat. As it is a marine park, diving and snorkelling among the reefs around the island are allowed.

Beach at Heron Island

Herons on the beach

Coral on Wilson Island

209

Pilgrims walking the Nangkhor

The Potala Palace seen from the roof of the Jokhang

Lhasa
Tibet

It is not just the altitude that makes Lhasa a dizzying experience, although at nearly 4300 metres you get only get 65 per cent of the oxygen you would get in each breath at sea level. That light-headed feeling comes in part from the deep spirituality of the place, and from the heady mix of juniper smoke and the ever-present smell of yak butter.

Expansion and modernization characterize the Chinese part of the city, but the old Tibetan quarter still has an ethereal, almost medieval atmosphere, especially in the network of small streets that surrounds the Jokhang Temple. The centre of Tibetan Buddhism, the Jokhang was completed in AD 647, although it has been continually restored and expanded ever since – most recently following damage caused when the Chinese brought their Cultural Revolution to Tibet.

There are several distinct pilgrimage circuits around the Jokhang. The outer one, called the Lingkhor, runs around the entire city. The Barkhor, or middle route, is a circular road that runs round the outside of the temple. Throughout the day and long into the night pilgrims process in a constant stream – always clockwise – around the Barkhor. Fearsome-looking Khambas (people from the eastern

Pilgrim with prayer beads

highlands), notable for the red threads braided into their hair, mingle with scarlet-robed monks and Golok nomads who wear huge sheepskin coats. Most spin prayer wheels as they walk, or mumble prayers which they keep count of on long strings of beads. Some stroll and chat, while others display penitence by repeatedly prostrating themselves along the route. Protected by leather aprons and with wooden paddles on their hands, they throw themselves across the paving flags, making a skittering sound that echoes around the Barkhor.

In the square in front of the Jokhang are two large braziers where pilgrims burn offerings of juniper: its pungent fragrance will for ever remind you of Lhasa. Also here is a small market, selling everything that the pilgrims might need for their devotions: yak butter, prayer flags, prayer wheels and, of course, fresh juniper.

Pilgrims taking a break outside the Jokhang

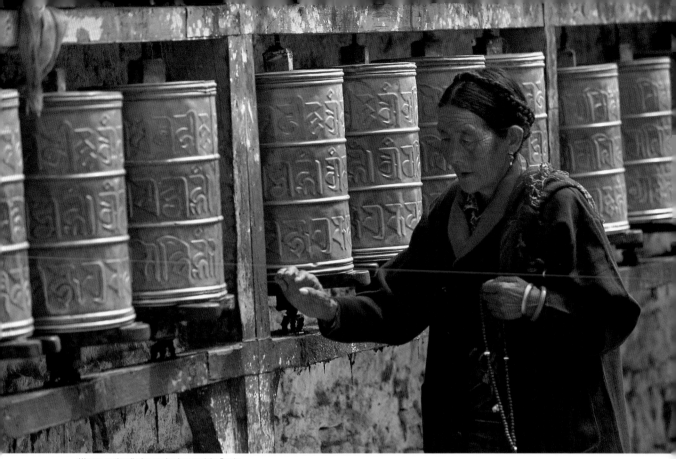

Woman on the pilgrimage circuit around the Potala

Within the main porch of the temple are two giant prayer wheels, kept in constant motion by the streams of pilgrims. On the patio in front, pilgrims of all ages prostrate themselves time and again in a repetitive ritual, seemingly inured to the discomfort.

Inside the Jokhang, a double row of prayer wheels skirts the outside of the main prayer hall. This inner pilgrimage route is called the Nangkhor, and pilgrims walking around it attempt to spin each of the prayer wheels by hand to release their prayers up into the sky.

Yak-butter lamps in the 1350-year-old Jokhang Temple

Inside the dark main hall of the Jokhang the air is heavy with the smell of yak-butter lamps, and the occasional low, rhythmic chanting of monks imparts a hallowed atmosphere that threatens to overwhelm the emotions. Pilgrims walk round the outside of the main hall – the centre being the exclusive preserve of monks, statues of former abbots and a giant golden Buddha image – past a number of small shrines and statues.

Towering above the whole city of Lhasa is the Potala Palace. The former home of the Dalai Lama, the spiritual leader of Tibetan

Pilgrim on the Barkhor

Gilded roof of the Jokhang

Buddhism, it is now little more than a museum. I had feelings of both guilt and sadness as I walked through the private quarters, realizing that the Dalai Lama, rather than I, should have been there. Once situated on the outskirts of Lhasa, the Potala is now somewhat isolated in the middle of the modern part of the city. Around the base there is another pilgrimage route of prayer wheels which, like the Barkhor, is in constant use.

The Dalai Lama, who fled Tibet in 1959, following the Chinese invasion in the early 1950s, has recently stated that he never expects Tibet to be liberated. While Tibetans enjoy more religious freedom than they originally did under the Chinese, pictures of the Dalai Lama are still banned and any dissent is strongly suppressed. Migration

from China means that Tibetans are now in a minority in their own country, so even if there were to be a referendum on the nation's future it would probably preserve the status quo.

(i) ···

Tibet is a politically sensitive area, so the rules on visiting are subject to change without notice. You will need a special permit as well as a Chinese visa. The easiest way there is to take a tour from either Kathmandu or the city of Chengdu in China, although travellers from Nepal are often unable to change the duration of their permit once they arrive. Travellers from Chengdu can change the date of their return flight and effectively stay in Lhasa for the duration of their visa. Tours from both places can be arranged with other travellers in a couple of days. At the time of writing (2003) it is possible to travel independently from Chengdu only. Shigatse Travels, a travel agency based in Lhasa, can help and advise with arrangements. Most of the cheaper accommodation is in the Tibetan quarter. Many travellers feel that they should support Tibetan, rather than Chinese-run, businesses and are prepared to sacrifice comfort for atmosphere.

Entrance to the main prayer hall of the Jokhang

Khamba women on the Barkhor with the Potala Palace behind

Yangshuo
Guilin, China

Karst scenery at Xingping

The bustling tourist town of Guilin in Guangxi Province is famous across the world for its limestone peaks, which rise majestically from lush green rice paddies. However, the best scenery is further down the Li Jiang (Li River), at Yangshuo.

A number of official tourist boats ply this route, but they are primarily designed for the burgeoning domestic tourist market and drastically overcharge the foreigners they ferry down the river, in a long and decidedly unatmospheric convoy, then whisk them to Guilin by coach.

A much better option is to take a bus from Guilin to Yangshuo and stay for a few days in this quiet town, hiring a bicycle and exploring the surrounding countryside at your leisure.

Areas with limestone peaks with eroded cavities and caves are described as 'karst'. Although other places have karst scenery – including Vang Vieng in Laos and Viñales in Cuba – none has the complexity or the magnitude of that around Yangshuo. Spectacular limestone peaks stretch as far as the eye can see, and delight in such names as Lion Ascending Five Finger Hill or Grandpa Watching Apple.

It is best to go sightseeing in the early morning or late afternoon. Apart from avoiding the heat and humidity of the day, the light is better. (This type of landscape looks flat and hazy in the midday light.) Sunrise and sunset are particularly evocative, even if the weather – exacerbated by the smog that seems to cover much of rapidly industrializing China – isn't perfect. The best position is at the top of one of the limestone peaks, and you should aim to climb at least a couple during your time here. The view from Yueliang Shan (Moon Hill) out to a sea of peaks bathed in early morning cloud is one of the most spectacular sights in the region, and well worth the 30-minute pre-dawn cycle ride and steep climb of similar duration to get there.

An almost equally stunning view of the sun slipping behind the peaks surrounding Yangshuo can be had from Pantao Shan, accessed via a steep and ragged path. The top is peppered with TV and radio masts, but gives almost a 360-degree panorama. Remember not to linger too long at the top or you will have to make the difficult journey back down in complete darkness.

About an hour by bus from Yangshuo is Xingping, from where you can take an unofficial boat trip to see some of the most impressive

Karst scenery just outside Yangshuo

scenery on the river. You can sign up for this at any of the restaurants and guest houses in Yangshuo. Limestone mountains line the river on either side, offering a different view of the peaks and paddy fields around Yangshuo. Most trips also take in a 500-year-old fishing village once visited by former US president Bill Clinton.

On the outskirts of Xingping is probably the most well-known spot in the whole region: a bend in the river between limestone peaks, immortalized on the back of the current 20-yuan notes. The image and reality are identical – even down to an overhanging clump of bamboo. It is all remarkably unspoilt, especially given China's predilection for stringing up fairy lights and constructing eyesores that (with no trace of irony) they call 'place-for-viewing-the-unspoilt-landscape'.

Synonymous with the Guilin region – and appearing on most picture postcards – is cormorant fishing, which takes place on the river at night. Boat trips will take you out to see fishermen using trained cormorants to catch fish. (The training obviously leaves something to be desired, as the fishermen still feel the need to tie string around the birds' throats to stop them swallowing the catch.)

Alternatively, there are always a couple of cormorant fishermen hanging out during the day by the riverside at Yangshuo, who are willing to pose for pictures for a few yuan.

ⓘ ··

Guilin airport can be reached by direct flight from Beijing, Shanghai and Chengdu, as well as a number of other Chinese cities. Buses run to Yangshuo every hour or so and take a couple of hours, passing through spectacular scenery. A range of accommodation is available at Yangshuo, from inexpensive guest houses to the three-star Yangshuo Resort Hotel. Excursions to Xingping or to see the cormorant fishermen can be booked from local hotels, restaurants or guest houses, and most also rent out bicycles for exploring the surrounding area.

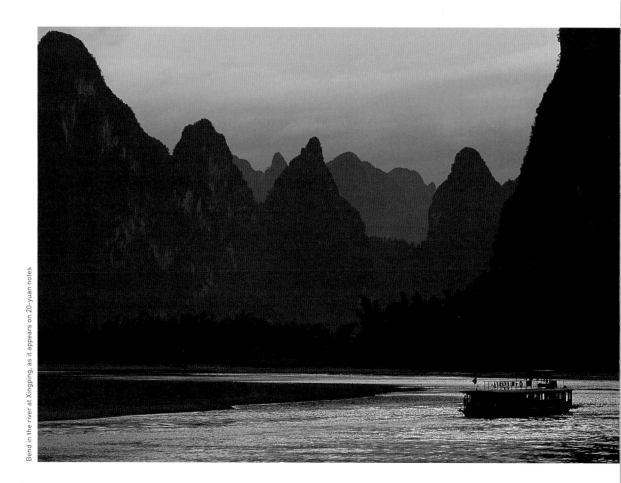

Bend in the river at Xingping, as it appears on 20-yuan notes

View of peaks from Pantao Shan, Yangshuo

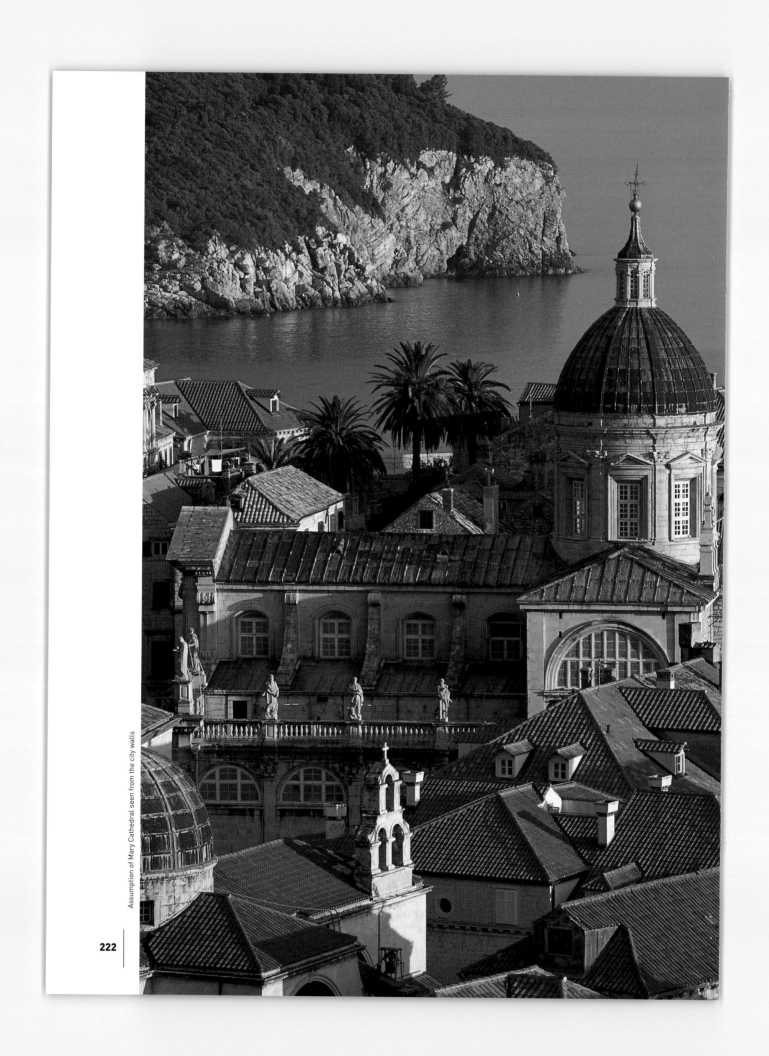

Assumption of Mary Cathedral seen from the city walls

View of the city from the north

Looking down on to the red-tiled roofs of the Old Town of Dubrovnik as it nestles quietly alongside the cool waters of the Mediterranean, it is hard to credit that its history is steeped in political intrigue, war and destruction. But appearances are deceptive, and Dubrovnik has a more violent and colourful past than most cities in Europe.

For most of its long history Dubrovnik was an independent city state. It came under the protection of Venice in the 13th century, and Hungary some 150 years later. The city preserved its independence by careful diplomacy and payment of tributes. Under these conditions it grew into a wealthy democracy with a wide network of trading outposts. As the importance of the city increased many civil construction projects, such as the city walls, were undertaken, and Dubrovnik proved attractive to writers and artists.

Although the sovereignty of Dubrovnik passed to the Ottoman Empire in the 16th century the city continued to flourish until it was

DUBROVNIK

all but destroyed by an earthquake in 1667. It was rebuilt in 1683, but the shifting trade allegiances and wars that rocked Europe during the 18th century weakened its power. The final death blow came in 1808, when Napoleon formally abolished Dubrovnik's tenuous independence, prompting a bombardment by British forces.

The city languished through subsequent wars and European politicking until it once again shot to prominence during the 1990s' Balkans War, following the break-up of Yugoslavia. During a siege which lasted seven months, before finally being lifted in May 1992, over 2000 shells slammed into the city.

Despite past violence and destruction, Dubrovnik is still a beautiful city. Indeed, the depredations of the siege have been

View of the city and the harbour

View from city walls with Lokrum Island in background

repaired so successfully (with financial assistance from UNESCO) that visitors could be forgiven for thinking that war had never touched it.

The best way to get orientated in Dubrovnik is to walk around the towering and immensely thick 13th-century walls that surround the Old Town. At the highest point of the walls on the landward side of the city is the distinctive Minceta Tower, which has the best panoramic views of the city, Lokrum Island near the harbour mouth and the Mediterranean beyond. The battlements at the top of the tower give great views down into the narrow streets and courtyards. Church domes and spires reach above the expanses of red-tiled roofs, and at sunset golden light skims these roof tops and casts the skyline into relief against the surrounding landscape.

The main thoroughfare, the Stradun, divides the city into two halves and extends over 200 metres, from the Pile Gate in the west to the clock tower at the harbour entrance. Once a marsh that separated the Roman and Slavic halves of the city, the Stradun is now paved with stones polished by years of pedestrian traffic, and lined with shops.

The city walls dropping down into the Mediterranean

City walls and street below

As you wander the narrow streets away from the Stradun, you get a sense of the tightly knit community. The houses in the Old Town are small and close together, with laundry strung between them, children play in the streets, and neighbours sit on front steps or lean from windows chatting and watching the world go by.

Positioned in the middle of some of the most beautiful coastline in Europe, Dubrovnik is the perfect place to while away a few days. Although it lacks the grandeur of Venice, and the power and influence it enjoyed in the 15th and 16th centuries has long since passed away, this small and modest city has a beguiling charm of its own.

ⓘ ⋯⋯⋯⋯⋯⋯⋯⋯⋯⋯⋯⋯⋯⋯⋯⋯⋯⋯⋯⋯⋯⋯⋯⋯⋯⋯⋯⋯⋯⋯⋯⋯⋯⋯⋯⋯⋯

Charter flights to Dubrovnik are available, but if you want the flexibility of a scheduled service your options are more limited. Alitalia fly there with a connection in one of three Italian cities. Alternatively, you can to fly to Belgrade and then take a domestic flight on Croatia Airlines. Dubrovnik offers a wide range of accommodation, but you should try and book during the summer months. Most of the better-quality accommodation is outside the city walls.

The Stradun (the main street of the city) seen from the city walls

Ephesus
Turkey

Columns on the way up to the Temple of Domitian

Sunset over the amphitheatre

The ruins at Ephesus are the best preserved of any Roman site in the Mediterranean. Although only 10 per cent of the city has been excavated, the wealth of surviving detail makes it easy to imagine the lives of the people who lived there: the latrines in the public baths are communal and packed close together; the brothel is across the street from the Library of Celsus; the agora, or market area, is vast, showing the importance of trade to the city; temples occur at frequent intervals; and a cemetery for gladiators has provided much information about their lives.

The ruins are spread along the slopes of two hills, with two level sites in between connected by the sloping Street of Curetes. The lower site, closest to the ancient harbour, has a vast amphitheatre that can seat 25,000 people. Concerts are still held here today.

Also on the lower site is the Library of Celsus, the single most impressive ruin at Ephesus, which is best seen at sunrise. All that remains is the front façade, with its entrances to the original building, and two huge storeys of pillars, statues and windows. Constructed using subtle techniques to manipulate perspective,

the building, when viewed from ground level, appears much larger than it really is.

The Street of Curetes climbs upwards from the library, its wide pavement concealing sophisticated sewerage and water systems. On either side are columns and façades – the ruins of terraced housing, public baths with rows of latrines, a brothel, shops and temples.

Ephesus was founded by the Greeks, who arrived in the 10th or 11th century BC. Under their influence it became a mighty city and sea port, with a population of some 200,000 people. The Temple of Artemis (Diana), built during their time, was one of the Seven Wonders of the World. The present-day ruins, now about 5 km away from the coast, date from a city that was founded in the 3rd century BC by

Temple of Hadrian

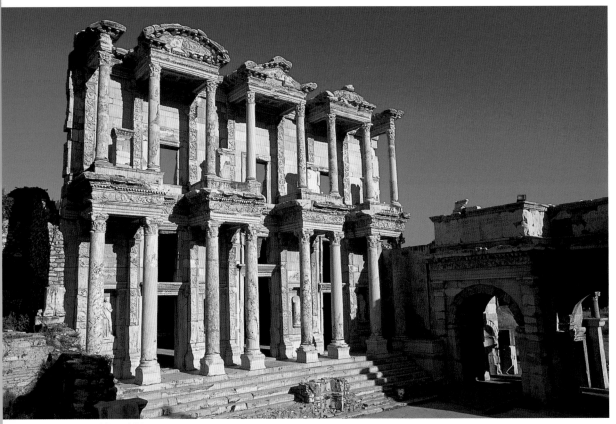

Library of Celsus

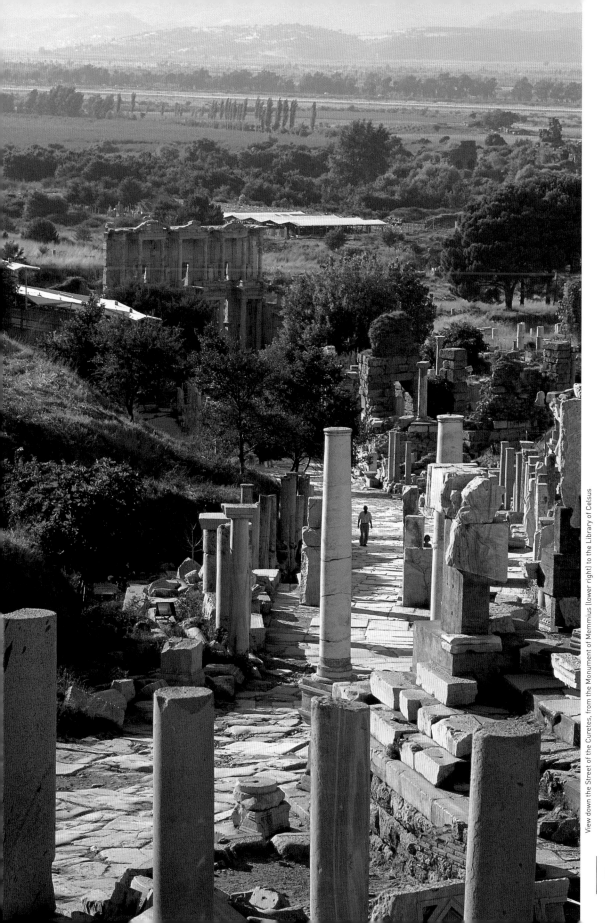

View down the Street of the Curetes, from the Monument of Memmius (lower right) to the Library of Celsus

Lysimachus, one of Alexander the Great's generals. The city came under Roman control in the 2nd century BC, and it later became an important centre of Christianity. (St Paul visited several times, and St John is said to be buried here.)

The Ephesus Museum in Selçuk has a great collection of artefacts and statues from Ephesus that will enhance your understanding of how the city must have looked, and what it might have been like to live there.

ⓘ ···

The airport closest to Ephesus is at Izmir, which is 30 km away from the nearby town of Selçuk. The ruins are open from 8 a.m. which is just before summer sunrise strikes them directly. The gates close at 7 p.m. but you can generally wander around for at least another hour. The ruins are occasionally lit at night for special events, so it is worth finding out if your visit coincides with this impressive sight. Many people visit the site on day trips from beach locations such as Kusadasi, but if you want to really explore Ephesus you should stay in Selçuk, 3 km away. The best accommodation here is at the Hotel Kalehan.

The Agora near the Library of Celsus

Statue in the façade of the Library of Celsus

Library of Celsus

The Bund
Shanghai, China

Pudong, the Bund and the Huançpu River from the top of the Peace Hotel

There are few cities in the world that have given rise to a verb, but it seems wholly appropriate that the frenetic city of Shanghai should have done so. 'To shanghai' originally meant to kidnap a drunken man and press him into work as a sailor, but it eventually came to mean compelling someone to do something by fraud or by force.

The verb fits the city that was once central to the commercial exploitation of China and much of Asia but had an underbelly steeped in vice, gambling, prostitution and opium. The British were granted

the first trading concession in 1842 after the First Opium War, when the Chinese government was forced to relegalize the import of the drug. The commercial exploitation of China by Europe had begun. Great fortunes were made in trade and lost on the spin of a roulette wheel. Shanghai thrived on intrigue, catered to every kind of perversion and allowed criminal gangs to roam the streets. Not for nothing was the city known as the 'Whore of the Orient'.

Other countries – notably France – were later granted concessions, and soon a virtual European city existed. European Shanghai laid a

Shopping by bicycle in the old streets of Shanghai

thin veneer of respectability over the city with the creation of the Bund, an imposing stretch of buildings along the Huangpu River. Many were the head offices of great trading companies, insurance houses and banks. The most imposing, however, is the Customs House, one of the few buildings on the Bund that retains its original function. Another place worth checking out is the Peace Hotel, formerly the Cathay Hotel, once the most fashionable place in European Shanghai. The art deco interiors have recently been restored, and the hotel is probably the most atmospheric and historic place to stay in the city.

Although the vice and intrigue of Shanghai were suppressed by the Communists when they took charge of the city in 1949, they are now making a comeback. Walk along the Bund and you will continually be offered fake Rolexes and even, occasionally, sex. (The

View across to the Bund

Looking down to the city from the top of the Oriental Pearl TV Tower

first sex shop in China opened recently on the main Nanjing Donglu.)

In a uniquely Chinese demonstration of one-upmanship, the city authorities didn't demolish evidence of the colonial era – they merely dwarfed the buildings of the Bund, making them look insignificant. On one side of the Huangpu River, the Pudong New Area has been reclaimed from marshland, and since 1990 has become a massive area of tower blocks. The most spectacular are the Oriental Pearl TV Tower and the 88-storey Jinmao Tower, the top 35 floors of which house the Grand Hyatt Hotel. A new skyscraper currently under construction is expected to become the tallest building in the world.

As you look down from the top viewing-stage of the Oriental Pearl TV Tower or the Cloud Nine Bar at the top of the Hyatt Hotel, the sprawling towers of Shanghai seem to threaten the buildings of the Bund and push them into the river. Nonetheless, the Bund remains one of the most potent symbols of Shanghai, and from ground level it retains some of the gravitas and presence that it enjoyed in the past.

Outdoor laundry in the backstreets

It also remains the centre of Shanghai life. From the early morning, when it is thronged with kite flyers, old people practising t'ai chi and *qi gong*, and couples ballroom-dancing before work, to the daytime, when tourists from all over China flock to be photographed against the backdrop of the Bund and Pudong, through to the evening, when locals emerge to stroll in the cool breeze coming off the river, this stretch of waterfront is always packed and bursting with life.

The old streets of Shanghai can still be found in the Chinatown area of the city. Peculiar as it seems to have a Chinatown in a Chinese city, this area is a throwback to the days when Europeans ruled the roost and locals were restricted to certain parts of the city. A sign on the old British public gardens at the end of the Bund used to ban, among other things, dogs and Chinese.

Many of the old streets have been demolished to make room for the tower blocks of new Shanghai, and the rest are probably under threat in the headlong dash for progress. Among the surviving streets,

some of the most atmospheric are between the old Yu Yuan (Jade Gardens) and the river. The gardens themselves are typically Chinese, created in the mid-16th century during the Ming dynasty. Shady pools, rock gardens and pagodas form a haven of peace in the noisy city, the atmosphere only slightly compromised by the Yu Yuan Bazaar, a sprawling 'old' themed shopping complex next door.

Life in the old streets of Shanghai seems to have remained unchanged for generations, and it is easy to imagine European sailors or traders staggering down alleys such as these in search of women or opium, never to be heard of again. The present, though, is less dramatic as daily life unfolds at a slow pace, punctuated by the constant chirruping of crickets kept in small bamboo cages for good luck.

(i) ⋯⋯⋯⋯⋯⋯⋯⋯⋯⋯⋯⋯⋯⋯⋯⋯⋯⋯⋯⋯⋯⋯⋯⋯⋯⋯⋯⋯⋯

Shanghai is one of the main international gateway cities of China and can be reached by air from most countries. Although there are many places to stay, the choice really comes down to the old – the atmospheric Peace Hotel right on the Bund – or the new, skyscraping Grand Hyatt Hotel. The city sprawls for miles, but most of the main sights are along the river – either along the Bund or in the reclaimed area of Pudong. There is a modern underground railway or you can catch a ferry across the river. A visit to see the famous Shanghai acrobats is a 'must'.

Morning exercise on the Bund

The Bund

Dome and minaret of Bibi Khanum Mosque

Dome of Tillya Kari Madrasa

The great city of Samarkand lies on the so-called Silk Road, the ancient trading route that led from China through the Middle East and into Europe. The city grew rich through trade, and constructed some of the finest buildings to be found in the Islamic world.

Detail of Shir Dor Madrasa

Its strategic position has led Samarkand to be conquered and sacked many times throughout its long and bloody history. The first settlement there was constructed in the 6th century BC and was first conquered by Alexander the Great some 200 years later. As trade routes built up over the next few hundred years, the city grew in power and wealth despite being captured by both the Turks and Hun tribes. Indeed, it continued to flourish, as recorded by the Buddhist monk and traveller Xuan Zang when he arrived there in AD 630.

At this time Samarkand followed the Zoroastrian religion of Persia, but the city fell to Islam when Qutaiba ibn Muslim invaded it in 712. This was the start of the first great period of Islamic development, which was curtailed at the beginning of the 13th century when the city was sacked by the Mongols of Genghis Khan, who slaughtered much of the population.

By the time another great traveller, Marco Polo, arrived at the end of the 13th century the city had been rebuilt, and he sang its praises. The Uzbek national hero, Tamerlane, chose it as the capital of the relatively small region of Transoxiana in 1370 and then proceeded to

expand his empire until it reached as far as India and Syria. He was responsible for several great buildings, most notably the Bibi Khanum Mosque. His grandson, Uleg Beg, ruled the city until it fell to nomadic Uzbeks. Uleg Beg's great-grandson, Babur, retook the city in 1512 but was later driven out to India where he founded the Mogul Empire. This was the end of a golden era. Ravaged by earthquakes, looting and changing trade routes, Samarkand eventually succumbed to the Bolsheviks and became part of the Soviet Union in 1924.

The ancient centre of Samarkand is the Registan. This square, one of the finest in Asia, is surrounded on three sides by madrasas, or Islamic colleges. Uleg Beg constructed the square and the first madrasa in the 15th century. The fronts of the madrasas are towering façades that lead into ornate courtyards ringed with two storeys of small cells where the religious students lived and studied.

Ironically, for all their anti-religious sentiment and public denigration of Islam, it was the Soviets who restored much of the Registan, straightening precarious minarets and reconstructing the characteristic turquoise-tiled domes. These still shine with an

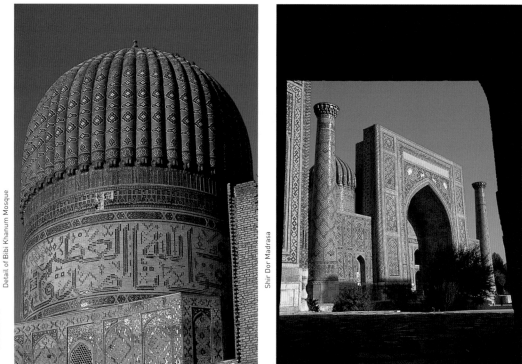

Detail of Bibi Khanum Mosque

Shir Dor Madrasa

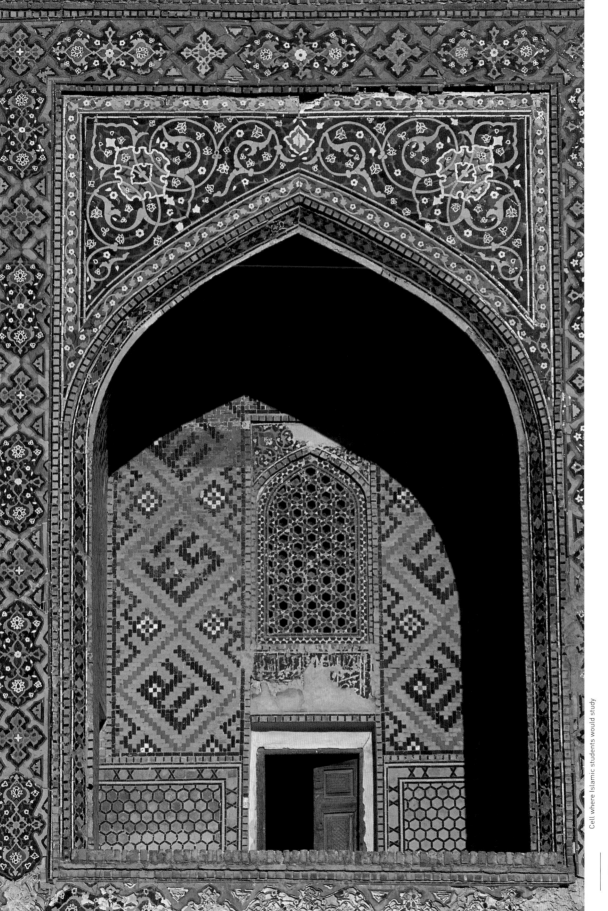

Cell where Islamic students would study

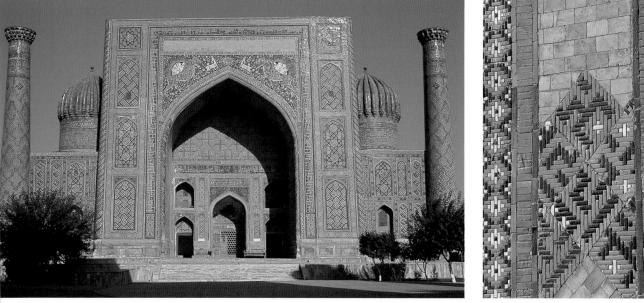

Shir Dor Madrasa

Shir Dor Madrasa

iridescence that perhaps suggests the cool water that is often lacking in this dry land.

Islam forbids the representation of living things, so each of the madrasas is covered with ornate patterns (none symmetrical, as this too is forbidden), intricate Kufic quotations from the Koran and inscriptions extolling the magnificence of the buildings. Bizarrely, though, the Shir Dor Madrasa on the eastern side of the square has two representations of lions in front of suns with shining human faces. This apparent heresy is attributed in part to the ego of the governor who built the madrasa and also to the continued influence of the Persian Zoroastrians who revered the power of the sun.

The Uleg Beg and Shir Dor madrasas are flanked by minarets, used more for decoration than for calling the faithful to prayer as the buildings were primarily colleges rather than mosques. In Tamerlane's day, however, they were also used for public executions: a favourite way of dealing with criminals was to throw them from the top in a sack.

For a couple of dollars, one of the uniformed guards might let you climb the crumbling steps to the top of the north minaret at Ulug Beg Madrasa for one of the most impressive views across the city to the Bibi Khanum Mosque. Tamerlane constructed this vast mosque from the finest materials after sacking the city of Delhi in 1398.

In the adjacent bazaar life and trade continue much as they did when the Silk Road brought spices, gold and fabrics to be traded

here. You can still buy the round hats worn by many of Uzbekistan's Muslims, decorated flat breads and exotic spices that hark back to the days when peppercorns and saffron were more valuable than gold.

Detail of Registan Square

ⓘ ⋯⋯

Samarkand is easily reached by bus or air from the capital Tashkent. Several airlines fly to Tashkent, including British Mediterranean. Uzbekistan Air has a remarkably modern fleet and a fairly good worldwide network. Buying a domestic ticket overseas can be difficult, so you will probably find it easier to attach it to your international flight. Hotel accommodation is plentiful in Samarkand, including the four-star Hotel Presidential Palace.

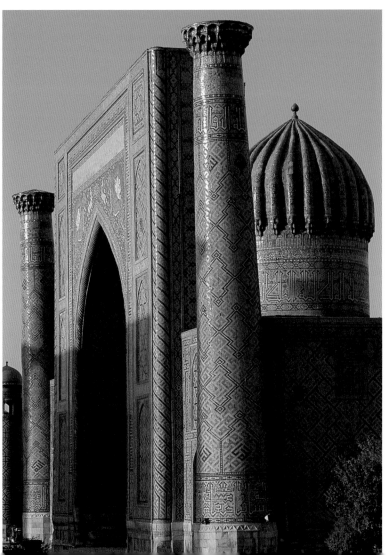
Shir Dor Madrasa

Killary Harbour
Connemara, Ireland

Connemara is an area that for many people best encapsulates what is great and beautiful about Ireland and its desolate west coast. The jagged coastline has many bays and inlets, none of which is more striking than Killary Harbour – a dramatic meeting of mountains and sea on the border between County Galway and County Mayo.

Separating the Mweelrea and Sheefry mountains on the north shore from the Maumturk Mountains and the Twelve Bens on the south shore, the harbour is actually Ireland's only fjord. It was formed during the last ice age, when characteristic U-shaped valleys were

carved between the mountains by glaciers, which then melted causing the sea to rise and flood the harbour.

About 1.5 km north of the harbour, in Mayo, is the Delphi Lodge and further up the valley is the beautiful and rugged Lough Doo. In 1849 potato-famine victims made the arduous trek from north Mayo through Lough Doo Pass to Delphi Lodge, and many people died along the way.

South of the harbour, a few kilometres beyond Lough Fee, is Kylemore Abbey, dramatically located at the base of Duchruach Mountain on the shore of Lough Pollacappul and home to Benedictine

KILLARY HARBOUR

nuns. The coast, beaches and roads around Renvyle on the south side of the harbour's mouth have the best views of the harbour and its mountains, and of the island of Inishbofin.

The Western Way hiking trail passes through Connemara and all the mountain ranges around the harbour. The stretch of trail above the harbour west of Leenane gives a great view of the sun setting at the mouth of the harbour, and of the islands within it.

The village of Leenane, at the very end of the harbour, is often called the 'Gateway to Connemara'. It boasts great views across the harbour, and two lively pubs which, for this part of Ireland, make it

Ballynakill Harbour, County Galway

Lough Doo

almost a metropolis. Whether you duck inside to avoid one of the regular showers of rain or linger all night to celebrate a perfect sunset, you will find enough of the legendary Irish *craic* (good times) to keep you entertained.

The weather in this part of the world can be dramatic and very variable, thanks to the mountains and the Atlantic Ocean creating localized conditions that can change from minute to minute. The peak of Mweelrea Mountain, the highest in Connemara, is almost always hidden by cloud, even on the clearest days, and storms can suddenly sweep through the area. But when the weather is good in Connemara, there is no more beautiful place to be.

ⓘ ...

The three airports nearest to Killary Harbour are at Galway, Shannon and Dublin. Driving to Leenane from these airports takes 1½ hours, 3 hours and 5–6 hours, respectively. The nearest large town is Clifden, where there is a wide choice of accommodation. There are also hotels and campsites throughout the area. The weather can be rough but it changes very quickly – if you drive from place to place, the good weather will find you. High summer is the best, though most crowded, time but conditions are very similar between May and September.

Grass on beach dunes at Doovilra, County Mayo Overleaf: Sunset at Renvyle, County Galway

1 ANGKOR WAT, CAMBODIA
2 ST PETERSBURG, RUSSIA
3 HAVANA, CUBA
4 WAT PHRA KAEO, THAILAND
5 THE GRAND CANYON, USA
6 TAJ MAHAL, AGRA, INDIA
7 EILEAN DONAN CASTLE, SCOTLAND
8 THE ALHAMBRA, GRANADA, SPAIN
9 AITUTAKI, COOK ISLANDS
10 PYRAMID OF KUKULCÁN, MEXICO
11 VENICE, ITALY
12 DEAD VLEI, NAMIBIA
13 IGUASSU, BRAZIL AND ARGENTINA
14 PETRA, JORDAN
15 COLLEGE FJORD, ALASKA, USA
16 KARNAK TEMPLE, LUXOR, EGYPT
17 RIO DE JANEIRO, BRAZIL
18 TAMAN NEGARA, MALAYSIA
19 JAISALMER FORT, INDIA
20 GALAPAGOS ISLANDS, ECUADOR

21 MANHATTAN ISLAND, USA
22 LAKE TITICACA, BOLIVIA AND PERU
23 MONET'S GARDEN, GIVERNY
24 NGORONGORO CRATER, TANZANIA
25 SANTORINI, GREECE
26 DRAKENSBERG, SOUTH AFRICA
27 ZANZIBAR, TANZANIA
28 MAKALU, HIMALAYAS, NEPAL
29 LALIBELA, ETHIOPIA
30 MACHU PICCHU, PERU
31 ULURU, AUSTRALIA
32 THE GHATS, VARANASI, INDIA
33 GREAT BARRIER REEF, AUSTRALIA
34 LHASA, TIBET
35 YANGSHUO, GUILIN, CHINA
36 DUBROVNIK, CROATIA
37 EPHESUS, TURKEY
38 THE BUND, SHANGHAI, CHINA
39 SAMARKAND, UZBEKISTAN
40 KILLARY HARBOUR, IRELAND

Useful web addresses

Cambodia

Bangkok Airways
www.bangkokair.com

Amansara Resort
www.amanresorts.com

Ministry of Tourism
www.mot.gov.kh

St Petersburg, Russia

Intourist
www.intourist.com

Cuba

Ministry of Tourism
www.cubatravel.cu

Thailand

Tourism Authority of Thailand
www.tourismthailand.org

USA

Grand Canyon
El Tovar Lodge
www.grandcanyonlodges.com

The National Parks Department
www.nps.gov/grca/grandcanyon

New York
www.iloveny.com

Alaska
www.travelalaska.com

India

Indian Trends, Delhi
www.indiantrends.com

Naryan Niwas Palace
www.narayanniwas.com

Mr Desert Camel Safaris, Jaisalmer
www.mrdesertjaisalmer.com

Amarvilas Hotel, Agra
www.tridenthotelsgroup.com

Ministry of Tourism
www.tourisminindia.com

Scotland

Scottish Tourist Board
www.visitscotland.com

Spain

Spanish Tourist Board
www.tourspain.es

Paradores of Spain
www.parador.es

Cook Islands

Air Rarotonga
www.ck/airrarotonga

Aitutaki Pacific Resort
www.pacificresort.com

Cook Islands Tourism
www.cook-islands.com

Mexico

Mayaland Hotel
www.mayaland.com

Mexican Tourist Board
www.visitmexico.com

Venice

Europa and Regina Hotel
www.starwood.com

Tourist Board of Venice
www.turismovenezia.it/eng

Namibia

Wilderness Safaris Namibia
www.wilderness-safaris.com

Namibia Tourism
www.namibiatourism.com

Jordan

Royal Jordanian Airways
www.rja.com.jo

Jordan Tourism Board
www.see-jordan.com

Movenpick
www.moevenpick-hotels.com

Egypt

Egyptian State Tourist Office
www.touregypt.net

Egyptair
www.egyptair.com.eg

Brazil

Brazil Tourist Board
www.embratur.gov.br

Las Cataratas Hotel
www.tropicalhotel.com.br

Macuco Safari
www.macucosafari.com.br

Helisight, Rio de Janeiro
www.helisight.com.br

Malaysia

Taman Negara Resort
www.tamannegararesort.com

Tourism Malaysia
www.tourism.gov.my

Galapagos

Metropolitan Touring
www.metropolitan-touring.com

Ministry of Tourism
www.vivecuador.com

Lake Titicaca and Machu Picchu

South American Experience,
London
www.southamericanexperience.co.uk

Orient Express
www.orient-express.com

Peru Tourist Board
www.peru.org.pe

Giverny, France

Information website
www.giverny.org

Tanzania

Sopa Lodge, Ngorongoro Crater
www.sopalodges.com

Abercrombie & Kent Travel
www.abercrombiekent.com

Air Excel
reservations@airexcelonline.com

Hotel Arusha
www.newarushahotels.com

Tanzania Tourist Board
www.tanzania-web.com

Santorini, Greece

Santorini Hotels online booking
service
www.santorini-hotels.net

Greek National Tourism
Organization
www.gnto.gr

Republic of South Africa

Ezemvelo KZN Wildlife
www.kznwildlife.com

Nepal

Nepal Tourism Board
www.welcomenepal.com

Ethiopia

Ethiopian Airlines
www.flyethiopian.com

Ethiopian Tourism Commission
www.visitethiopia.org

Australia

Qantas
www.qantas.com.au

Ayers Rock Resort
www.ayersrockresort.com.au

Heron Island Resort
www.heronislandresort.com.au

Australian Tourist Commission
www.australia.com

Tibet

Tibet Government in Exile
www.tibet.com

China Tourism
www.cnta.com

China

Peace Hotel, Shanghai
www.shanghaipeacehotel.com

China Tourism
www.cnta.com

Dubrovnik, Croatia

Croatian National Tourist Office
www.croatia.hr

Hotel Kompas, Dubrovnik
www.hotel-kompas.hr

Ephesus, Turkey

Hotel Kalehan, Selçuk
www.kalehan.com

Republic of Turkey, Ministry of
Culture and Tourism
www.turizm.gov.tr

Samarkand, Uzbekistan

Cox and Kings Travel
www.coxandkings.co.uk

Tourism Uzbekistan
www.tourism.uz

Ireland

Renvyle House Hotel,
County Galway
www.renvyle.com

Tourism Ireland
www.tourismireland.com

Acknowledgements

The following organizations have contributed material support and assistance with the travel and photographic arrangements. We thank them for their vision and their generosity. Without them this project would not have been possible.

Photography: Classic Photographic, London. **India:** Indian Trends, Delhi; Naryan Niwas Palace. **Cook Islands:** Air Rarotonga; Aitutaki Pacific Resort; Cook Islands Tourism. **Mexico:** Mayaland Hotel. **Venice:** The Europa and Regina Hotel. **Namibia:** Wilderness Safaris Namibia. **Brazil:** Brazil Tourist Board; Las Cataratas Hotel; Macuco Safari; Helisul Helicopter Tours, Foz do Iguaçu; Helisight, Rio de Janeiro. **Jordan:** Royal Jordanian; Jordan Tourism Board. **Malaysia:** Taman Negara Resort. **Galapagos:** Metropolitan Touring. **Lake Titicaca and Machu Picchu:** South American Experience, London; Orient Express. **Tanzania:** Sopa Lodge, Ngorongoro Crater; Abercrombie & Kent Travel; Air Excel; Hotel Arusha. **Republic of South Africa:** Ezemvelo KZN Wildlife. **Ethiopia:** Ethiopian Airlines. **Australia:** Qantas; Ayers Rock Resort; Heron Island Resort; Northern Territory Tourist Commission. **China:** Peace Hotel, Shanghai. **Dubrovnik:** Croatian National Tourist Office; Hotel Kompas, Dubrovnik. **Ephesus:** Hotel Kalehan; Republic of Turkey, Ministry of Culture and Tourism. **Ireland:** Renvyle House Hotel; Tourism Ireland.

And finally, special thanks to Marc Schlossman, who photographed the following locations for this book: St Petersburg, Eilean Donan Castle, Dead Vlei, College Fjord, the Galapagos Islands, Manhattan Island, Lake Titicaca, Giverny, Drakensberg, Makalu, Machu Picchu, Dubrovnik, Ephesus and Killary Harbour.

First published 2004
Reprinted 2004 (six times), 2005 (seven times)

Text copyright © Steve Davey 2004
The moral right of the author has been asserted.

Photographs copyright © Steve Davey and Marc Schlossman

Photograph of orcas on page 98 © Jeff Pantukhoff/Seapics.com

ISBN 0 563 48746 1

Published by BBC Books,
BBC Worldwide Ltd, Woodlands,
80 Wood Lane, London W12 0TT

Commissioning editor: Nicky Ross
Project editor: Christopher Tinker
Copy-editor: Trish Burgess
Art director: Linda Blakemore
Designer: Bobby Birchall (DW Design)

Set in DIN Regular
Printed and bound in Great Britain by Butler & Tanner Ltd, Frome
Colour separations by Radstock Reproductions Ltd, Midsomer Norton